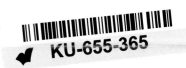
ROAD TO REPEAL

THE LILLIPUT PRESS

DUBLIN

Dedication

This book is dedicated to

All the women, girls and men who contested
the repression of women's rights to control
their fertility over the past 50 years;

The activists and groups in Ireland and
overseas whose unrelenting commitment
helped to remove the Eighth Amendment
from the Constitution on May 25th, 2018;

Solidarity with those who experienced
tragedy during this half century and with
women everywhere seeking a better world.

The State acknowledges the right to life of
the unborn and, with due regard to the equal
right to life of the mother, guarantees in its
laws to respect, and, as far as practicable, by
its laws to defend and vindicate that right.

— *Eighth Amendment*
of the Constitution of Ireland

September 7th, 1983

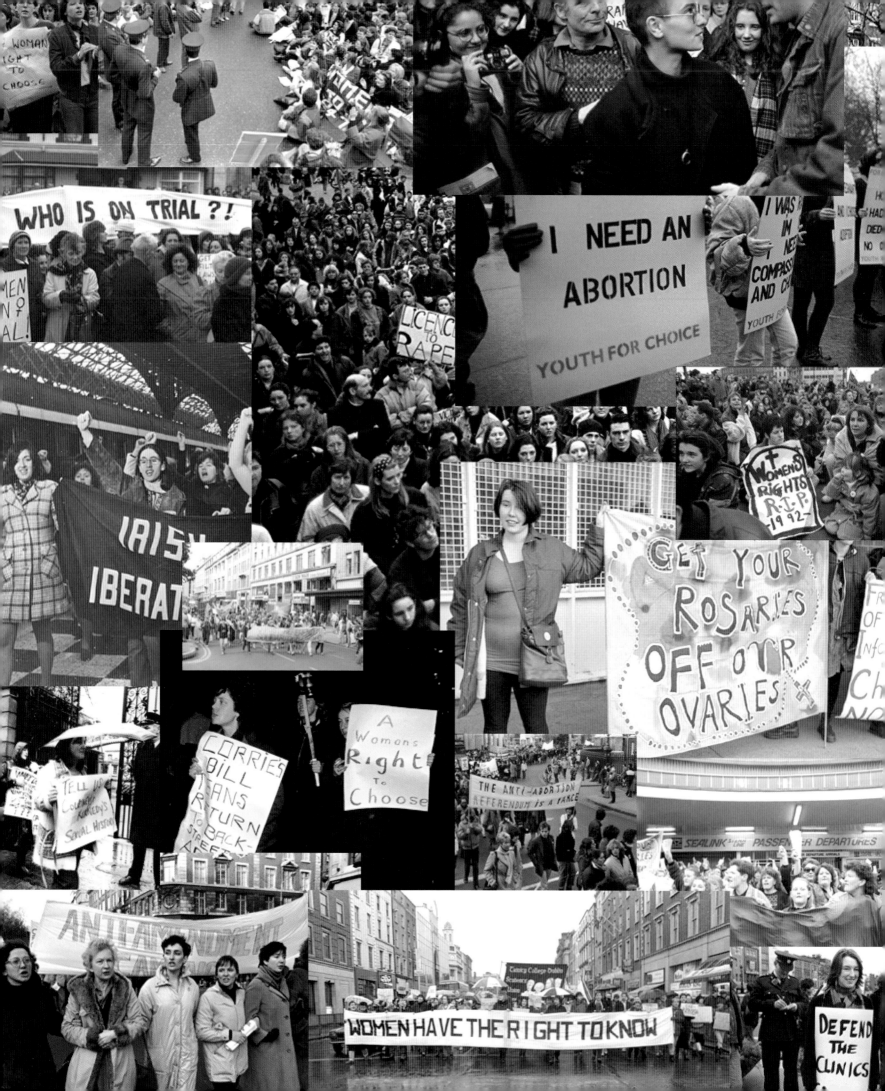

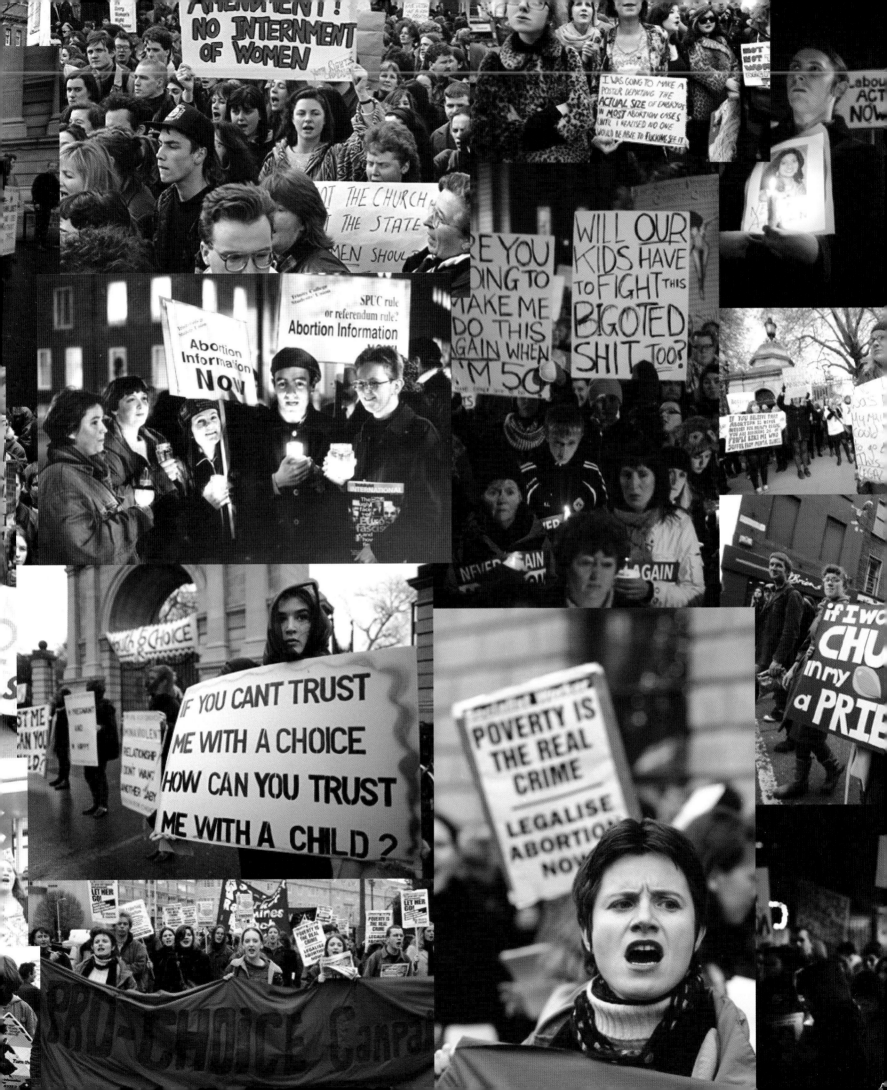

FREE LEGAL CONTRACEPTION NOW

17TH FEBRUARY 1992.
.. the introduction
of internment
in Ireland...........

...... for 14 year
old girls....

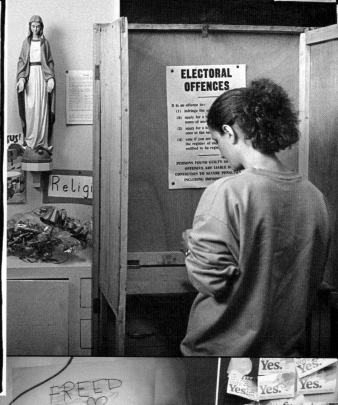

ELECTORAL OFFENCES

Religi

blackboard

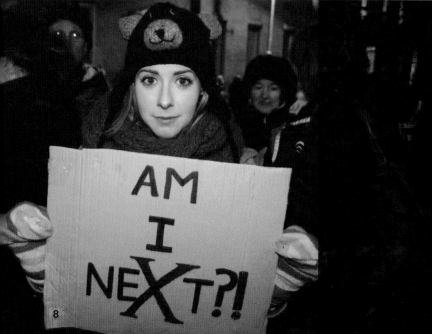

AM
I
NEXT?!

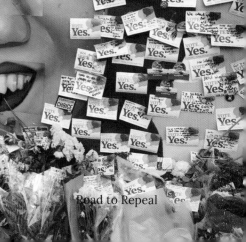

FREED

Yes.

CONTENTS

*Miss X graphic courtesy of The Irish Times.
Other photos by Derek Speirs including
the mural by artist Aches which became a
shrine where people remembered the death
of Savita Halappanavar during the repeal
referendum.*

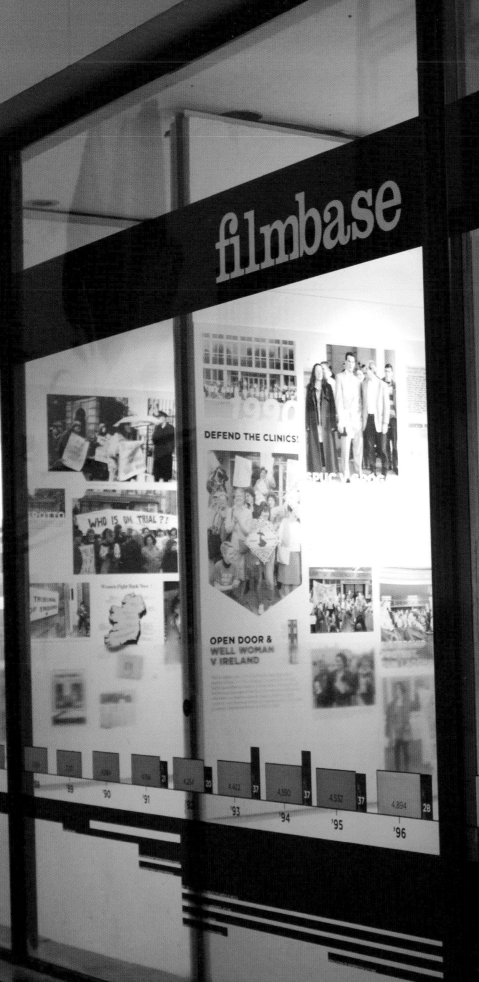

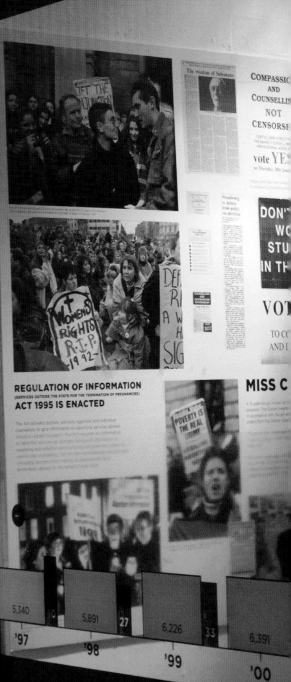

filmbase

filmbase

DEFEND THE CLINICS!

SPUC v GROGAN

OPEN DOOR &
WELL WOMAN
V IRELAND

REGULATION OF INFORMATION
(SERVICES OUTSIDE THE STATE FOR THE TERMINATION OF PREGNANCIES)
ACT 1995 IS ENACTED

MISS C

COMPASSION
AND
COUNSELLING
NOT
CENSORSHIP

vote YES

WHO IS ON TRIAL ?!

SPARE RIB
LIVES !

WOMEN'S
RIGHTS
R.I.P.
1992 —

POVERTY IS
THE REAL

'95 '96 '97 '89 '90 '91 '93 '94 '95 '96 4,402 4,590 4,532 4,894 4,264 '97 '98 '99 '00 5,340 5,891 6,226 6,391

ACKNOWLEDGMENTS

Road to Repeal, the photobook, arose from an exhibition launched in 2014 in Filmbase, Dublin. The multimedia history took in four decades of women's organisations, struggles and activism to secure contraception and abortion rights in Ireland. It aimed to prevent a public forgetfulness of fraught times, five referendums and the suffering of too many women.

Choice campaigners were instrumental in making it happen. They shared precious posters, leaflets, logbooks and files, magazines and film reels for inclusion in what became Women to Blame: Forty Years of Struggle in Ireland for Contraception and Abortion. A special mention must be made of writer and Irish Women's Liberation Movement founder Nell McCafferty whose book about Joanne Hayes, A Woman To Blame, inspired its title.

The 2014 team (journalist Therese Caherty, social researcher Pauline Conroy, photographer Emma Loughran, graphic designers Adam May and Clio Meldon) remain indebted to Maura Molloy, Ruth Riddick, Evelyn Conlon, Molly O'Duffy, the late Anne O'Brien, Helen Mahony, Anthea McTeirnan, Sandra McAvoy, Mary Muldowney, Anne Speed, Eddie Conlon, the late Joe Kelly, Kieran Meagher, John Meehan, Fintan Vallely and film-makers Cathal Black and Ruth Jacob.

In 2022, Road to Repeal expands the exhibition to include 10 more years with a strong focus on 2018's amazing referendum result. The authors, Therese Caherty and Pauline Conroy, are grateful to Mary Gordon, Goretti Horgan and Patricia Kelleher for their contributions. We thank Imelda Brophy, Mary Diskin, Tom Duke, Stephen Grogan, Marese Hegarty, Sinéad Kennedy, Albert Lesegang, Tomás McEoin, Paula Meehan, Paul O'Driscoll, Sha Gillespie, Sarah O'Toole, George Row, Ralf Sotscheck and Brendan Young for their advice and help.

We thank photographers Clodagh Boyd, Rose Comiskey, Paula Geraghty, Emma Loughran, Derek Speirs, Tommy Clancy and Joanne O'Brien – without their generosity and that of The Irish Times and Liam Ryan neither exhibition nor book would have seen the light of day.

We thank the Communications Workers Union, Mandate Trade Union, UNITE the Union and the Trade Union to Repeal the 8th Amendment for invaluable solidarity and financial support.

We thank Catholics for Choice for continuing belief in and funding for book and exhibition. Likewise the National Women's Council of Ireland and Orla O'Connor who endorsed both from the outset.

The text of Road to Repeal was scrutinised by readers and we are obliged to Laurence Cox of NUI Maynooth, archivist and broadcaster Catriona Crowe, Padraic Ferry of Ferrys Solicitors LLP, Maeve Taylor of the Irish Family Planning Association and an anonymous reader for helpful and critical comments on early drafts.

Adam May developed the design concept for the 2014 exhibition and Road to Repeal with graphic designers Clio Meldon and Kayleigh McCarthy. The final segments of the book and cover design were brought to fruition by photographer Derek Speirs and graphic designer Stephanie Boyle.

Our thanks to the Jonathan Williams Literary Agency and to Antony Farrell of The Lilliput Press for their counsel and backing.

We are deeply grateful to the late Emer Dolphin and Donagh O'Mahony who helped push the project over the line.

We acknowledge the countless people over so many years who have enabled the realisation of Road to Repeal.

Finally, while we use the term "woman" throughout exhibition and book, the authors recognise that not everyone who needs an abortion is a woman. We support full access to abortion for every person, be they cis, trans or genderfluid.

2014 Women to Blame Exhibition.

INTRODUCTION

"It is hardly necessary to point out that whatever may be the law on birth control, those like myself who are disseminating knowledge along that line are not doing so because of personal gain or because we consider it lewd or obscene. We do it because we know the desperate condition among the masses of workers and even professional people, when they cannot meet the demands of numerous children. It is upon that ground that I mean to make my fight when I go into court. Unless I am very much mistaken, I am sustained in my contention by the fundamental principles in America, namely, that when a law has outgrown time and necessity, it must go and the only way to get rid of the law, is to awaken the public to the fact that it has outlived its purposes and that is precisely what I have been doing and mean to do in the future."

— Emma Goldman, 1916

From its foundation, the Irish State followed the lead of the Catholic Church in maintaining that a woman's place was in the home, making babies. Both institutions conspired to insert that belief into the 1936 Conditions of Employment Act and the 1937 Constitution (Article 41.2). Mothers were promised they would "not be obliged by economic necessity to engage in labour to the neglect of their duties in their home". Contested at the time to little effect, in 1970 a group of women burst onto the scene with five demands for a more equal society.

The manifesto of the Irish Women's Liberation Movement, Chains or Change, demanded equal pay, equality before the law, equal education, justice for deserted wives, unmarried mothers and widows. Contraception was the linchpin: without being able to decide themselves when or if they got pregnant, women would never enjoy full social, economic, political and workplace parity.

Herein lay the beginnings of what would culminate in the repeal movement and was the springboard for our 2014 decade-by-decade exhibition in Filmbase, Temple Bar, Dublin. Over a year in the making, Women to Blame – 40 years of the Struggle for Contraception and Abortion in Ireland was a visual and feminist account of the Eighth Amendment / Article 40.3.3. It depicted the repression, shame and criminal sanctions that women and girls experienced before and after its arrival into the Irish Constitution. And its focus was a stubborn and regenerating grassroots anti-amendment movement that despite decades of limited progress, setbacks and individual tragedy stood its ground.

The exhibition featured campaign souvenirs and artefacts all entrusted to us by veteran activists who had emptied attics and basements for our sakes. Campaigning photographers donated their work. All these images spoke for themselves.

Short film interviews by Cathal Black and Ruth Jacob were included. Our title recalled writer and IWLM stalwart Nell McCafferty's account of Joanne Hayes's torment at the hands of the State.

In the following four years, Women to Blame had several outings (see page 14) and was championed by Amnesty UK, the National Women's Council of Ireland, the Abortion Rights Campaign and the Irish Council for Civil Liberties.

So what more could Road to Repeal, the photobook sequel to Women to Blame, say about contraception, abortion and the right to give birth safely in Ireland? Plenty, as it happens.

We now have an accompanying narrative for the five decades along with redesigned and up-to-date artefacts. We situate the struggle for women's freedom to make decisions about their own bodies alongside other major political and economic events and justice campaigns. We have a victory to explore and more heroines to identify.

Our account is not exhaustive. While Church and State were to the fore in repressing reproductive rights, Road to Repeal is more a story of the movement whose founders and supporters rose up with an alternative vision and reality. Our account is presented within a broad "choice" framework, embracing many of the issues women and girls in Ireland have had to brave by continuing or terminating a pregnancy.

Between its covers, Road to Repeal depicts the wave after wave of young people who have taken up the struggle for legal and safe contraception and abortion, risking arrest and imprisonment.

Journalists, lawyers and doctors have been among the professions who have intervened in debates on a conscientious basis to affirm their belief in a rights-based Ireland. Trade unions, student unions, service-providing agencies and artists have added very specific contributions. Many of the reproductive rights cases spilled out into courts and institutions across Europe. This has been a vital aspect of upending brutal law.

It would be foolish to believe the struggle is over. Ireland's new abortion legislation is flawed. The absence of a law on exclusion zones around facilities that advise on or offer abortion services illustrates this point. Then there is the peculiar waiting period for a termination, extraordinary criminal sanctions for breaking the law, unequal access to services in various parts of the country and the lack of alignment north and south of the border. Not all doctors prescribe the abortion pill. And not all hospitals supply full medical care for pregnant women. In 2022, doubts persist over ownership of the proposed National Maternity Hospital and its ability to comply with abortion law and provide other reproductive treatments.

The Eighth Amendment may have gone away, but this book's trajectory shows the habit history has of repeating itself. There is no room for complacency and every need for continuing vigilance.

Therese Caherty and Pauline Conroy
March 2022

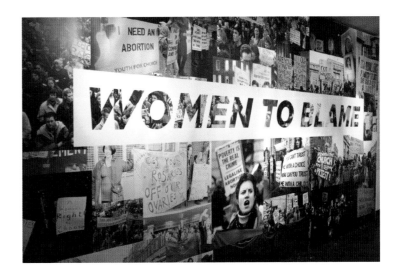

WOMEN TO BLAME: THE EXHIBITION

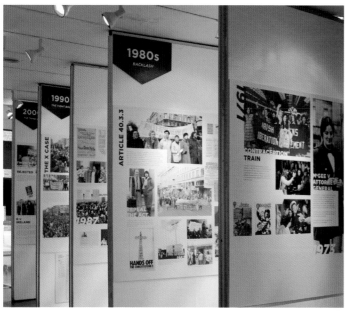

2014 Women to Blame Exhibition.

On November 6th, 2014, Women to Blame: Forty Years of Struggle in Ireland for Contraception and Abortion opened in Filmbase, Dublin. The multimedia exhibition remained on show for seven days. Its aim was to tell the story of what happened before, during and after the insertion of the Eighth Amendment or Article 40.3.3. into the Irish Constitution in 1983, the moment when a pregnant woman's life was made equal to that of the foetus she was carrying. The exhibition linked some of the attitudes of the 1970s, when contraception was the issue of the day, to 21st century Ireland.

In 2015, Amnesty International took Women to Blame to London. Ireland's Abortion Rights Campaign exhibited the work at its annual March for Choice event. In March 2017, the National Women's Council of Ireland erected the exhibition at its World Congress on Women's Mental Health in Dublin's RDS. Finally, just before the landmark repeal referendum of 2018, the Irish Council for Civil Liberties featured Women to Blame at its retrospective on choice activism in Ireland.

The following message of support and solidarity was written by Ruth Riddick, one of Ireland's staunchest and most courageous abortion rights activists, for inclusion in the Women to Blame multimedia exhibition of November 2014.

Destruction through Reproduction
"An Irish Solution to an Irish Problem"

Apposite in a thousand applications, this legendary phrase conforms to the first rule of Irish communications: whatever you say, say nothing. The present exhibition proposes to confound this rule. And it's surely fun to revisit the antics of our yesterday selves, now no longer lost to history. Just don't expect a happy trip down memory lane. As theologian Mary Daly wrote about women under patriarchy: there's no good news here.

Ever-louder calls for legalized contraception revealed what this exhibition identifies as a strategic refusal by government to address the reproductive practices of people in Ireland. The legislative idiocy ("solution") introduced with this phrase took its lexicon – "bona fide family planning purposes" - from liquor law! Caricature "Irish".

Such innocence. A bigger betrayal was in store. I remember – for all that it's thirty years ago – standing gobsmacked on the corner of Marlborough Road, newspaper in hand, reading of Ann Lovett; one tragedy from that Irish true-crime genre we might classify as "destruction through reproduction". Tom Mathews and I responded with a postcard which, employing cold war iconography, warned, "Danger. You are now entering Post-Referendum Ireland."

Lest we forget, the Eighth Amendment's saving grace – "due regard to the equal right to life of the mother" – was designed to protect against fanaticism. To our bereavement, Garret FitzGerald's intention has been repeatedly and lethally dishonoured, as documented here.

Versed as we are in recent turns-of-the-screw, this exhibition nonetheless confirms that nothing fundamental has changed in Ireland since my mother's time, the midcentury "dark ages" of unreconstructed socio-catholicism. Know thy enemy: implacable, murderous, constitutional. No mere "Irish solution" (the perennial political cop-out) will fix it.

The scale of the moral challenge is not new. To younger activists reviewing the material gathered in this exhibition, I say: You have your work cut out for you. Let me know how I can help.

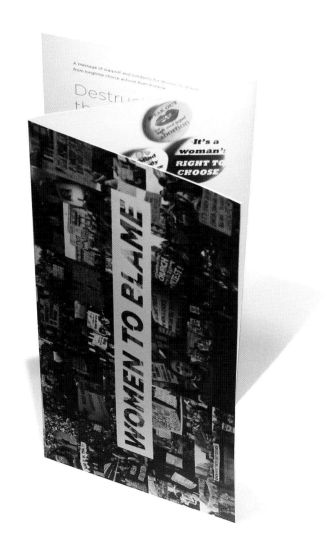

WHY
ARE YOU
AFRAID
OF WOMEN
?

so70s
1970s

REBELLION AND NEW BEGINNINGS

The arrival of contemporary campaigns and movements for women's rights makes the 1970s a very special period. A consciousness of sexism and discrimination among women was emerging. New organisations of women appeared on the Irish stage.

Galvanised by anti-Vietnam war protest and the civil rights movement in the US, a small group of women meeting first in Bewley's on Grafton Street and then often in Mrs Margaret Gaj's restaurant on Baggot Street in Dublin, began to discuss the role of women in Irish society. They did not like what they were uncovering.

The Irish Women's Liberation Movement was launched in the Mansion House in April 1971 with 1,000 women in attendance. They published a Manifesto: Chains or Change and mobilised a contraceptive train to Belfast and back in May to defy Section 17 of the Criminal Law Amendment Act, 1935 banning contraception.

The movement petered out but several other groups were formed by its members including Cherish (1972), Women's Aid (1974), and Irishwomen United in 1975 with its banner publication, Banshee.

Women's status in society was under scrutiny. While viewing equality in a human rights context, particularly around reproductive rights, was some way off, it was these early developments that cleared the way for that shift in thinking.

The Government set up the first Commission on the Status of Women in 1970, led by Dr Thekla Beere. Its final report in 1973 found Irish society's treatment of women sorely lacking. Maura Breslin, general secretary of the Irish Women Workers Union and a champion of the as yet unresolved quest for "equal pay for equal work", criticised the lack of equality in training, recruitment and promotional opportunities for women.

Hilda Tweedy, chair of the Irish Housewives Association,

Facing page: Members of Irish Women United Monica Hughes (left), Patricia Kelleher, Nicky Quinn and an unidentified woman at the group's invasion of the all-male Fitzwilliam Tennis Club in the mid-1970s. One of the world's oldest tennis clubs, Fitzwilliam, now based in Ranelagh, Dublin, allowed women to become members in 1996 and elected its first woman president, Helen Shields, almost 140 years after its foundation in 1877. Photographer unknown.

guided a group of feminists in 1973 to create the Council for the Status of Women, forerunner to the National Women's Council of Ireland.

In 1973 Mrs Mary McGee, from Skerries, Co Dublin, and a mother of four children challenged the law that prohibited her from importing a diaphragm and spermicidal jelly into the State. Her life was at risk were she to become pregnant again. Barristers Mary Robinson and Donal Barrington (1928-2018) represented her in a Supreme Court appeal. She won in a landmark case that expelled the State from the privacy of the marital bed.

The decriminalisation of contraception was not followed by a new law, but all kinds of public direct actions exposed the need for just that. The issue had moved from the private to the public domain. Contraceptives were sold in markets and record shops and through the Contraception Action Programme. The Rotunda maternity hospital offered services. So too did the Irish Family Planning Association, founded in 1969 and in which Frank Crummey was a prominent contraception reformer. There was legal uncertainty around these services. Not until 1979 did the Government introduce a Bill regulating contraception services restricted to "bona fide family planning purposes", in other words married women and men.

In November 1976, the Censorship Board banned the IFPA's 1971 family planning guidebook on the grounds that it was "indecent or obscene". In 1977 the IFPA won its High Court challenge to the ban and it became publicly available again.

Contraception could still not be advertised, and information was actively censored with prosecutions.

The pope's visit to Ireland in 1979 gave a huge confidence and boost to conservative thinking among Catholic lay organisations horrified by the success of the McGee case in terms of conventional Irish Catholic values.

Meanwhile, the Abortion Act 1967 legalised abortion in Britain in certain circumstances. Between 1968 and 1979, 16,300 women gave Irish addresses at British abortion clinics.

THE IRISH WOMEN'S LIBERATION MOVEMENT – 1970

The Irish Women's Liberation Movement (IWLM) began in 1971 with a meeting in Bewley's café on Westmoreland Street, Dublin. Partly inspired by the US women's movement, the methods of protest adopted by the IWLM were highly controversial and attracted much media attention.

The IWLM manifesto Chains or Change outlined five demands: equal pay, equality before the law, equal education, contraception and justice for deserted wives, unmarried mothers and widows. It suggested that the condition of single women was far better than those who were married. It also drew attention to the advantages of "living in sin".

The achievements of this movement, which lasted just one year, were far-reaching and long-lasting, and are still being experienced today.

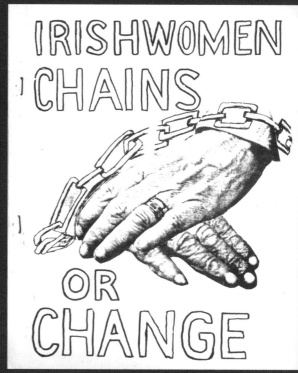

Irishwomen United was launched in June 1975 (International Women's Year) with its charter of 10 demands, among them the right to abortion. A proponent of direct action, the group had its own publication, Banshee, in which it recorded its own aims and commentary on every aspect of Irish society at the time. When Banshee folded, a group of feminists launched Wicca magazine in 1978. Pictured is the first copy of Wicca with a list of the original founding members among them photographer Clodagh Boyd, Mary Doran of Attic Press, journalist and broadcaster Roisin Boyd and the late Anne O'Brien.

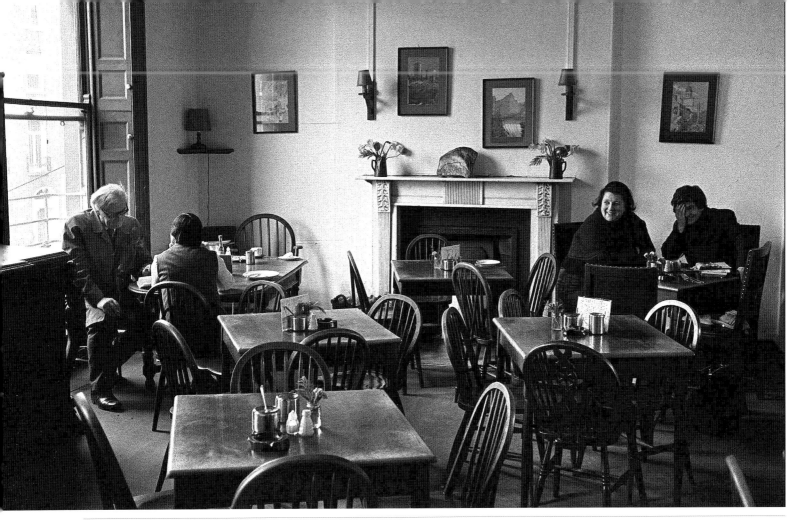

Margaret Gaj and Frank Crummey, above right, in Gaj's Restaurant on Dublin's Lower Baggot Street in March 1980. Below, noticeboard and public telephone at Gaj's. Photos by Derek Speirs.

Born in Scotland in 1919, activist Margaret Gaj, seen here with her friend and fellow activist, Frank Crummey, was well-known in left-wing circles and the women's movement in the 1960s and 1970s. Her restaurant on Lower Baggot Street, Dublin, became a hub of political activity and the venue for meetings of the fledgling Irish Women's Liberation Movement in 1970. Anne Stopper's book Mondays at Gaj's: The Story of the Irish Women's Liberation Movement (Liffey Press, 2006) recounts its importance.

Founding member and leader of the Irish Housewives'
Association (1942-92), Hilda Tweedy (1911-2005) was
a lifelong campaigner for women's right to equal pay,
women's right to serve on juries and an opponent
of the marriage bar under which a woman civil
servant had to resign when she married. The IHA was
instrumental in setting up the Council for the Status
of Women (now the National Women's Council of
Ireland) on March 31st, 1973.

Photo courtesy of The Irish Times.

CONTRACEPTIVE TRAIN – 1971

Members of the IWLM travelled by train to Belfast in May 1971 to buy contraceptives over the counter. On their return to Dublin they challenged the customs officers at Connolly Station to arrest them for illegal importation. The customs officers allowed the women to pass through.

Left and below: The IWLM's protest against Ireland's strict anti contraceptive laws was a media sensation in 1971, creating a furore throughout the State and beyond. Photo courtesy of The Irish Times.

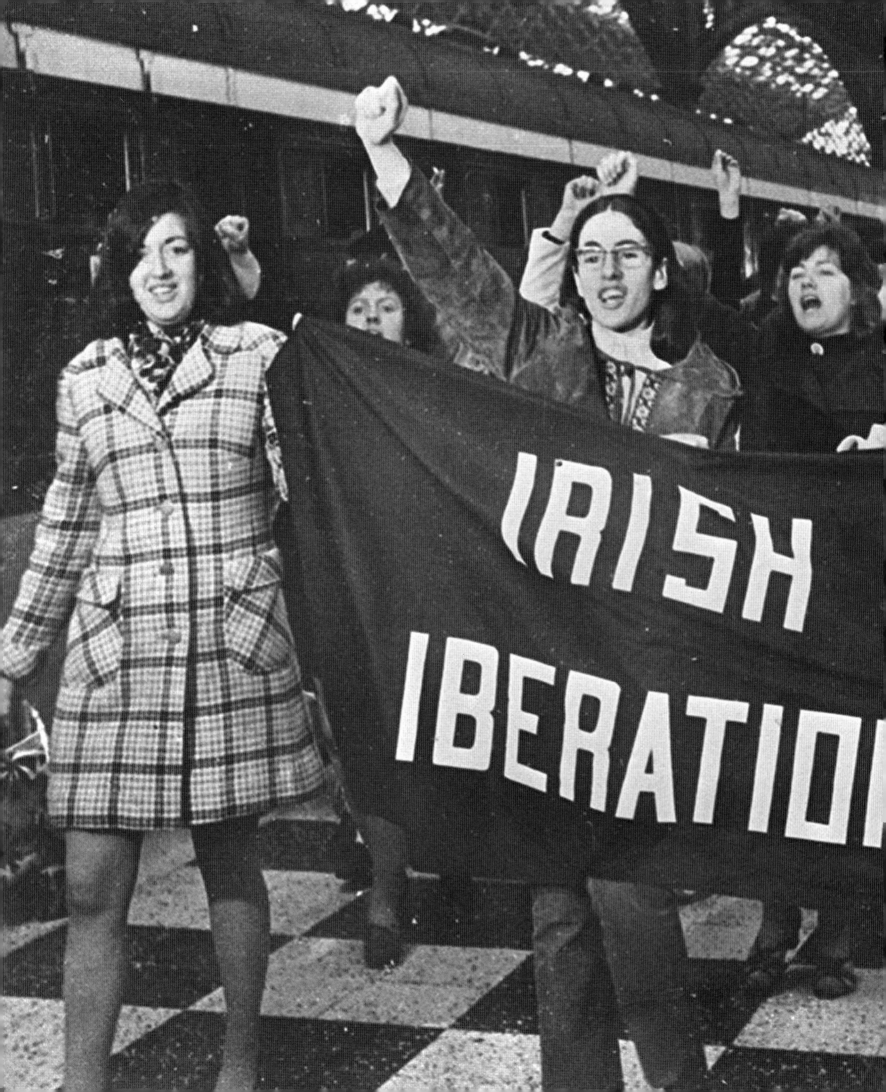

Some 49 members of the Irish Women's Liberation Movement returning to Dublin's Connolly Station in 1971 after their infamous trip to Belfast to buy contraceptives. Photo courtesy of The Irish Times.

From the Archives
February 22nd, 1974

John Healy's Dáil Sketch covered Mary Robinson's Seanad attempt to legalise contraceptives, plus Fianna Fáil's baiting of Conor Cruise O'Brien in the Dáil.

It was a long and busy Oireachtas day yesterday as the Upper House continued the debate on the Family Planning Bill and the Lower House got on with the estimate for the Department of Justice where, in [Labour's] Barry Desmond's speech, we had a part echo of the Upper House deliberations when he welcomed the [Fine Gael-Labour] Government's announcement to introduce contraceptive legislation [for married couples].

You could take your pick between the two Chambers: if you wanted to know what a somewhat tired Redemptorist missioner sounded like in Christian Ireland 15 years ago, you had only to catch Michael O'Higgins [Fine Gael leader of the Seanad] moving his amendment to Senator Mary Robinson's Bill on Family Planning.

Michael had a nervous twitch of a cough which needed throat tablets during his long speech and Alexis Fitzgerald [Fine Gael] worked away beavering in the final touches to his speech while Michael droned on.

There was nothing droning about Professor Paddy Quinlan [NUI university senator] when he got in: he was very impressed

the Lower House, certainly at Ministerial level, taking up seats in the Senate public gallery.

In the Lower House it was a typical Thursday end to the week: the Justice debate gave deputies an innings on everything from gardaí who need "cop-on pills" (according to Michael Begley [Fine Gael], who thinks they pull people for niggling offences sometimes) to Dublin vandalism and the soaring crime rate and to Barry Desmond's concern for family legislation as it is covered by such matters as adoption and contraception. Deserted wives, too, had a mention from Barry, as well as Ben Briscoe [Fianna Fáil].

Question Time was an exercise in Cruiser-baiting, that popular past time which the Fianna Fáil party enjoys in baiting the Minister for Posts and Telegraphs, Dr Conor Cruise O'Brien. They had him up to his popping eyes in telephone kiosks again yesterday, but Conor drew the fire on himself with the very first question from George Colley [Fianna Fáil] on the G.I.S. [Government Information Service] monitoring R.T.É.

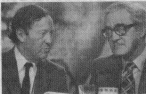

■ Mary Robinson (top) at a rally in the 1970s and Conor Cruise O'Brien (left) and Brendan Corish at a Labour Party conference in August 1974. PHOTOGRAPHS: EDDIE KELLY, PADDY WHELAN

with Michael's speech and could do nothing but endorse every word of it as masterly ...

Paddy's contribution was a plain unvarnished piece of Hibbery - if contraceptives were the price of a United Ireland let them keep the North. We'd never sell out. He didn't go along with those who held 1916 was a mistake and would rewrite modern Irish history; we stood with 1916 and its, heroes and he'd stand against contraceptives.

However, the floodgates were now open as a result of the Supreme Court decision [allowing married couples to import contraceptives] which he thought was unconstitutional in its ruling (the Chair pulled him on that one) and when it broke for lunch I left it there.

Paddy Cooney [Minister for Justice], who sat under Michael O'Higgins, seemed to be as impressed as I was with the debate, but what continues to be interesting about the Upper House debate is the number of deputies who come in and listen to speakers on the subject. We had Conor [Cruise O'Brien] again for long stretches of Michael O'Higgins and it is very rarely that you find members of

It was a longish question in which George wanted to know if the monitors had records of when and how price increases were announced by the State broadcasting service, but Conor gave him one of those strictly factual replies suggesting George didn't know how to put down a question with the required precision for the specific information.

There's nothing to madden Fianna Fáil front-bench members more than that kind of thing and from there to the end of Conor's stint, any chance they got of a dig was taken and he was Doctor Goebelled a few times until the Chair pointed out that this wasn't funny at all. Conor allowed they did him much honour - but it was well known Fianna Fáil had more respect for the same Nazi doctor than they had for an Irish Minister of State.

Read the original article at iti.ms/1fs5Usg

Selected by Joe Joyce; email fromthearchives@irishtimes.com

Shane Hegarty is on leave

Newscutting and photo courtesy of The Irish Times.

LEGALISING CONTRACEPTIVES – 1971

In 1971, along with Senators John Horgan and Trevor West, Senator Mary Robinson made the first of her three attempts (1971, 1973, 1974) to legalise contraception in Ireland.

The Bill was refused a reading and denied publication.

McGEE v ATTORNEY GENERAL – 1973

December 1973: The Supreme Court ruled in McGee v Attorney General and the Revenue Commissioners that when customs, in accordance with the Criminal Law Amendment Act 1935, seized spermicidal jelly that Mrs Mary McGee had ordered from England, her constitutional rights to privacy in marital affairs were violated.

Mrs McGee was a housewife from Co Louth, living in a caravan with her children and husband who was then a fisherman.

Mary and James McGee outside the High Court in 1972. Photo courtesy of The Irish Times.

In 1959, Thekla Beere (1902-91) became the first woman secretary of a Government department – Transport and Power. One of very few Protestants in senior positions in the civil service, she earned less than her colleagues and faced leaving her job if she married. She chaired the first commission on the status of women 1970-72, described by Mary Robinson as "a charter for women in the modern Irish State". Over half the commission's recommendations – on the civil service marriage bar, widow's pension and equal pay – were implemented within a few years, thanks in no small part to pressure from women trade unionists.

Thekla Beere (right) pictured with Fine Gael politician and activist Nuala Fennell (1935-2009). Photo courtesy of The Irish Times.

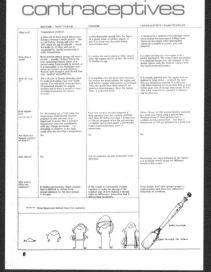

Frank Crummey: gets the price

F.P.D. Prepares For Durex Boom

By Des Crowley

THE LONG struggle to secure the lucrative Durex contraceptives import agency appears to be over with the prize going to FPD Ltd, whose managing director is Frank Crummey. Durex, of course, is the leading brand product of LRC International (formerly London Rubber) which has a dominating position in the British and international contraceptive business.

It is believed that a host of Irish businessmen, trod the trail to LRC in attempts to win the import agency for Ireland, but the claims of Crummey and his associates who played an active role in setting up the clinics and mail order service in the teeth of obscurantist opposition and legal pitfalls, have won the day.

Family Planning Services Limited founded the first clinic in Ireland and last year, Crummey and others decided to prepare for the legalising of the sale of contraceptives by setting up a distribution company called FPD Limited, a company limited by guarantee. The directors are Robin Cochran, Frank Crummey, Anne O'Donnell and another yet to be elected. Other members of the company include Jan and Alan McConnell (formerly company secretary of FPS), Jim and Pat O'Donovan (a founder member of FPS), Evelyn Crummey and Vivienne Crummey. The members were anxious to ensure that the profits would go to promoting the spread of family planning education in Ireland, so the company will pay no dividends or directors fees and the profits, which will be at the normal commercial level, will be ploughed back into the family planning campaign.

Durex products include condoms, diaphragms, creams and gels. The promotors have felt it necessary to exercise moral restraint in the financial opportunities of the business, no doubt because of the frequent allegations that they were a front for the multi-nationals. FPD is already the bulk supplier of family planning goods to the clinic, and the annual turnover is now around £250,000. With legalisation, it is highly likely that demand should fairly quickly double but no-one is prepared to hazard a guess at the ultimate size of the market.

It is envisaged that there will be two office employees, two field reps, one 'packer and loader' and one van. It seems rather small for what many considered to be a possible bonanza, but the terms of the new legislation, yet to be signed by the President, do not allow vending machines or other hard sell techniques. *Ortho* another major brand leader in creams, gel and intra-uterine devices is already distributed by Cahill, May Roberts while a major American condom maker, Ackwell Industries, has also expressed an interest in the Irish market.

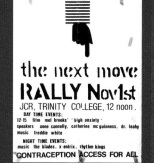

the next move
RALLY Nov 1st

JCR, TRINITY COLLEGE, 12 noon.

DAY TIME EVENTS:
12-15 film mel brooks' ' high anxiety'
speakers anne connolly, catherine mcguinness, dr. leahy
music freddie white

NIGHT TIME EVENTS:
music the blades, x entrix, rhythm kings

CONTRACEPTION ACCESS FOR ALL

Anne Speed, seen here in April 1978, was a founding member of Irish Women United and its offshoot the Contraception Action Programme (CAP). She later became a leading light in Ireland's tradeunion movement. Photo by Derek Speirs.

NEWS CONTRACEPTION

CAP – the Contraception Action Programme is the name of a national campaign on contraception, which has been launched on the initiative of Irishwomen United. Since its foundation (June 8th 1975), Irishwomen United has been involved in the struggle for the right of all women to control their own bodies. The responsible use of contraception is an essential prerequisite for the exercise of this right, which has been consistently ignored by successive Irish governments. CAP was established to press for the legislation of contraception and the provision of full Health Education and Distribution Services relating to birth control.

PARTICIPANTS

At a meeting held in Buswells Hotel (JUNE 22 1976), the following groups came together to form the steering committee of the action programme
- Family Planning Services
- The Irish Family Planning Association
- Irishwomen United
- Labour Women's National Council
- North Dublin Social Workers' Association
- Women's Aid
- Women's Liberation Movement
- Women's Political Association

The committee is an open-ended one consisting of one delegate from each organisation.

DEMANDS

CAP's demands are as follows:

1. The legislation of contraception and the ending of restrictive legislation.
2. The availability of contraception to all who wish to use it.
3. The provision of contraceptive advice and counselling in all maternity and child welfare clinics.
4. The introduction of education programmes on sexuality, birth, contraception and personal relationships in schools and in the curricula of all colleges of education.
5. The inclusion of a study of birth control in the training programmes for all doctors and nurses.

The distribution of contraceptives free through health service clinics and at controlled minimum cost through G.P.'s pharmacies and specialised voluntary clinics.

ACTIONS

The first action to be undertaken by CAP is the launching of a national petition in the autumn to demonstrate public support for contraception. This petition is only one of a number of actions being considered by the committee – these include rallies, lobbying TDs and taking legal action.

CAP needs your support. All these organisations and individuals interested in contributing either work, ideas or finance, please contact:

CAP
67 PEMBROKE ROAD
DUBLIN 2

12

CONTRACEPTION ACTION PROGRAMME

1976-1981

The Contraception Action Programme (CAP) was formed by the women's movement and supported by members of the Labour Party and the Irish Family Planning Association. It was most active between 1976 and 1979. The campaign travelled the country giving talks and - illegally - distributing contraceptives. CAP opened a shop called Contraceptives Unlimited and had a caravan distributing contraceptives parked in housing estates like Ballymun.

Contraception Action Programme members leading a march in December 1978 to demand the provision of free legal contraceptives. Photo by Derek Speirs.

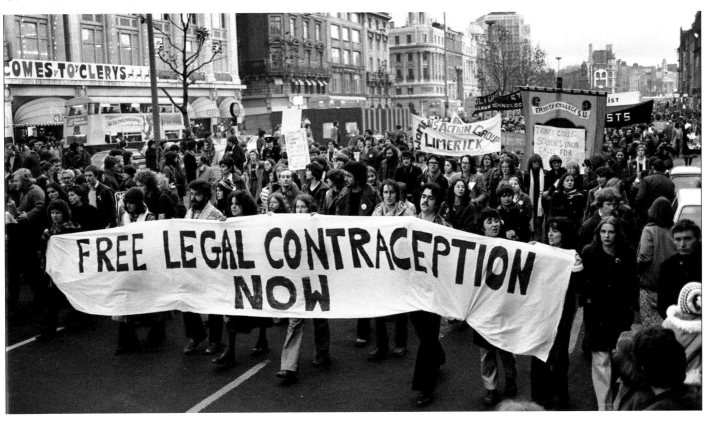

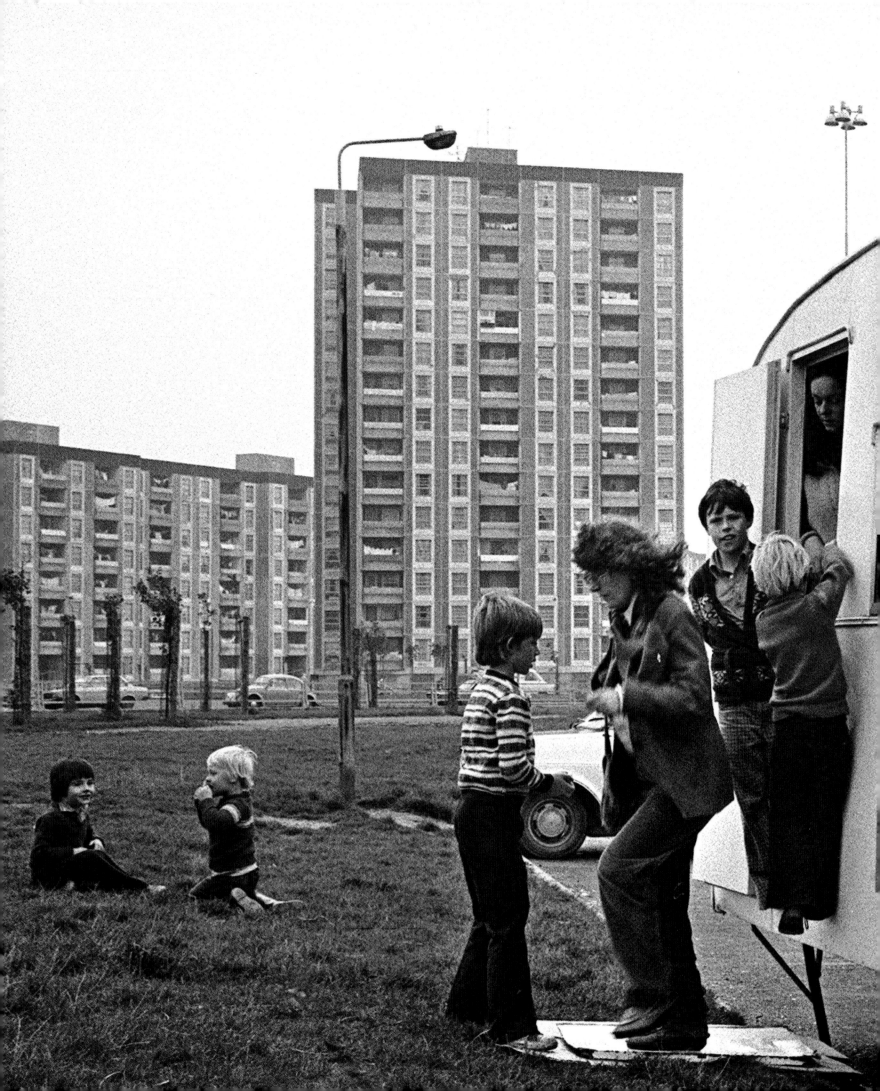

Contraception Action Programme activists providing contraceptives outside the Ballymun flats in north Dublin on October 13th, 1979. Photo by Derek Speirs.

SPARE RIB BANNED

– 1977

Co-founder of Irishwomen United Marie Mac Mahon was arrested in February 1977 for defacing public property by advertising a meeting on the censorship of Spare Rib. Launched in 1972 and published until 1993, the iconic Spare Rib was a second-wave feminist magazine published in Britain. It's name comes from the biblical reference to Eve - created from Adam's rib.

Below: Marie Mac Mahon, 1979. Photo by Derek Speirs.

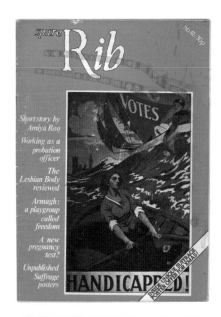

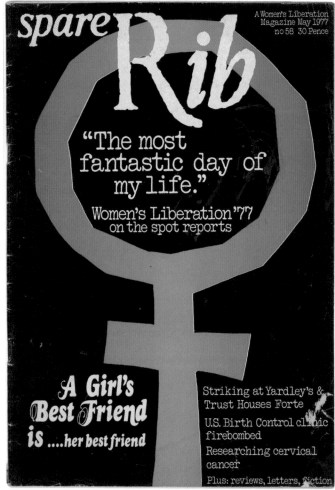

Cosmopolitan Magazine
Publisher's Statement

Dear Cosmopolitan Reader,

I very much hope that you enjoy this October edition of Cosmopolitan.

Unfortunately you will find that the feature entitled 'All you need to know about abortion', which begins on page 90, is incomplete, with the last page having been removed.

This particular page carried a section which gave details and telephone numbers of various organisations which offer advice and help on abortion related matters, which may have contravened the laws of the Irish Government.

I therefore felt it necessary to remove these details rather than withdraw the whole October issue from circulation in Eire.

I do very much hope that the lack of this page will not spoil your enjoyment of Cosmopolitan too much.

Yours

Publisher

THE RIGHT TO KNOW, THE RIGHT TO READ

– 1977

The banning of books and films began early in the life of the Irish Free State; in the case of films in 1923. Contraception and abortion were important indicators of bad books with bad thoughts. Feminist and East London activist Dorothy Thurtle's short book – Abortion: Right or Wrong? published in London was banned in 1942. The Guardian Newspaper was censored in 1992 for carrying an ad for the Marie Stopes clinic. The London-based National Abortion Campaign had their pamphlets banned in 1983. Following the repeal of the Eighth Amendment, publications regarded as advocating abortion were no longer censored. However, the law was not retrospective and the words of Dorothy Thurtle and the UK National Abortion Campaign remain banned.

Above left: Censorship of Cosmopolitan Magazine, 1989;
Left: Press cutting from Hibernia Magazine.

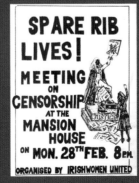

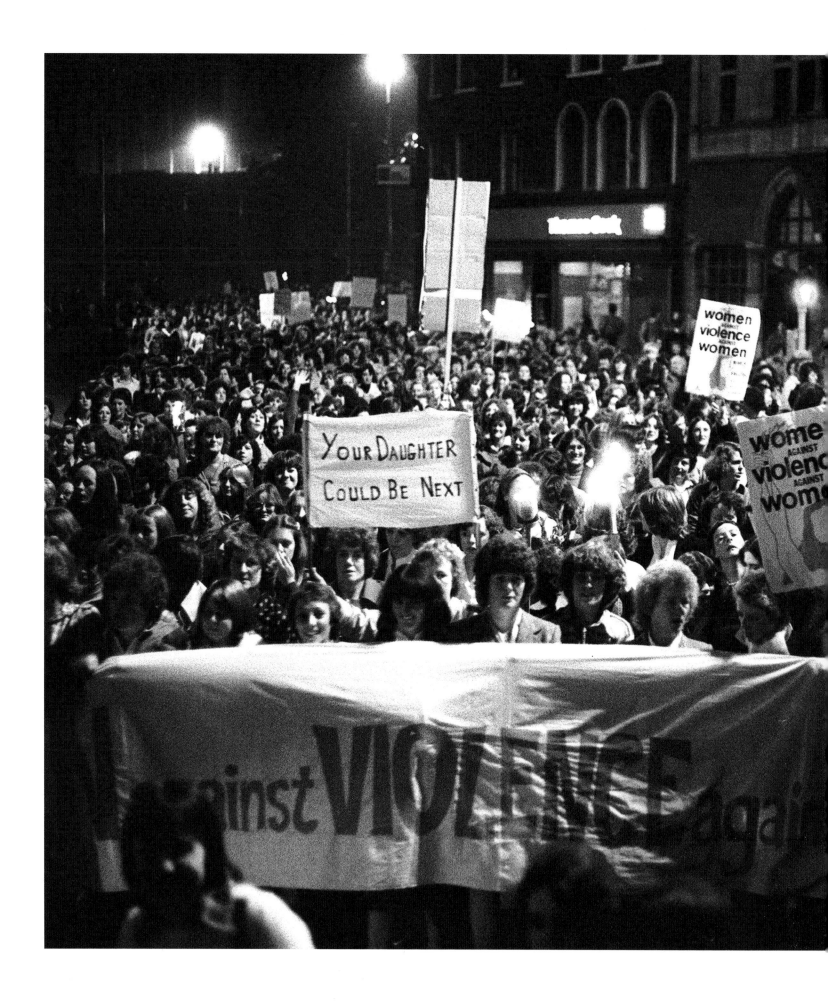

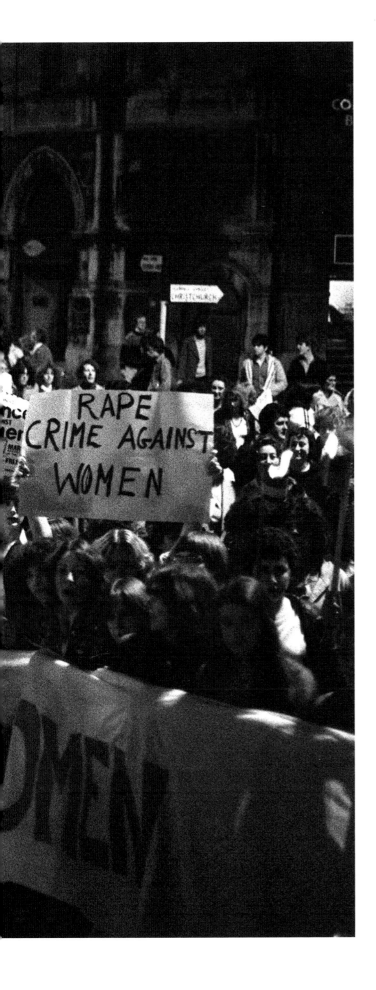

WOMEN AGAINST VIOLENCE AGAINST WOMEN

– 1978

On an October evening in 1978, some 5,000 Irish women marched through the centre of Dublin to protest about rape and reclaim the night. Inspired by the ideals of the broader women's movement, this landmark protest led to the establishment of the Dublin Rape Crisis Centre in 1979.

Photos by Derek Speirs.

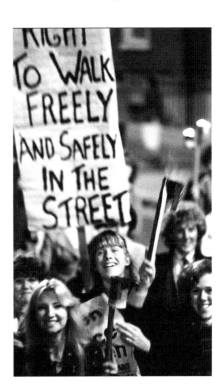

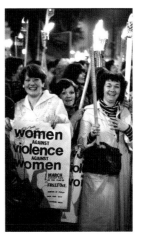

CONTRACEPTION 1922–1980

Contraceptives – mainly condoms manufactured by The London Rubber Company and under the brand name Durex – were imported, distributed, and sold in the then Irish Free State between 1922 and 1935. Contraceptives were important not only for fertility control but also to prevent the spread of sexually transmitted diseases. Dr Steevens Hospital in Dublin treated 1,078 women and men in 1922 for syphilis.

In 1934, there were 13 deaths from syphilis of which six were infants under one year old. In 1935 the Dáil passed the Criminal Law (Amendment) Act, 1935. Section 17 of the Act made the importation and sale of contraceptives a criminal offence for the first time. Despite this, contraceptives were still smuggled in on a small scale.

Contraceptives were defined as "any appliance, instrument, drug preparation or thing designed prepared, or intended to prevent pregnancy". Anyone found guilty of the offences could be sentenced to a fine or up to six months' imprisonment or both. The importation of condoms was included in Section 42 of the Customs Consolidation Act of 1876. Section 42, however, contained no reference to condoms, merely to "indecent or obscene articles". The first arrest under the Act was made in 1936.

1922-1935	Contraception legal
1929	Censorship of Publications Act, 1929 *Bans material advocating or promoting contraception or abortion.*
1935	Criminal Law (Amendment) Act, 1935 *Contraception made illegal.*
1946	Censorship of Publications Act, 1946 *Bans material advocating or promoting contraception or abortion.*
1970	Irish Women's Liberation Movement Contraceptive Train women went to Belfast and purchased contraceptives, defying the law.
1971	Criminal Law (Amendment Bill), 1971. First private member's Bill to change the law on contraception is placed on the order book of the Seanad by Mary Robinson. It aimed to repeal Section 17 (3) of the Criminal Law Amendment Act, 1935, sections 16 and 17 of the Censorship of Publications Acts 1929 and sections 7 and 9 of the Censorship of Publications Acts of 1946. *Bill prepared by Mary Robinson, to legalise contraception. Refused a first reading.*
1971	Bill given a first reading without any prior notice. *Defeated by 25 votes to 14.*
1972	Mary McGee was defeated in the High Court in her case to prove that the confiscation of her contraceptives at customs had been unconstitutional.
1973	Mary Robinson's second private member's Bill, the Family Planning Act, 1973, passed its first stage. *Seanad agrees by 27 votes to 12 that her Bill should proceed to second stage. Seanad Debates, November 14th, 1973.*

1973	Supreme Court ruling

The Court decided December 12th, 1973 that Mrs Mary McGee had the right to import contraceptives for her own use. The law that stopped her was an invasion of her right to privacy under Article 50 of the Constitution. Section 17(3) of the Criminal Law Amendment Act 1935 was unconstitutional.

1974	IFPA was charged under the 1935 Criminal Law (Amendment) Act with the promotion of unnatural methods of contraception in its booklet. The case was dismissed.

1974	Debate on Mary Robinson's Family Planning Bill, 1973

Defeated 32 votes to 10.

1974	Third private member's bill, Family Planning Bill, 1974 granted first reading and published.

Finally defeated by 23 votes to 20. Mary Robinson had pushed for this Bill to be under the Department of Health and not the Department of Justice.

1977	High Court declared banning of the booklet Family Planning null and void. An appeal was lodged against this decision by the Attorney General and the Censorship Board.

1978	Supreme Court upheld the decision of the High Court on the booklet Family Planning.

1979	Irish Family Planning Association versus Ryan (1979)

Mary Robinson represented the IFPA when its booklet on contraception was banned and won.

1979	Health (Family Planning) Act, 1979 enacted

Contraceptives including condoms to be made available on prescription from a doctor for medical reasons, or for bona fide family planning purposes, to married couples.

1980	Health (Family Planning) Act, 1979 in operation.

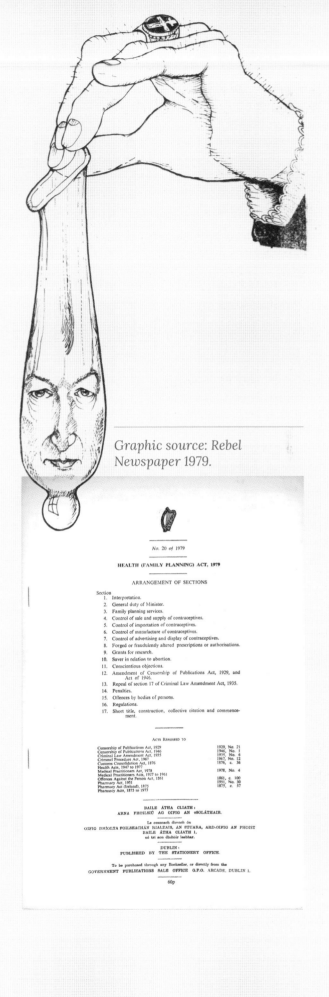

Graphic source: Rebel Newspaper 1979.

HEALTH (FAMILY PLANNING) ACT – 1979

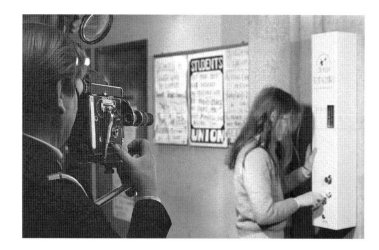

This Act, a belated response to the McGee judgment, legalised contraception but specified that contraceptives, including condoms, were only available on prescription from a doctor and the doctor had to be satisfied that the person was seeking the contraceptives for bona fide family planning purposes. This was largely interpreted to mean that only married couples were legally entitled to access contraception. Despite this, sympathetic doctors sometimes helped others access contraception, particularly in later years.

Top: Officer of UCD Students' Union Brigid Ruane pictured beside the first Durex machine installed in the Belfield campus in 1979. Photo by Derek Speirs.

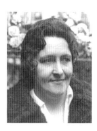

Josie Airey (1932-2002) faced down an implacable State for 10 years in her quest for free legal aid. Eventually, in 1979, the European Court of Human Rights found Ireland in breach of the European Convention on Human Rights since it had failed to provide her with legal assistance in seeking a judicial separation from her husband. The State was forced to introduce a civil legal aid scheme.

Josie Airey. Photo courtesy of The Irish Times.

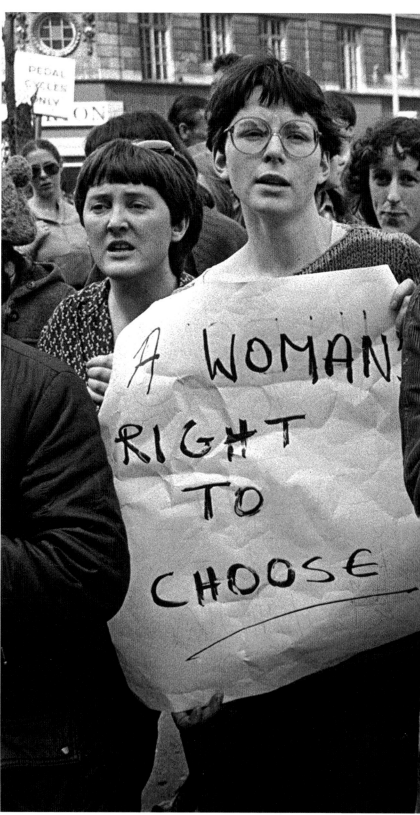

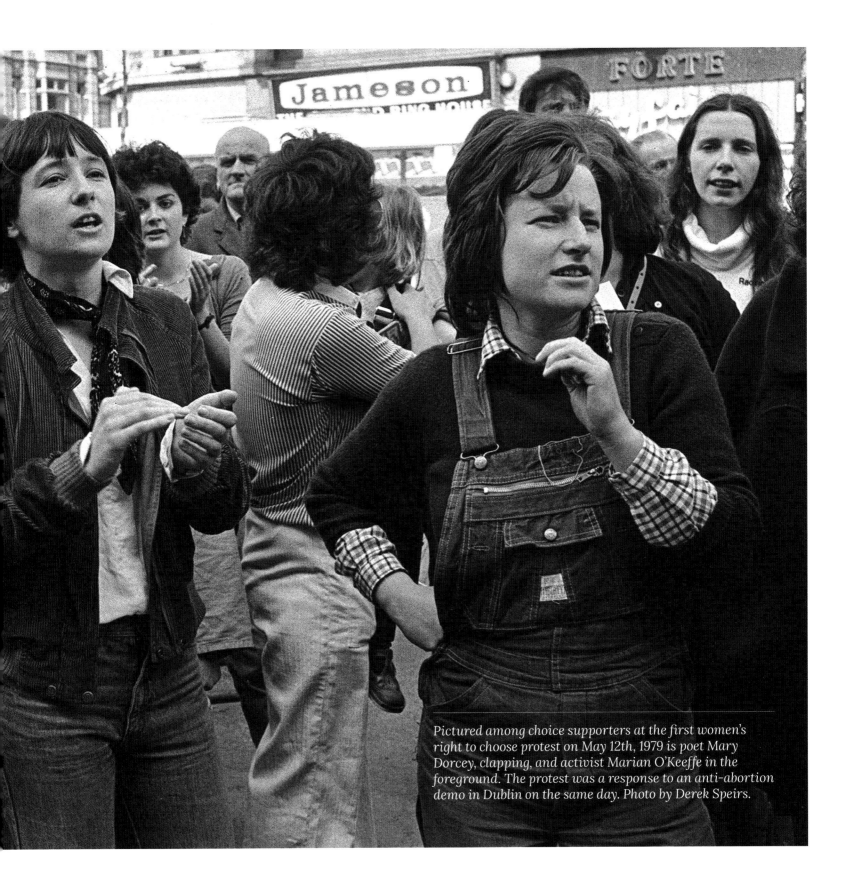

Pictured among choice supporters at the first women's right to choose protest on May 12th, 1979 is poet Mary Dorcey, clapping, and activist Marian O'Keeffe in the foreground. The protest was a response to an anti-abortion demo in Dublin on the same day. Photo by Derek Speirs.

FINDING A VOICE – WOMEN AND THE MEDIA

A growing understanding among feminists of the media's influence was evident in the early 1970s.

The Irish Women's Liberation Movement published its manifesto Chains or Change (1971); the Irish Women United had Banshee magazine (1978); and Irish Feminist Information (IFI) delivered a feminist wall calendar (1979) – An end and a beginning. Women in Ireland were finding a voice and a determination to contribute to public discourse unapologetically and on their own terms.

Women's pages appeared in publications and the equivalent held for radio and TV. All were driven by a viewpoint that went beyond knitting, food and fashion. None of this was quite by accident - several prominent supporters worked in journalism.

In Galway in 1975, when a deal fell through for Catherine Rose's book The Female Experience, she self-published under Arlen House. The late Margaret MacCurtain of UCD wanted to push the Arlen experiment further. Janet Martin, Eavan Boland (1944-2020) and Terry Prone joined forces. Arlen House, an exclusively women's press, was founded in 1978 and is still functioning today.

In 1980, IFI abandoned its calendar for the first Irish Women's Diary. With its menstrual chart, lists of relevant addresses and pages highlighting landmark moments in women's history, it was shorthand for "feminist" and a flagship publication for the fledgling Attic Press (1984).

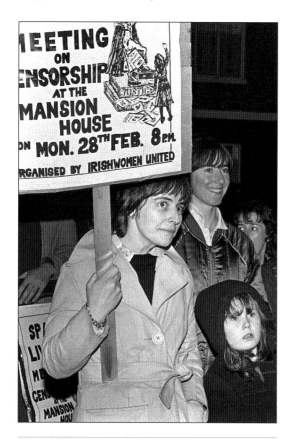

Roisin Conroy, co-founder of Attic Press, at a Dublin picket on March 11th, 1980 in support of Marie McMahon, who was jailed for posting "illegal" notices for the Irishwomen United protest meeting over the banning of Spare Rib magazine in Ireland. Photo by Derek Speirs.

Above, The Irish Women's Guidebook & Diary - "Your own pocket-sized resource" - and some other Attic Press titles from 1984 to 1987.

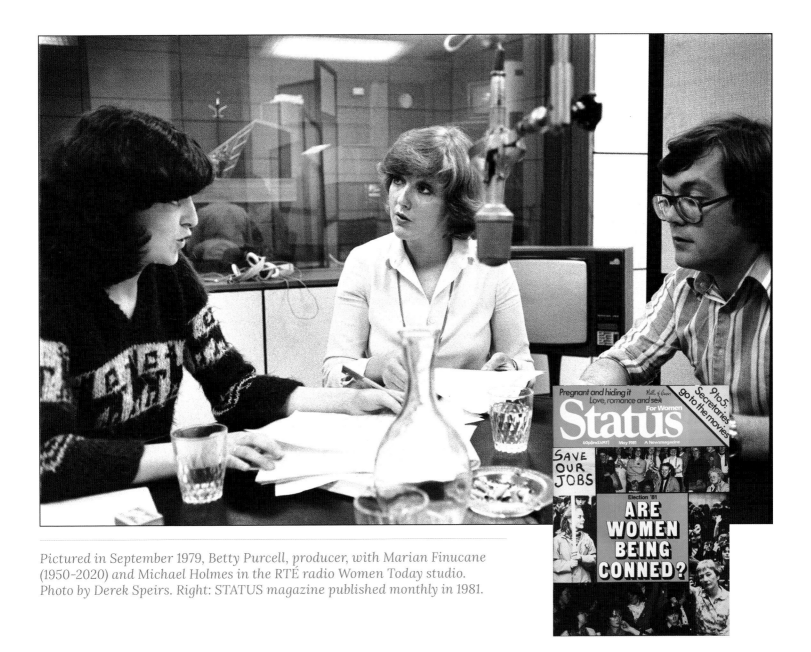

Pictured in September 1979, Betty Purcell, producer, with Marian Finucane (1950-2020) and Michael Holmes in the RTÉ radio Women Today studio. Photo by Derek Speirs. Right: STATUS magazine published monthly in 1981.

Meanwhile, RTÉ producers Clare Duignan and Betty Purcell responded to a noted gender imbalance in the State broadcaster's programming with the landmark Women Today. First aired in 1979, the show fielded issues affecting women's lives with Marian Finucane at the helm and reporters Doireann Ní Bhriain and Hilary Orpen.

On International Women's Day in 1991, the iconic Late Late Show handed over to a panel of women who talked about progress – or otherwise – in the women's movement in Ireland.

These informative advances were a lifeline for women living outside the main cities.

Book publishers were bitten by the bug too. Women in Publishing (WIP) – including Catherine Rose - surveyed Ireland's books landscape in 1983. They found only 11 per cent were by women: 9 per cent by Arlen House; 2 per cent by mainstream publishers. Mary Doran and Roisin Conroy of IFI and Mary Paul Keane of Wolfhound Press moved to redress the balance with two Women in Publishing courses during 1983-85 funded by State training agency AnCO. These courses enabled Keane and Conroy to launch Attic Press in 1984.

As the years mounted and women's presence was normalised in all forms of media, including emerging media, the urgency eased as did the prevalence of women's publishers, newspaper pages and dedicated shows on the airwaves.

THE NORTH – A WAITING GAME

As activists in the south began campaigning against 1983's Eighth Amendment, their northern counterparts had by then been struggling for almost 20 years to have Britain's 1967 Abortion Act extended to the North where terminations were allowed only if a woman's life or mental / physical health was at risk.

It had seemed a simple job. But anger over repeated delays had led to waves of pro-choice groups fighting for the Act's extension while also helping women and girls with crisis pregnancies. Grit and unswerving focus were needed for a journey that would last 54 years and counting.

In 1970, the new Ulster Pregnancy Advisory Association offered counselling and referrals to British clinics. The emerging Northern Ireland Abortion Law Reform Association (NIALRA) was doing what it said on the tin. In 1980, after the death of Charlotte Hutton (21) in a backstreet abortion – and in reaction to the UK's regressive Corrie Bill (1979) – the Belfast Women's Collective set up the brief Northern Ireland Abortion Campaign.

Despite the heated political atmosphere across the island during the H-Block campaign and Hunger Strikes, NIAC and the Dublin Women's Right to Choose Group met in Belfast in 1981. Partnerships like this were a feature of the North's choice activism. Not long after, NIAC sent 600 coat hangers with fake British Airways tickets to every MP in Westminster, a searing image symbolising the crisis pregnancy options. The Irish Women's Abortion Support Group began to support those travelling for terminations.

As NIAC faded, a new version of NIALRA continued their campaign with an international tribunal on abortion in Belfast in 1987. The Derry Women's Right to Choose Group was set up shortly after and the Family Planning Association publicly supported abortion rights.

In 1993, the courts ruled that an abortion was in the best interests of K, aged 14 and in care. She had to go to England. In 1995, the judge in the A case ruled that abortion should be available in the state. In 1995, S, aged 17 and described in court as "mentally handicapped", had a termination on home soil.

In 1996, Alliance for Choice (AfC) ran for about 18 months in Derry and Belfast. But the Belfast group folded, mainly into the emerging Women's Coalition, a cross-community political party (1996-2006). The Belfast alliance resurfaced in October 2008. In the meantime, the Derry group produced an A2 poster in 1997 with photos of 40 women and the slogan "40 women from here go to Britain every week for Abortions. Stop exporting the issue. Change the law now!"

On April 10th, 1998, a deal under the Good Friday Agreement ensured no progress was made on amending the law. Every year thereafter, Derry AfC sent letters to all Westminster MPs demanding an end to the bartering of women's rights for political expediency. After the UPAA was firebombed in 1999, a supporting letter was published on the front page of the Belfast Telegraph and a march was organised in Belfast with about 1,000 supporters.

During 1998-2008, Alliance for Choice Derry worked closely with Voice for Choice and the All Party Sexual Health Group at Westminster for the Act's extension. In 2007, the slogans were: "40 years behind" and "Extend the Abortion Act now!"

In June 2000, Stormont passed a non-binding motion opposing the Act. The NI Family Planning Association took a case in 2002 against the Department of Health, Social Services and Public Safety demanding that it issue clear guidelines on when abortion could be carried out. In 2004 the DHSSPS was obliged to draft these. Inevitably, SPUC contested them in 2009. They were deemed legal – but unclear and were thus withdrawn.

Poster produced by Derry Alliance for Choice group.

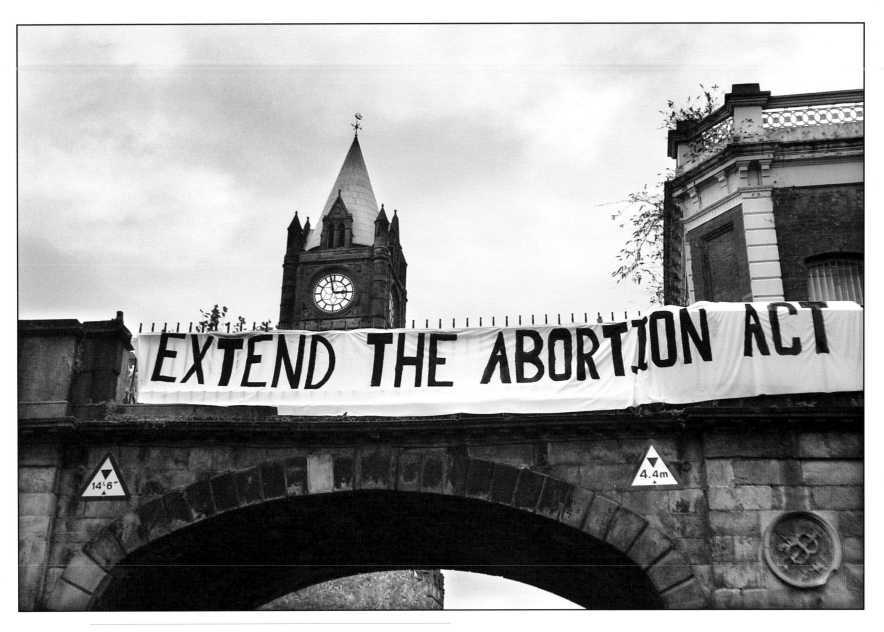

Derry Alliance for Choice banner placed on the Derry wall to coincide with their trip to Westminster in October 2008. Photo by Sha Gillespie

The VfC partnership succeeded in getting the issue onto the parliamentary agenda in 2008.

The British Labour Party's Emily Thornberry was to table an amendment to the Human Fertilisation and Embryology Act but was stymied when the four main party leaders informed Labour prime minister Gordon Brown that extending the Act would damage the peace process. Thornberry acquiesced. Her party colleague Diane Abbott MP was willing to step in, ignore Number 10 and go for it. In response, AfC Derry initiated a civil society open letter rejecting that the political parties spoke for the majority on abortion. Leaders of the main trade unions signed up along with many community and voluntary sector leaders and politicians - including Eileen Bell, First Speaker of the Stormont Assembly. It was delivered to Brown when, that October, pro-choice activists, mainly from AfC Derry and UNITE the Union, went to Westminster for the vote knowing that a parliamentary manoeuvre by Labour's Harriet Harman MP would, as the Guardian newspaper put it, give in to "the Stormont Boys Club".

Choice activists in the North highlighted developments in the South throughout their campaign. In 1992, they ran a petition to let X travel. During the 1992 referendums and again in 2002, campaigners from the North canvassed in Donegal and other border counties.

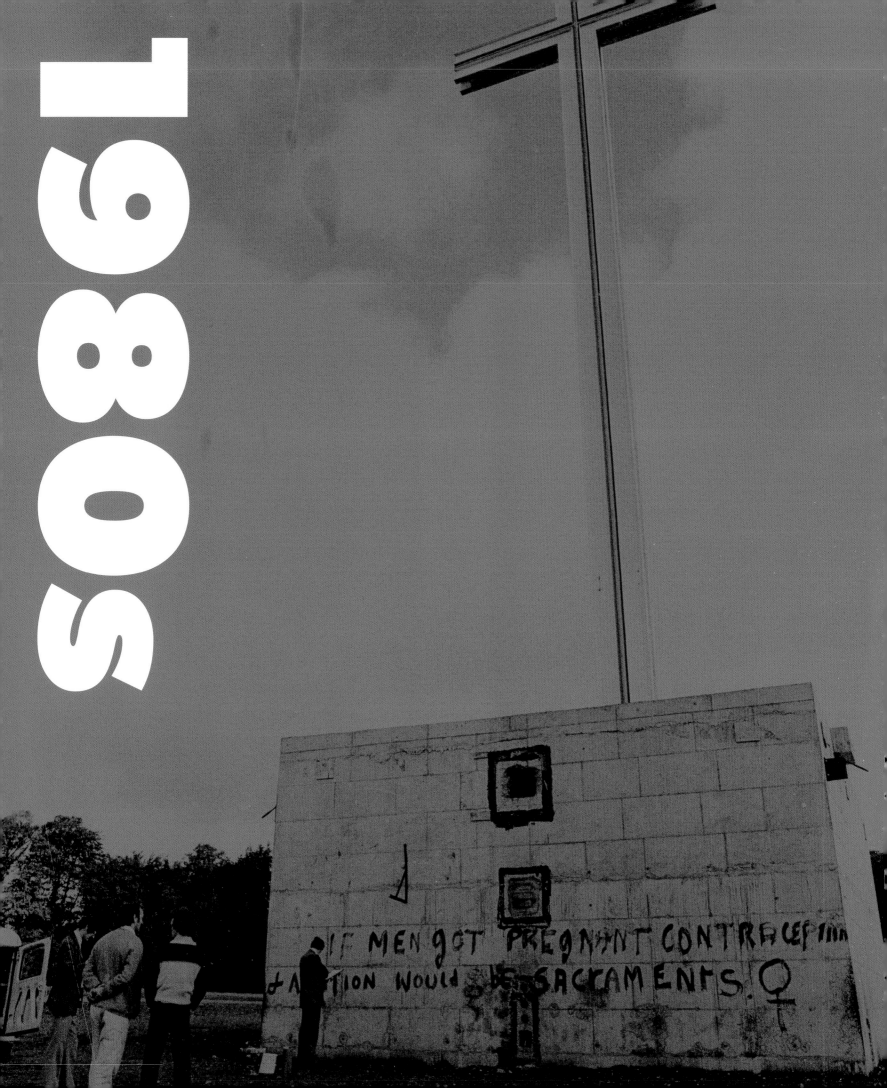

1980s

BACKLASH AGAINST WOMEN'S RIGHTS

The decade of the 1980s saw a backlash against the women's rights movement of the 1960s and 1970s, and the struggle for reproductive rights. It was a period of economic crisis and a fall in living standards with increased emigration of about 31,000 a year, especially among young people.

In 1980 and 1981 hunger strikes took place among prisoners in Long Kesh and Armagh prisons against the removal of political status from political prisoners. The strikes generated a large response in Ireland, north and south.

In 1981 the move to introduce a right to life of the foetus into the Constitution was launched by a coalition of right-wing groups calling themselves the Pro-Life Amendment Campaign. Abortion had been illegal for over 100 years – since 1861. Having persuaded the Government of the day to hold a referendum on the issue, they presented abortion as a harmful act against which the population needed to be protected.

Two significant meetings of women and men opposed to this proposal were organised by the Women's Right to Choose Group in Liberty Hall in Dublin in 1981. Among the prominent supporters were the late author and journalist Mary Holland (1935-2004); Mary McAleese, a Catholic intellectual who later became President of Ireland; journalist Ann-Marie Hourihane; trade unionist Anne Speed; and activist and academic Goretti Horgan.

Opposition to the referendum prompted informal local groups of women and men to spring up across Ireland which ultimately became the Anti-Amendment Campaign. The fight against these activists was bitter. There was hate mail, sabotage of meetings, witch hunts and accusations of "murderer" against known campaigners. It was frightening.

Two years later on September 7th, 1983 the referendum introduced the Eighth Amendment, also known as Article 40.3.3. On a turnout of 53.67 per cent, 67 per cent voted for it, 33 per cent against. Attorney general Peter Sutherland, who drafted the amendment, said the wording was ambiguous and might have the opposite outcome to the one intended.

Between 1980 and 1983 some 13,253 women went to England for a pregnancy termination in total secrecy. Some were helped there by the Irish Women's Abortion Support Group.

The Deadly Solution to an Irish Problem: Backstreet Abortion was published by the Women's Right to Choose Campaign on July 20th, 1983. Written by Pauline Jackson and Brian O'Reilly, the document charted use of the 1861 Offences Against the Person Act enacted 122 years earlier. Sections 58 and 59 prohibited the procurement of abortion by any means with the possible penalty of life imprisonment. Since the Act was in force, the document challenged the need for a referendum.

The 1980s was a period when the Irish public was exposed to some tragic stories about young women. On January 31st, 1984, Ann Lovett, a 15-year-old schoolgirl died in Co Longford giving birth to a baby at an outdoor grotto of the Virgin Mary. No one seemed to know or notice she was pregnant. She had no one to turn to.

In Co Kerry, Joanne Hayes, a young unmarried woman who had recently given birth, was effectively "put on trial" during an inquiry into the case of the Kerry babies. Nell McCafferty's book – A Woman to Blame, an account of the Kerry babies investigation – recounts the extraordinary prejudice against young, pregnant, unmarried women in Ireland.

Facing page: Gardaí in Dublin are investigating the daubing of slogans on the Papal Cross in the Phoenix Park on Thursday night. The photograph shows the base of the cross daubed with a slogan which reads "If men got pregnant contraception and abortion would be sacraments". Photo and original caption courtesy of The Irish Times.

Eileen Flynn outside the Four Courts, Dublin, on July 3rd, 1984. Photo by Derek Speirs.

Wexford schoolteacher Eileen Flynn was sacked in 1982 for becoming pregnant by a married man with whom she lived. She argued that her private life was not the school's business and refused to resign. She lost her job and went to court. The Circuit Court's Noel Ryan found the nuns had been lenient with Flynn and upheld the sacking. In 1985 in the High Court, Declan Costello supported that ruling on the basis that her dismissal was about her non-marital relationship, not her pregnancy. The cost of a Supreme Court case put it beyond Flynn's reach.

Founded in 1983, the Women's Information Network for years provided abortion information. The helpline's volunteers operated without funding and in secret because their work was illegal. WIN's slogan was its phone number, 6794700. It appeared on the back of toilet doors, lampposts, on banners and was heard chanted at demos. Around 1,425 women used the service before it closed in 1996.

In 1983, the first case taken under the (Health) Family Planning Act was against Dr Andrew Rynne for supplying 10 condoms directly to a patient. He was fined £500 but the fine was later lifted.

Not content with winning the Eighth Amendment, opposition to groups and bodies that had fought against it escalated into the court rooms of Dublin and Strasbourg in France. The Open Door Counselling Service and the Well Woman clinic were taken to court for providing information on abortion in Britain (case of SPUC v Open Door Counselling and Well Woman Clinic, 1988).

Three student unions were prohibited from giving information to students on how to obtain an abortion in Britain (case of Society for the Protection of the Unborn Child [SPUC] v Grogan, 1989).

These extremely expensive and complicated cases had the effect of almost strangling the emerging grassroots reproductive rights movement into a litany of court hearings, judgments, legal appeals and worries as to who was going to pay for it all.

Here was the origin of the repeal movement. The Anti-Amendment Campaign was a grassroots driven movement. There was no central executive, just a coordinating committee. Groups of lawyers, doctors and students produced documents to argue against what was to become the Eighth Amendment to the Constitution. Adding to the disappointment of the abortion referendum was the ballot on divorce in 1986 which also failed. This gloomy context was the background to the fightback of the 1990s.

On February 20th, 1985, a coalition of the Fine Gael and Labour parties led by Dr Garret FitzGerald defeated the opposition of the conservative Fianna Fáil party by an 83-80 vote on the Health (Family Planning) (Amendment) Act, 1979. The latter permitted sale of condoms to those aged 18 years plus without a prescription from a range of named outlets. The vote marked a major turning point in Irish history – the first-ever defeat of the Catholic Church in a head-to-head battle with the Government on social legislation.

Meanwhile, the Eighth Amendment did nothing to deter women from having abortions abroad. In fact, the numbers continued to rise after 1983.

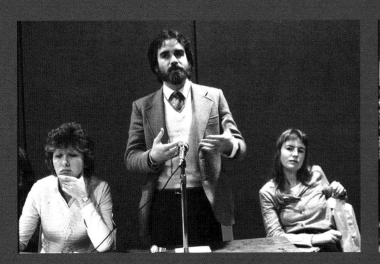

Pictured at a Women's Right to Choose meeting in Liberty Hall in March 1981 are, from left: the chair and future President of Ireland Mary McAleese, an unidentified panelist and activist Goretti Horgan. Photos by Clodagh Boyd.

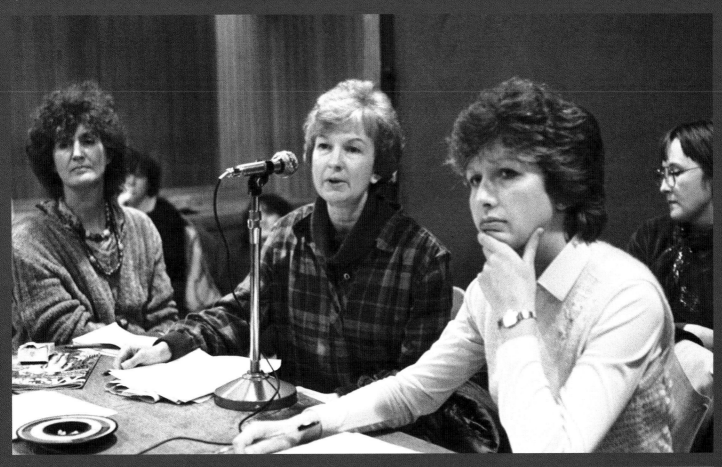

At the same meeting are, from left: British writer and feminist Jill Tweedie (1936–93), journalist Mary Holland (1935–2004), Mary McAleese and Anne Speed. Photo by Clodagh Boyd.

WOMEN'S RIGHT TO CHOOSE

In February 1980, a handful of women founded the Women's Right To Choose Group. Its first public event was held in August 1980 in TCD's Junior Common Room followed in March 1981 by a public meeting in Liberty Hall, Dublin, chaired by Mary McAleese.

The group called a conference in December 1981 to consider how to respond to the Pro-Life Amendment Campaign that had emerged in April of that year. The majority favoured a Women's Right to Choose Campaign to keep a clear voice for abortion rights and be open to men and the affiliation of pro-choice organisations. Shortly after, then-Taoiseach Charles Haughey (1925-2006) called a referendum to insert an anti-abortion amendment – Article 40.3.3 or the Eighth Amendment – into the Irish Constitution.

Members of the Women's Right to Choose Group set about creating a broad-based movement to campaign against it.

They organised two consecutive meetings in the Clarence Hotel in April 1982 from which the Anti-Amendment Campaign emerged with its five-point basis of opposition to Article 40.3.3. Both the Women's Right to Choose Group and Campaign affiliated to the AAC and, while neither formally disbanded, their members worked more or less exclusively under its auspices. Differences between positions were argued within rather than outside the Anti-Amendment Campaign on tactical issues such as the use of the argument for therapeutic abortions in certain circumstances.

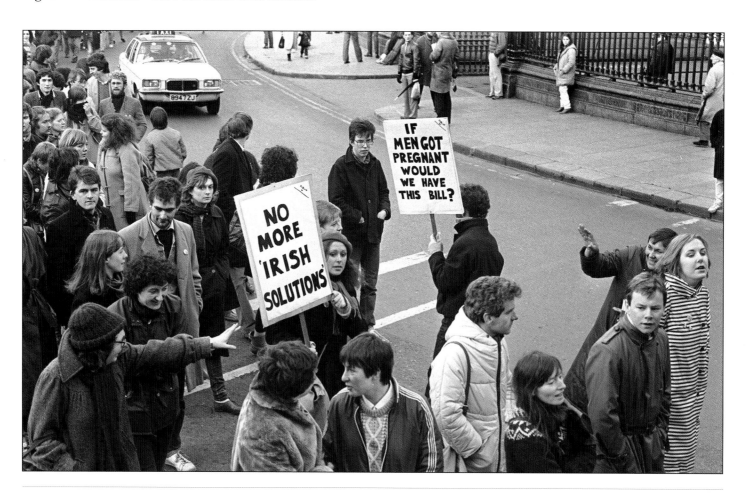

Anti-Amendment Campaign supporters marching in Dublin in November 1982. Photo by Derek Speirs.

THE ANTI-AMENDMENT CAMPAIGN

The primary aim of this national movement, run from the basement of the Well Woman Centre on Eccles Street, Dublin, was to stop the 1983 referendum under the slogan: "It's life that needs amending, not the Constitution." When it was clear that the ballot would proceed, the Anti-Amendment Campaign already had its five-point opposition to an anti-abortion measure that would:

1. Not solve the problem of unwanted pregnancies.

2. Allow for no exceptions even in cases where pregnancy severely threatened a woman's health or was the result of rape or incest.

3. Be sectarian.

4. Impede further discussion and possible legislation on abortion.

5. Be a waste of public funds.

An elected executive committee led the movement and reflected its broad base. Among its ranks were barristers and solicitors including future Supreme Court judges Frank Clarke, Adrian Hardiman and John McMenamin, medics such as Moira Woods, journalists, professional politicians and members of left wing organisations such as Mary Gordon, Goretti Horgan and Eddie Conlon. Monthly delegate conferences formulated policy and strategy.

Many public figures were supportive and included doctors Mary Henry, Ivor Browne and Paddy Leahy, another future Supreme Court judge Catherine McGuinness, Protestant clergymen such as Victor Griffin, radicals like Peadar O'Donnell (1893-1986) and Noël Browne (1915-97), elected politicians such as Monica Barnes and Nuala Fennell of Fine Gael, Michael D Higgins of the Labour Party, Independent Jim Kemmy (1936-97), representatives from women's organisations like the National Council for the Status of Women, academics, trade unionists and journalists. A broader range of spokespersons from the executive addressed local political meetings around the country.

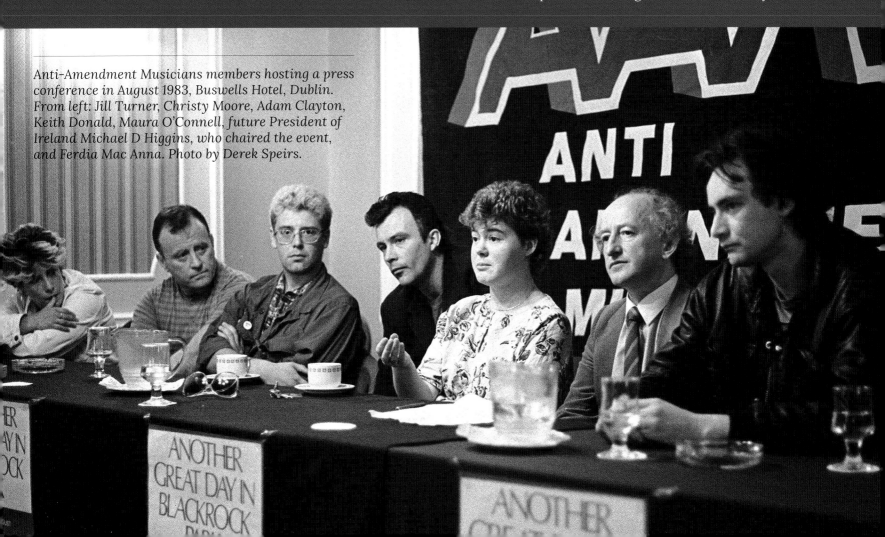

Anti-Amendment Musicians members hosting a press conference in August 1983, Buswells Hotel, Dublin. From left: Jill Turner, Christy Moore, Adam Clayton, Keith Donald, Maura O'Connell, future President of Ireland Michael D Higgins, who chaired the event, and Ferdia Mac Anna. Photo by Derek Speirs.

ARTICLE 40.3.3

The referendum on the Eighth Amendment of the Constitution was passed after a bitterly contested campaign. On an electoral turnout of 53 per cent, 841,233 voted for the abortion ban and 416,136 against. Article 40.3.3 read: "The State acknowledges the right to life of the unborn and, with due regard to the equal right to life of the mother, guarantees in its laws to respect, and, as far as is practicable, by its laws to defend and vindicate that right."

VOTE NO TO THE AMENDMENT

OPPOSE THE AMENDMENT TO THE CONSTITUTION

DUN LAOGHAIRE PUBLIC MEETING MONDAY 22nd NOVEMBER 1982 8.00pm ROYAL MARINE HOTEL

SPEAKERS:
Cllr. Jane Dillon Byrne
Doctor Maura Woods
Senator Shane Ross

Organised by the Dun Laoghaire Branch of the Anti-Amendment Campaign

THE IRISH TIMES, THURSDAY, JULY 15, 1982

LETTERS to the EDITOR

THE ABORTION REFERENDUM

Sir,—We are writing on behalf of the Anti-Amendment Campaign, to highlight some areas in the debate on the proposed amendment to the Constitution on abortion, which have to date, largely been ignored. Over the past few months, correspondents have discussed the legal, medical, theological and philosophical aspects of the proposed amendment, through your columns. Although these arguments are fundamental to an informed and balanced opposition to the amendment, they do not relate to the practical problems of women living in present day Ireland.

Since the launching of the AAC, many women we have encountered have expressed concern that their major fears and doubts have not been adequately voiced. We would like to take this opportunity to outline some of these areas.

Single women with unwanted pregnancies face a double-blind situation. On one hand they are discriminated against for having children outside marriage, receiving inadequate State support. On the other hand they are stigmatised if they choose to have an abortion. The State alone is not responsible for the lack of support offered to such women. General social attitudes to pregnant single women and single mothers are often uncaring and negative. Many women in this situation are rejected by their families, forcing them to seek help from State or voluntary agencies. There must be thousands of Irish women who daily mourn the child they might have kept, but for the lack of family or social support.

The proposed amendment concentrates on the rights of the unborn children. The hypocrisy of this move is incredible, in the light of the appalling social and physical conditions in which many of our children live, and the stigma of the illegitimacy imposed on the children of single women. Families who already have more children than they can afford to cope with, are forced to live in overcrowded conditions and receive minimal financial allowances from the State.

The proposed amendment will not allow for exceptions in cases where women/girls become pregnant as a result of rape or incest. One of the most traumatic after-effects of rape is the constant fear and worry of an unwanted pregnancy. Rape and incest are acts of forcible sexual violence, for which the girl/woman has no responsibility. Who then has the right to insist that these victims of male violence should be forced to carry and bear an unwanted child, conceived during rape? No hospital in Ireland offers a raped woman the opportunity to terminate her pregnancy, even immediately after possible conception.

Throughout the last decade, there has been concerted campaigns aimed at removing the status of illegitimacy, abolishing capital punishment and lifting the ban on divorce. No referenda have been called, or even promised by the State on these important issues, which affect the lives of so many people in Ireland at the present. It is sinister that, a campaign, so recently launched as the Pro Life Amendment Campaign, has succeeded in obtaining commitments on a referendum from at least two of the three major political parties. The call for this referendum has been declared sectarian and divisive by all the Protestant Churches and the Chief Rabbi. There is another more subtle and pervasive way in which that as a referendum solely on abortion, it singles out women, the most discriminated against section of our community for attack. —
Yours, etc.,
LORRAINE SCULLY,
Steering Committee,
Anti-Amendment Campaign.

* * *

Sir,— May I refer to the statement made by Mrs. Catherine McGuinness concerning the mythology and folklore of Irish Protestantism. The terminology used evokes an image of the world of make-believe and fairy tales. May I contrast this reference with a statement of fact in the World of Reality.

Many Catholic (and non-Catholic) women in Britain have a real fear about consulting non-Catholic doctors and gynaecologists where the option of an abortion is often put to them as casually as if all that was involved was something as simple and as of little consequence as the extraction of a tooth. I have come across cases of women in Britain who have been cajoled and pressurised towards giving consent to having an abortion when that eventuality had not even occurred to them. Sadly for many people in the medical profession in Britain abortion is no longer an ethical problem. Pro abortion propaganda, brainwashing, and financial considerations have changed moral attitudes. When abortion was legalised in Britain fifteen years ago few people could have foreseen how the initial stringent conditions attached to the implementation of the Abortion Act would in a short time be diluted to the point where there is now an "Abortion on Demand" situation.

Would those who oppose the proposed Referendum look now objectively at the Abortion Scenario in Britain. Do they really think the same could not happen here? I feel sad that the representatives of the Protestant Churches cannot see that the choice being given to the People of Ireland is not the opportunity for one Church to voice its opinion at the expense of other Churches but rather for the Members of all Churches to proclaim to the world that Ireland believes in the value of the life God has created to His own image and likeness.— Yours, etc.,
(Father) CON McGILLICUDDY,
C.C.
30 Kilclare Crescent,
Jobstown, Tallaght,
Co. Dublin.

LEBANON CASUALTIES

A chara,— Some of the preposterous claims contained in the advertisement submitted by "eyewitnesses" recently returned from Lebanon" (July 6th) need to be challenged... responsible for the deaths of 98,854 people." A less biased source than the French language Beirut newspaper quoted is the authoritative yearbook "The Middle East and North Africa '81-82." According to this "it...

THE SCOURGE OF POLLUTION

Sir.—The continuing despoliation of Lough Sheelin through industrialised pig farming (recently referred to in your columns by Michael McCabe of the Sheelin Shamrock Hotel)...

PINK PARTY

IN AID OF THE ANTI-AMENDMENT CAMPAIGN

AT THE HIRSCHFELD CENTRE
10 FOWNES STREET, DUBLIN 2
TUES., 23 AUG., '83 10:30 - 3

£2:00, WAGED ; £1:50 UNWAGED

WEAR SOMETHING PINK
PINK PRIZES ; FOOD ; WINE

G.A.A. GAYS AGAINST THE AMENDMENT

A WOMAN'S RIGHT TO CHOOSE

IRELAND ALREADY HAS ABORTION

7,000 women travel to England each year, and two-thirds of these made the decision privately and in isolation, without any help from referral agencies, doctors or counsellors.

No woman takes this decision lightly and few would find it an easy task to raise the minimum of £200 to make the journey to the English clinics.

To put a constitutional prohibition on abortion in Ireland would only worsen an already difficult situation for those women who find themselves with an unwanted pregnancy.

If women in Ireland did not have the option of proper and safe abortion facilities (in England), then the problem of back-street abortions would be as serious in Ireland as in countries such as Portugal, where official figures show that 2,000 women die each year through back-street methods.

It is appalling figures like these which led to the "liberalising" of abortion laws in the U.S.A., France, Germany, England, Scotland, Wales, Australia etc.

As workers, people have struggled within trade unions for proper working conditions. Women have no such organisation or support in the whole area of reproduction and childcare.

ANY AMENDMENT WHICH RESTRICTS WOMEN'S ABILITY TO TAKE CONTROL OVER THEIR OWN LIVES IS A STEP BACKWARDS FOR IRELAND.

What you can do:-

Vote NO to any amendment
Write letters to the Newspapers
Speak to your local T.Ds.
Join your local action group

The Anti-Amendment Campaign,
P.O. Box 1285, Dublin 7.
Phone: 308636.

This leaflet was written by women in Dublin 4.

Dublin 4 Action Group meets every Monday night at 8 p.m. at the Pembroke Pub in Pembroke Street.

THE ABORTION AMENDMENT

what does it mean for women?

ORGANISE !

STOP THE REFERENDUM !

The Anti—Amendment Campaign

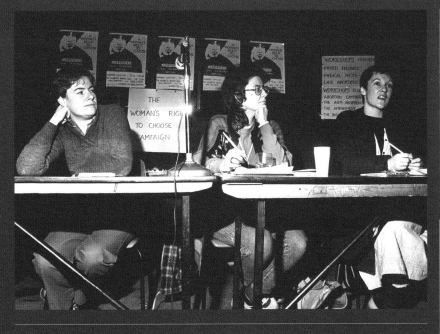

Pictured at a Women's Right to Choose conference, Dublin 1981 are, from left: activist Goretti Horgan, Angela Phillips, co-author of the hugely influential Our Bodies Ourselves (Penguin 1978), and activist Mary Gordon. Photographer unknown.

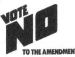

Voting Yes won't stop one abortion —
Voting Yes could put women's lives at risk!

VOTE **NO** TO THE AMENDMENT

THE ANTI-AMENDMENT CAMPAIGN

P. O. BOX 1285 DUBLIN 7 PH: 308636

"ITS LIFE THAT NEEDS AMENDING, NOT THE CONSTITUTION"

ANTI-AMENDMENT CAMPAIGN EXPERIENCES

We are making a final appeal for accounts of people's experiences during the campaign. While we have received some excellent material, we do not have enough to consider publication. Everything is welcome, whether two lines or twenty pages long. Don't let this opportunity pass. Contributions should be sent to us at 59, Mountjoy Square, Dublin 1.

Catriona Crowe

Helen O'Donoghue

12th November 1983.

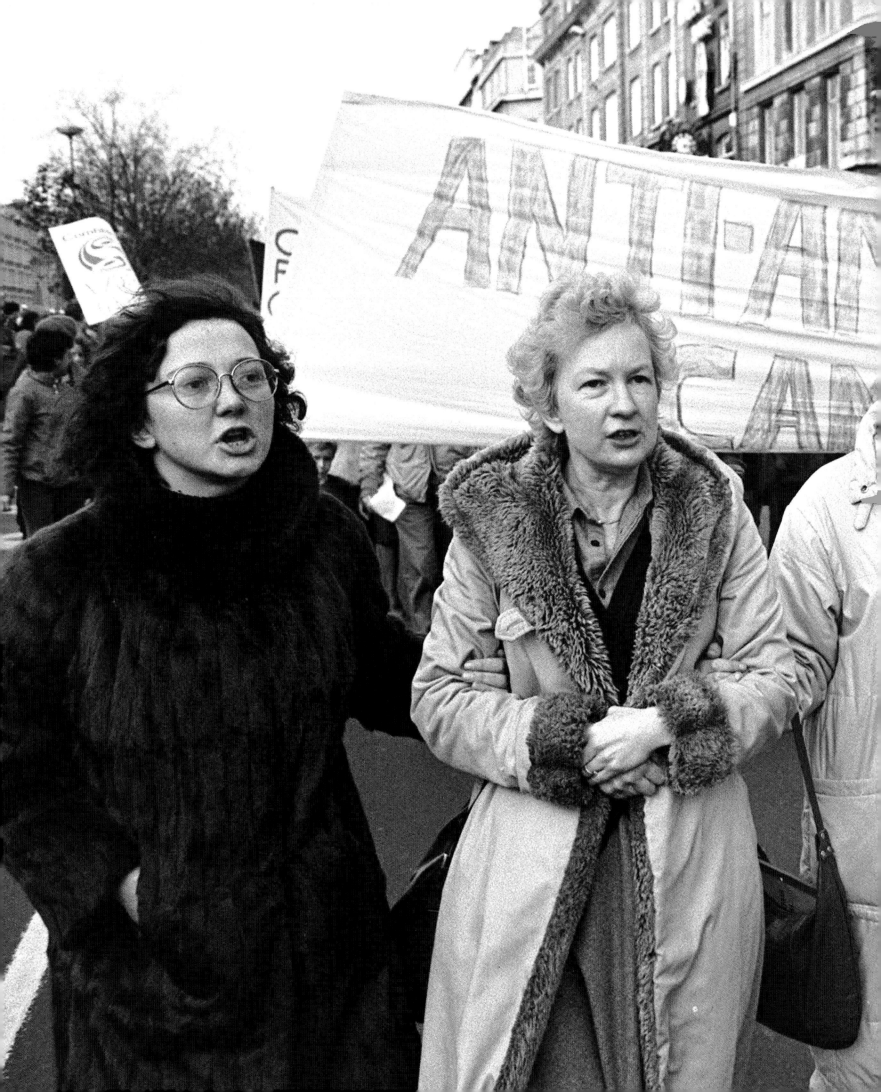

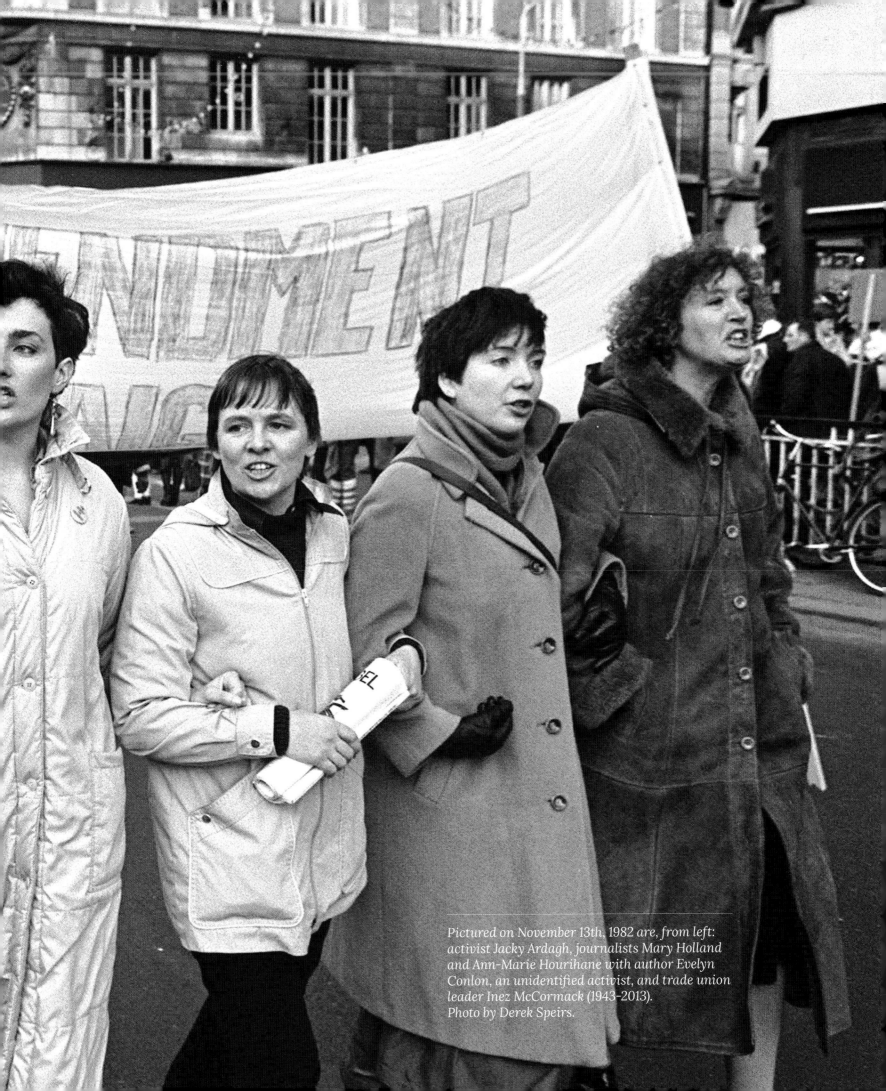

Pictured on November 13th, 1982 are, from left: activist Jacky Ardagh, journalists Mary Holland and Ann-Marie Hourihane with author Evelyn Conlon, an unidentified activist, and trade union leader Inez McCormack (1943–2013).
Photo by Derek Speirs.

Activists Ursula Barry and Eddie Conlon at an
Anti-Amendment Campaign meeting in Mullingar,
Co Westmeath, on June 20th, 1983. Photo by Derek Speirs.

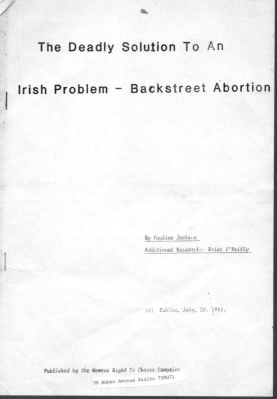

The Deadly Solution To An

Irish Problem — Backstreet Abortion

By Pauline Jackson

Additional Research:- Brian O'Reilly

(c) Dublin, July, 20. 1983.

Published by the Womens Right To Choose Campaign
39 Ruben Avenue Rialto 758071

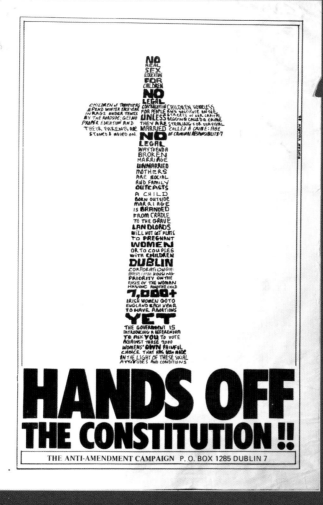

HANDS OFF
THE CONSTITUTION !!

THE ANTI-AMENDMENT CAMPAIGN P. O. BOX 1285 DUBLIN 7

Pictured in 1983: Irish Labour Party politician
Joe Costello (left) with Dr Noël Browne (1915-
1997), who as Health Minister during 1948-51
introduced the controversial Mother and Child
Scheme. Photo courtesy of The Irish Times.

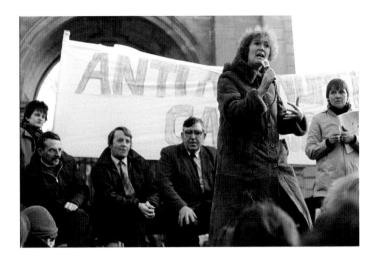

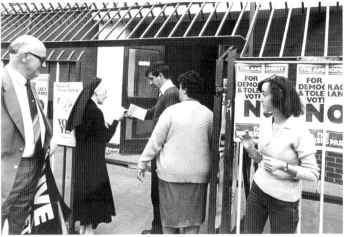

Trade unionists Inez McCormack with, to her left, Des Bonass who died in 2018 and politician Jim Kemmy (1936-97) and, right, author Evelyn Conlon. Photo by Derek Speirs.

A nun casting her vote on the Eighth Amendment on September 7th, 1983. Photo courtesy of The Irish Times.

A polling booth in Clane, Co Kildare, in 1983. Photo by Derek Speirs.

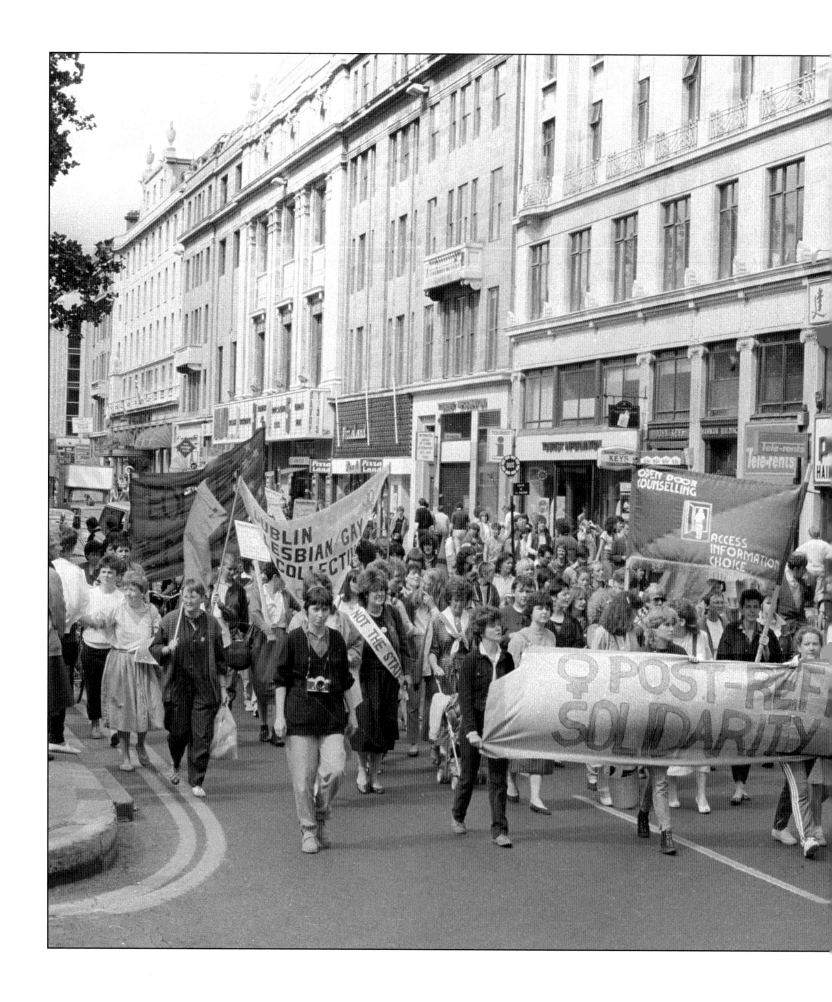

Mr Justice Adrian Hardiman (1951-2016),
a staunch opponent of the Eighth Amendment.
Photo courtesy of The Irish Times.

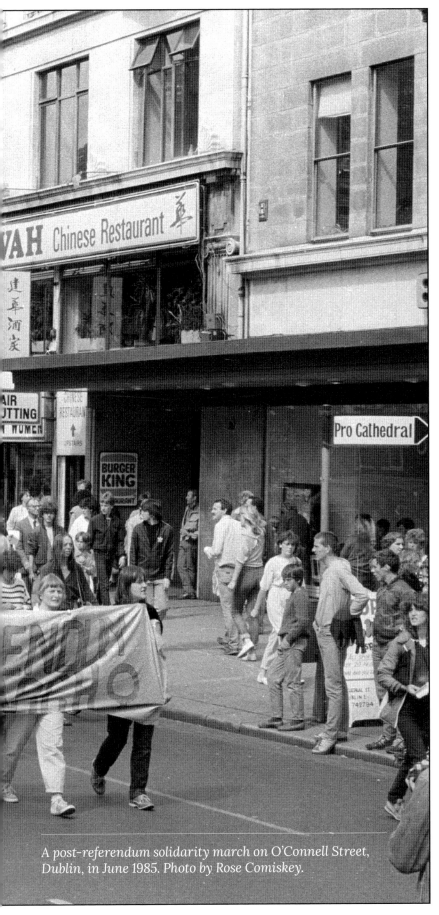

A post-referendum solidarity march on O'Connell Street,
Dublin, in June 1985. Photo by Rose Comiskey.

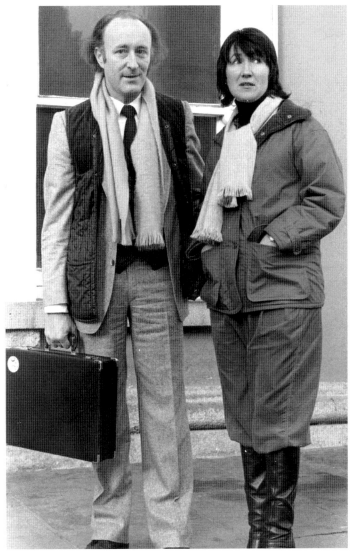

The first case taken under the (Health) Family Planning
Act in 1983 was against Dr Andrew Rynne for supplying
ten condoms directly to a patient. He was fined £500
but the fine was later lifted.
Photo courtesy of The Irish Times.

MATERNITY IN IRELAND 1980S

Sheila Hodgers from Dundalk, Co Louth, died on March 19th, 1983, two days after giving birth to a baby girl, Gemma, who died immediately. Sheila had cancer and she and her husband had repeatedly asked for a Caesarean operation or an abortion. Sheila's story became prominent during the Anti-Amendment campaign of 1983.

Ann Lovett was 15 years old when she was found at a grotto in Granard, Co Longford (pictured below), having given birth to a baby at the foot of a statue of the Virgin Mary. Mother and child died on that same day, January 31st, 1984.

In 1984, the Garda Síochána charged **Majella Moynihan** with breaching the force's disciplinary rules for having a child outside marriage. Moynihan was more or less hounded out of the force, her good name ruined. In the 2010s she resorted to the courts for loss of earnings and personal injuries.

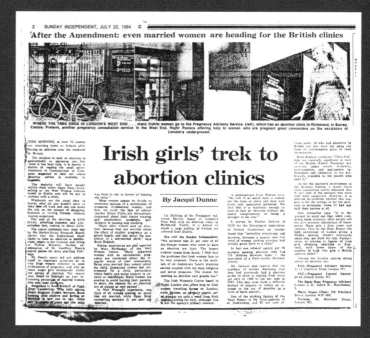

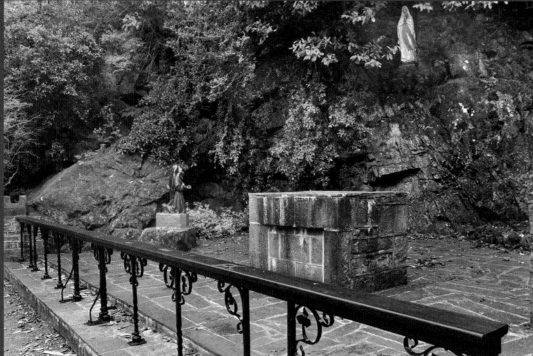

The grotto in Granard, Co Longford where Ann Lovett gave to birth to a son who died there. Ann died shortly after in Mullingar Hospital. Photo by Derek Speirs.

THE KERRY BABIES

In 1984 a young unmarried mother from Abbeydorney Co Kerry, Joanne Hayes, was accused of the murder of a baby to whom she had given birth on the family farm. She was also accused of stabbing to death a baby whose body washed up on a beach in Cahirciveen, Co Kerry, 65km away. Her family was accused of crimes related to these events. The gardaí claimed to have statements in which they admitted to these "crimes." In the event, all prosecutions were dropped against her.

A tribunal was established to find out how this had come to be. Its hearings lasted over 80 days into 1985 during which Joanne Hayes was pilloried and scorned in public by the all male corps of judge, lawyers and Garda witnesses.

The State apologised to Joanne Hayes in 2020, 35 years later.

Nell McCafferty's book A Woman to Blame – The Kerry Babies Case (1985, Attic Press, independent women's publisher), provided an alternative, factual and feminist account of the case. The title of the 2014 exhibition, Women to Blame, was inspired by this publication.

Joanne Hayes with her daughter Yvonne opens cards and letters of support during a break in the tribunal in January 1985. Photo by Derek Speirs.

Below press cutting from The Sunday Tribune.

Author Nell McCafferty at the launch of A Woman to Blame in October 1985. Photo by Derek Speirs.

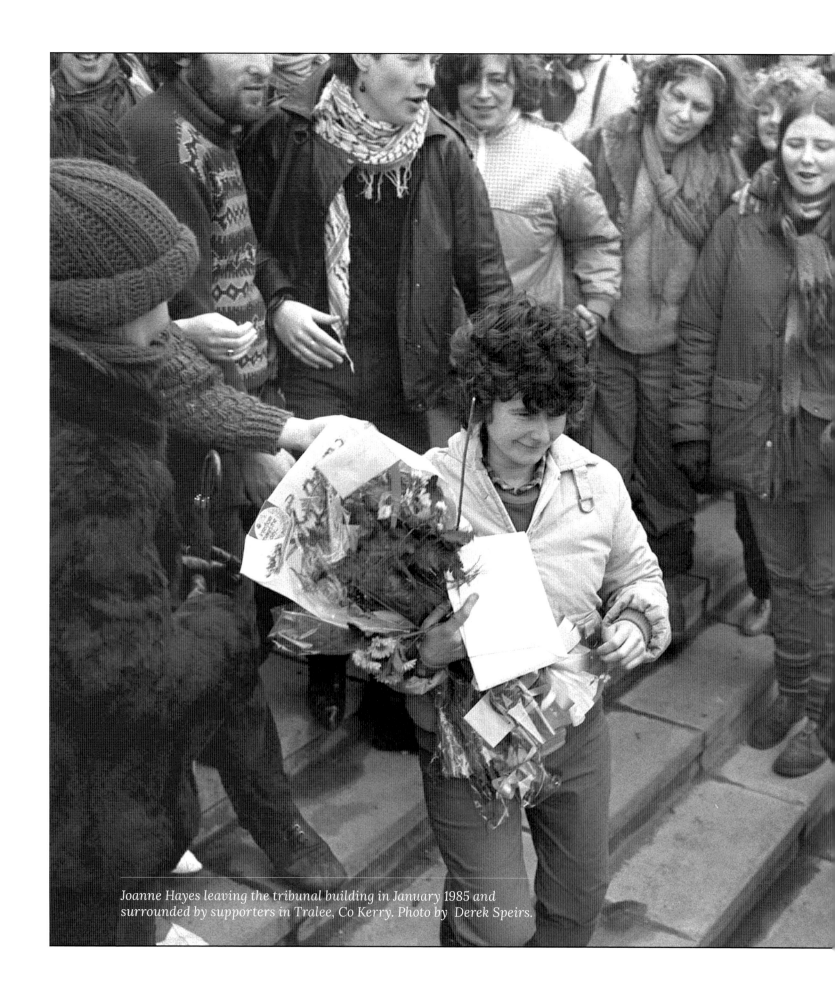

Joanne Hayes leaving the tribunal building in January 1985 and surrounded by supporters in Tralee, Co Kerry. Photo by Derek Speirs.

Road to Repeal

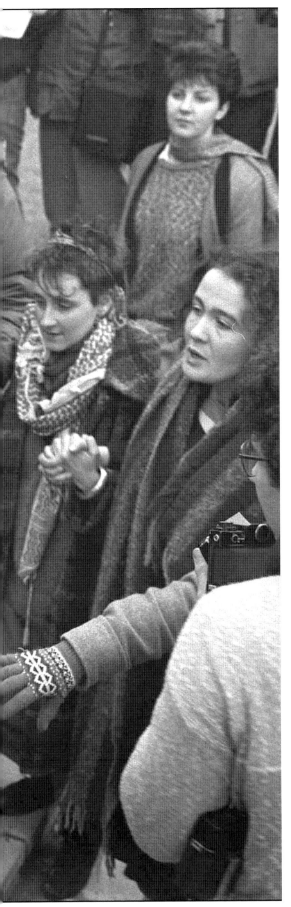

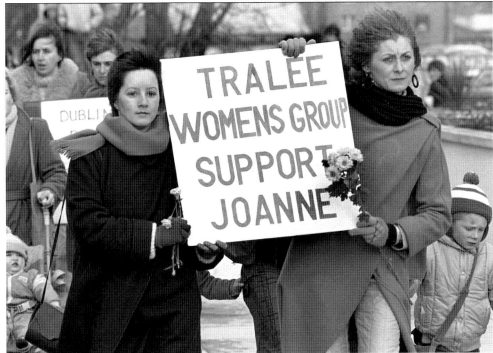

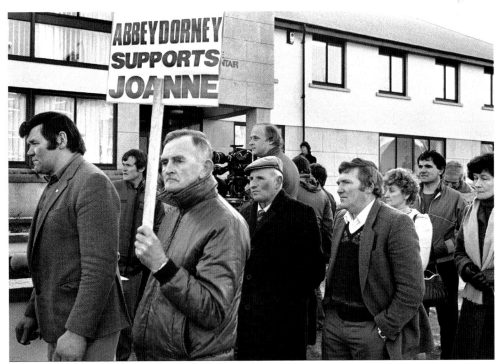

Above: The people of Abbeydorney and Tralee protest in support of Joanne Hayes outside Tralee's tribunal building. Photos by Derek Speirs.

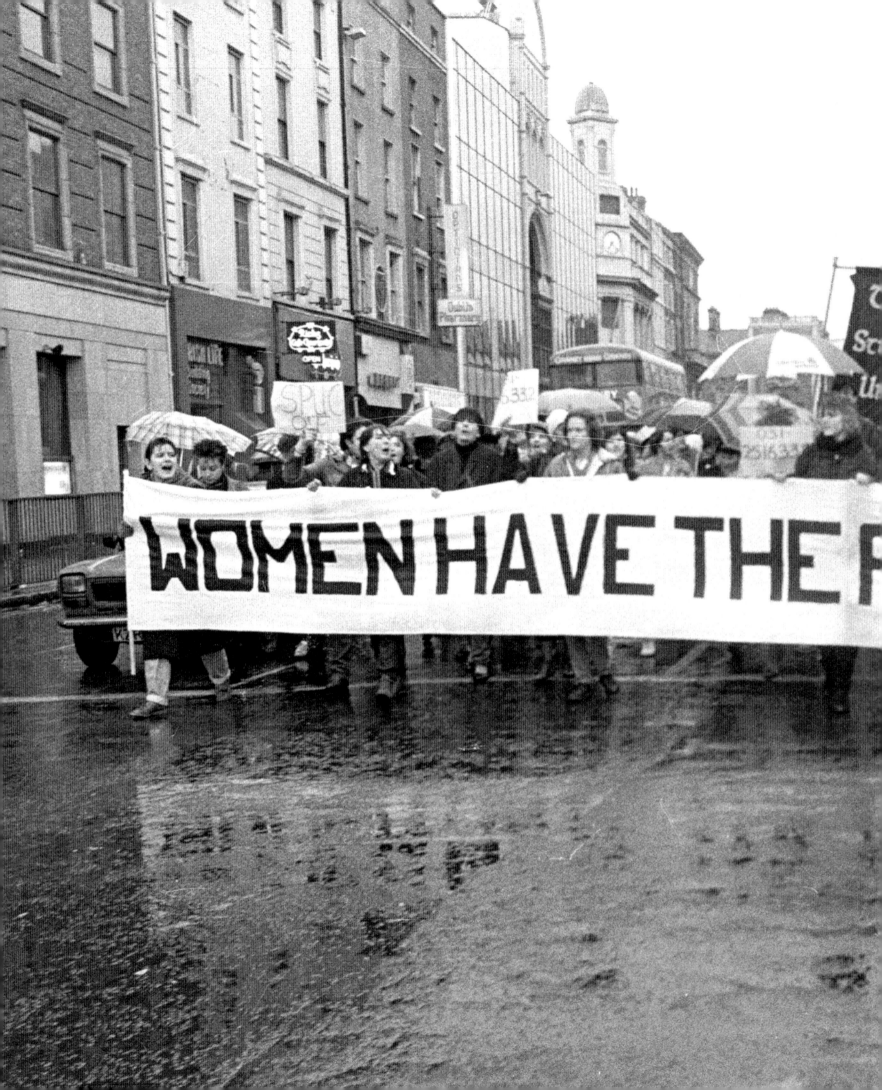

Activists demonstrating for the right to information on abortion on Westmoreland Street, Dublin, February 7th, 1987. Photo courtesy of The Irish Times.

WELL WOMAN & OPEN DOOR SUED BY SPUC – 1986

In the 1980s clinics provided advice on abortion services outside the State. In 1986, the Society for the Protection of Unborn Children sued these clinics and succeeded in outlawing any such information.

Mr Justice Hamilton, president of the High Court, said at the time: "I am satisfied beyond doubt that having regard to the admitted facts the defendants were assisting in the ultimate destruction of the life of the unborn by abortion in that they were helping the pregnant woman who had decided upon that option to get in touch with a clinic in Great Britain which would provide the service of abortion."

This ruling was to be upheld by the Supreme Court in 1988.

OPEN LINE COUNSELLING

Defend The Clinics
Fund Raiser
RADICAL QUIZ
For
LEFTIES
LIBERALS
+ LEFT-OVERS

VENUE
HOLLY BROOK HOTEL
CLONTARF

TEAMS OF 5 £15 PER TEAM

Date 20th Nov 86 Time 8pm

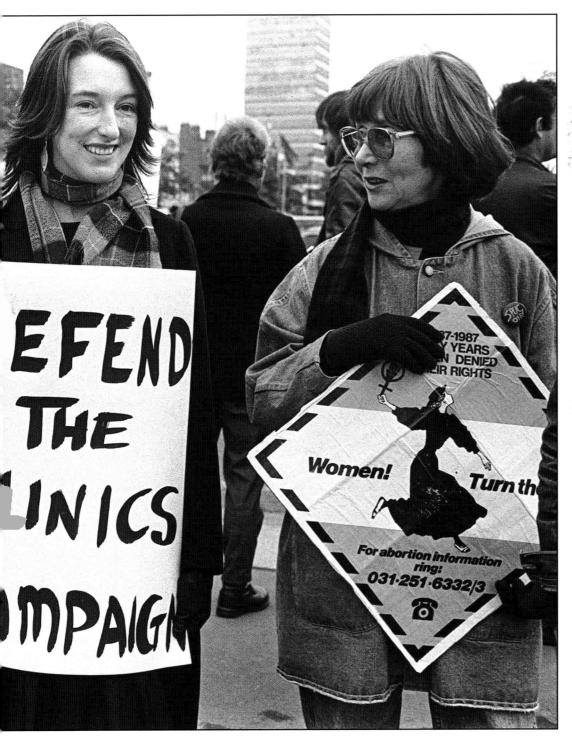

SPUC sues Well Woman centres

THE Society for the Protection of Unborn Children, SPUC, has instigated legal proceedings against the two Dublin Well Woman Centres and Open Line Counselling, saying that they are abortion referral agencies.

The action has only been taken, SPUC says, "after giving the Government and the Director of Public Prosecutions ample opportunity to act." SPUC says that since the passing of the anti-abortion amendment, in which the society was one of the most vociferous campaigners, the State has a clear duty to prevent such agencies, but that approaches have been made to the Minister for Justice with no result. Their prosecution is being initiated "in order to save human life."

SPUC claims that statistics show the agencies are referring 2,600 women to Britain, and that this constitutes 70 per cent of all the abortions performed on women giving Irish addresses there.

Campaigners Nora Mannion and novelist and short story writer Val Mulkerns (1925–2018) on O'Connell Bridge, Dublin, defending the right of clinics to give abortion information on October 10th, 1987. Photo by Derek Speirs.
Above right: The Irish Times press cutting, 1986.

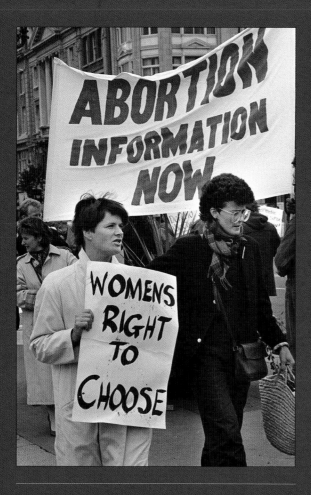

At a pro-choice demo on October 10th, 1987 supporting women's right to information and the abortion referral clinics are activist Anne Conway and campaigning photographer Rose Comiskey. Photo by Derek Speirs.

Ruth Riddick of Open Line Counselling selling her pamphlet (see left) outside Dublin's Olympia Theatre during the Third World Women's Interdisciplinary Congress event in July 1987. Photo by Derek Speirs.

Road to Repeal

Staff members of the Well Woman Centre outside the Four Courts March 16th, 1988, from left, Marguerite Woods, Felice Cohen, Mary McNeany and Bonnie Maher. The Supreme Court dismissed the appeal by the Well Woman and Open Door Counselling Ltd against a High Court order restraining them from assisting pregnant women going abroad for abortions. They had lost a High Court action taken against them originally by the Society for the Protection of the Unborn Child (SPUC) which was later replaced by the Attorney General.
Photo courtesy of The Irish Times.

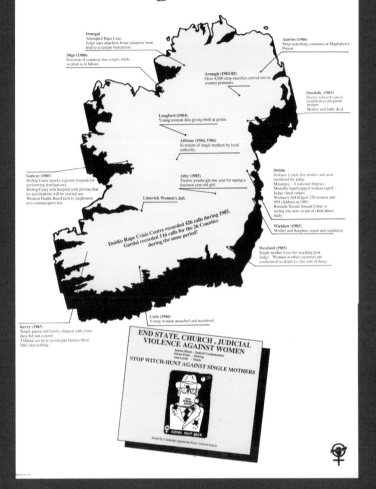

Poster Jole Bortoli

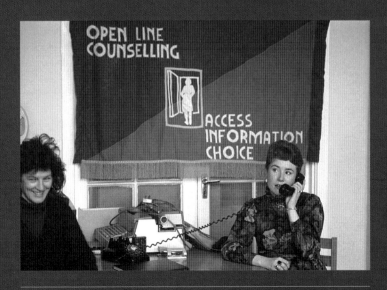

Ruth Riddick with Corinna Reynolds in Open Line Counselling HQ in December 1986. Photo by Derek Speirs.

SPUC SUES STUDENTS

The Society for the Protection of the Unborn Child (SPUC) applied to the High Court to prevent student groups from giving information on abortion service providers in England. The High Court referred certain questions to the European Court of Justice before delivering a judgment.

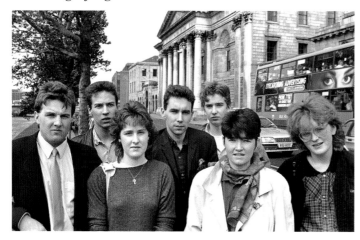

Students at the Four Courts, Dublin, on August 24th, 1988, from left: Diarmaid Coogan, François Pittion, Anna Farrell, Tom McEnany, Mark Little, Fidelma Joyce and Anne Marie Keary. Photo by Derek Speirs.

More Irish women seek British abortions

By Dr David Nowlan, Medical Correspondent

ABOUT 4,000 women with addresses in the Republic had their pregnancies terminated in England during 1984, giving a higher abortion rate than for women from Northern Ireland having terminations in Britain.

This is one of several significant findigs in the Medico-Social Research Board's latest analysis of abortions preformed in Britain on women from Ireland. Others include the fact that the great majority of women involved were not using contraception; the highest abortion rates were among secretarial or clerical classes of women; and the increase in the total between 1983 and 1984 is largely accounted for by more women having their second or third abortions.

The report was presented to the Minister for Health, Mr Desmond, by the Director of the Board, Dr Geoffrey Dean.

The overall total of 3,946 women having abortions in the UK who gave their home address as being in the Republic is only the total which was officially reported. It does not include the unknown number of Irish women who gave accommodation addresses in England when they sought abortions there. The Medico-Social Research Board's analysis of the situation in 1984 is based on examination of 2,502 questionnaires answered (in absolute confidentiality) by the women when they attended the British abortion clinics.

It shows that most women (55 per cent of the total) gave their address as Dublin city or county, although the number giving addresses outside Dublin had increased somewhat over the previous year. Of those women under the age of 20, 99 per cent were single while 96 per cent of those between 20 and 24 were unmarried. Comparison with data on Northern Ireland women indicates that while the abortion rate is higher among Northern women under 20, the rate among women from the Republic over the age of 20 years is higher than in the same age group from the North.

There was no significant change between 1983 and 1984 in the number of first abortions being carried out on women from the Republic. The increase in the overall reported total between the two years was accounted for by an increase in second and subsequent abortions — more than 700 in 1984.

This finding must throw a direct challenge to the various family planning organisations in the Republic as well as to the State's very restrictive contraception laws. Not only are more than 3,000 probably unwanted first pregnancies not being prevented but women who have already aborted earlier pregnancies are finding themselves pregnant again.

Meanwhile, 83 per cent of the women under 20 years of age reported that they had not used contraception prior to this conception. Likewise 79 per cent of those between 20 and 24, 72 per cent of those between 25 and 29 and 64 per cent of those over 30 years of age. The percentages of those who had never used contraception at any time ranged from 13 among the over 30s to 42 among those under 19.

Irish women are still more likely to have the baby than to have it aborted: 5,030 single women had the baby compared with 2,988 who had it aborted. But Dublin women were more likely to have an abortion than their country counterparts and between the ages of 25 and 29 more single Dublin women who became pregnant had an abortion than went on to have the baby. The social classes among which abortion was most prevalent were the "other non-manual" (including largely office workers) followed by the professional-managerial classes. Termination rates were three times higher among "Other non-manual" classes than among the skilled manual class.

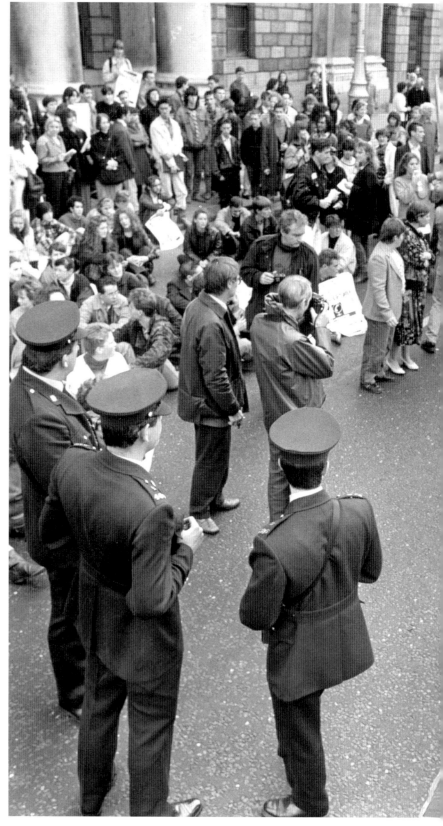

Students may face jail on abortion issue

Irish Times 9/10/89

By Carol Coulter

ON THE EVE of her High Court appearance today, the president of Trinity College Students' Union, Ms Ivana Bacik, was taking phone calls in her office from women seeking information on how and where to obtain an abortion.

Ms Bacik, the union's welfare officer, Ms Grainne Murphy, its education officer, and Mr Eoin Lonergan and Mr Jim Davis, its entertainment and services officers, appear in court today asked to show cause why they should not go to jail. This follows the Society for the Protection of Unborn Children obtaining leave last week to seek a committal order against them for defying an injunction restraining them from distributing abortion information.

SPUC also got an interim injunction against the officers of the Union of Students in Ireland and UCD Students' Union, seeking to prevent them also from distributing abortion information, so these groups are likely to face committal proceedings later.

Ms Mary Robinson, senior counsel for the students, is seeking the referral of the matter to the European Court in Luxembourg. This court deals with issues where there is a potential conflict between European law, especially the Treaty of Rome, and domestic law.

A spokeswoman for SPUC, Mrs Marie Vernon, told *The Irish Times* yesterday that it did not think there was any reason for the matter to go to the European Court, as there was no transnational issue at stake. She also said that the question no longer was to do with abortion, but with law and order. "The students are thumbing their noses at the court," she said.

Ms Bacik and her colleagues were adamant yesterday that the campaign will continue, and that if jailed today for contempt of court, they will remain in jail until a solution is found. They are not prepared to purge their contempt by giving undertakings not to distribute the information, she said.

A group of 50 students have signed a statement saying they would continue to distribute the leaflets in question, and four executive members of the union, Mr Michael O'Siochru, Ms Cathy Conlon, Mr Paul McDermid and Mr Edward Doyle would be co-ordinating this and running the union while the officers were in jail, she said.

Ten other students' unions had also pledged themselves willing to distribute abortion information, and 100 prominent individuals who had indicated support had been written to asking them to distribute it as well.

Asked how she felt about the prospect of going to jail, possibly for a long period, Ms Bacik said: "I'm not looking forward to it. But we're determined to go through with it. We won't come out until the situation is changed. This may not be before the European hearing, but we hope that there would be enough pressure before that to allow us to be released unconditionally".

Jail is not the only sanction being sought against the students' union. In court last week, counsel for SPUC also asked for the sequestration of the union's assets, and, if Ms Robinsons arguments are not accepted by the court, this may prove a less controversial sanction than sending the students to jail.

If her application fails, and the students do go to jail, this will not end the matter, as other organisations and individuals are pledged to defy the injunction. Asked if it would seek injunctions against the other students' unions, Mrs Vernon said she hoped that an order would be made so that anyone made aware of it would have to comply with it.

Responding to the suggestion that there was no law prohibiting the distribution of abortion information, she said that the Constitution was self-executing. "There does not have to be back-up legislation. It is the highest law of the land."

However, she added that SPUC would like to see proper legislation introduced. "We do not want to be the guardians of the Constitution for ever and a day."

Students from Trinity College will march to the court today as the hearing opens, and there will be a rally outside the court, which will be addressed by representatives of the Labour Party, the Workers' Party and individuals who support the students, such as Ms Monica Barnes, TD. Mr Emmet Stagg, TD, yesterday condemned SPUC in a statement in which he said that those who supported it also opposed the abolition of illegitimacy, the extension of sex education and the right of separated people to remarry.

Ms Ivana Bacik

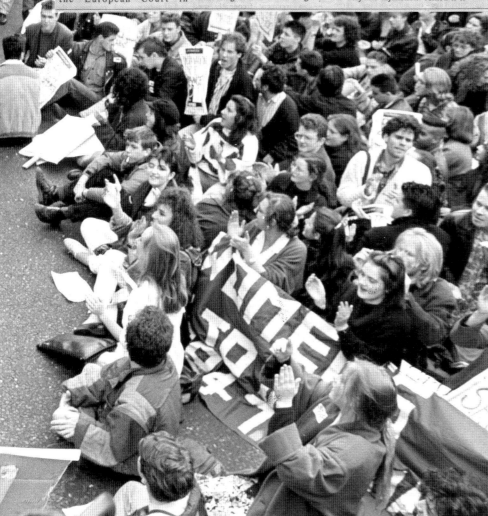

Students protesting outside the Four Courts, Dublin, in the late 1980s. Photo courtesy of The Irish Times.

Far left and above right: press cuttings from The Irish Times.

WOMEN ORGANISING IN THE COMMUNITY

At a time when the second wave of the women's movement was fragmenting into a diversity of organisations, women's groups were becoming a significant force in working-class areas.

KLEAR (Kilbarrack Local Education for Adult Renewal), founded in 1982 by Angela Mulligan, Carmel Jennings and Úna McCabe, was one of the first of these groups to make their mark. It pioneered an innovative model of woman-centred community education.

By the mid-1980s and 1990s community-based women's groups had taken many forms both outside and within the cities and included small local groups, women's networks, women's projects and women's forums. Some were issue-based concerned with women's health, Traveller concerns, lone parents, lesbian rights, creative arts and the environment. Comprising over 2,500 organisations by the year 2000, these groups had become an important component of the women's movement.

Former president Mary Robinson understood their significance in rural and urban Ireland. During her presidential campaign, she pointed to their decentralised style of organising and their potential to be transformative at local neighbourhood and parish levels.

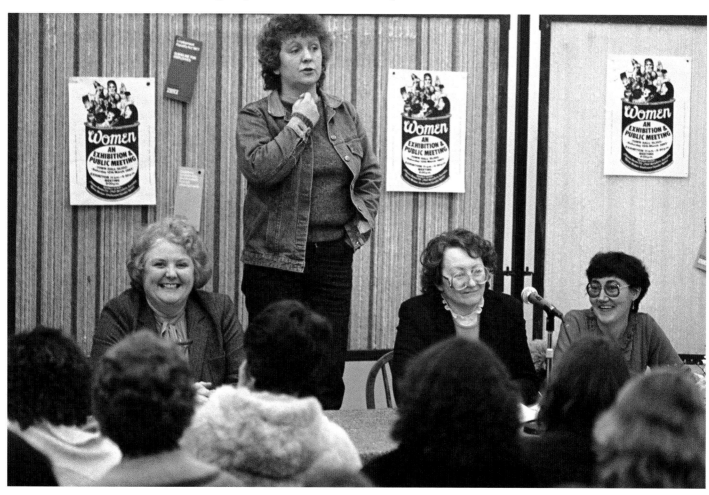

Monica Barnes (1936-2018), Nell McCafferty, Sylvia Meehan (1929-2018) and Anne Gilmartin who died in April 2019, taking part in the public meeting that launched Sligo Women's Group during International Women's Day Celebrations on March 12th, 1983. Photo by Derek Speirs.

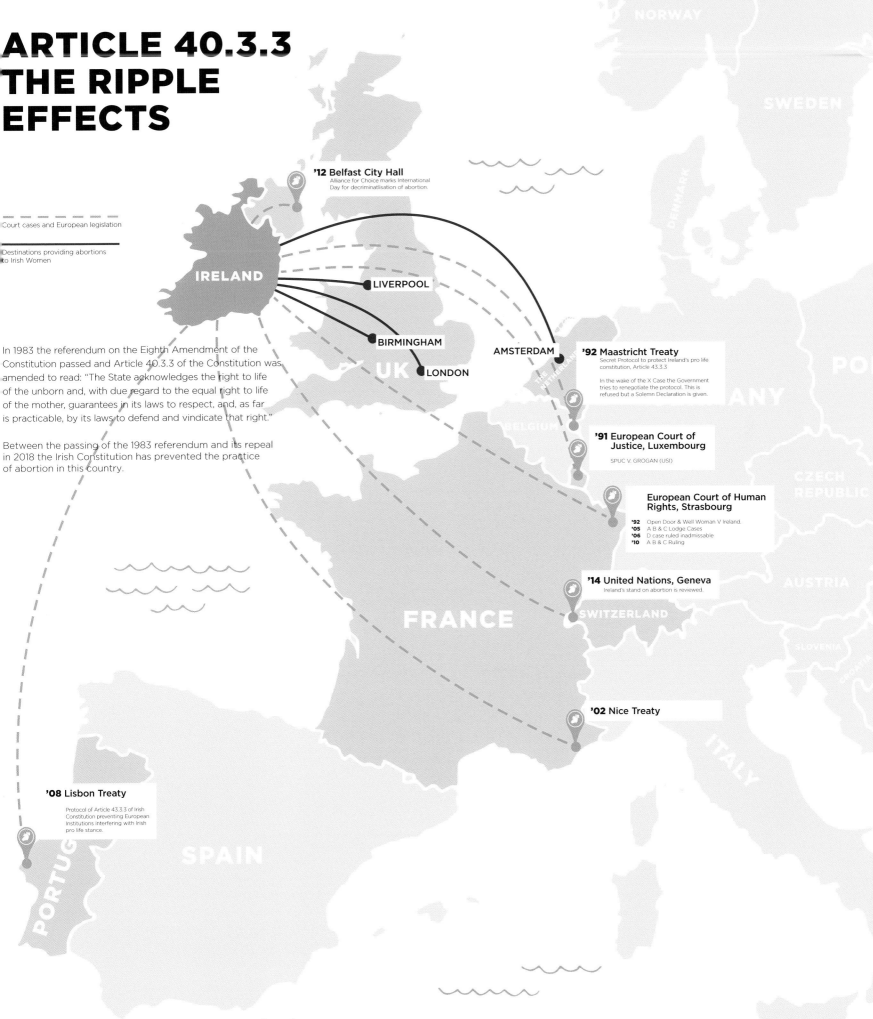

ARTICLE 40.3.3
THE RIPPLE
EFFECTS

Court cases and European legislation

Destinations providing abortions to Irish Women

In 1983 the referendum on the Eighth Amendment of the Constitution passed and Article 40.3.3 of the Constitution was amended to read: "The State acknowledges the right to life of the unborn and, with due regard to the equal right to life of the mother, guarantees in its laws to respect, and, as far is practicable, by its laws to defend and vindicate that right."

Between the passing of the 1983 referendum and its repeal in 2018 the Irish Constitution has prevented the practice of abortion in this country.

'12 Belfast City Hall
Alliance for Choice marks International Day for decriminatlisation of abortion.

IRELAND

LIVERPOOL

BIRMINGHAM

AMSTERDAM

UK

LONDON

'92 Maastricht Treaty
Secret Protocol to protect Ireland's pro life constitution, Article 43.3.3

In the wake of the X Case the Government tries to renegotiate the protocol. This is refused but a Solemn Declaration is given.

'91 European Court of Justice, Luxembourg
SPUC V. GROGAN (USI)

European Court of Human Rights, Strasbourg
'92 Open Door & Well Woman V Ireland.
'05 A B & C Lodge Cases
'06 D case ruled inadmissable
'10 A B & C Ruling

'14 United Nations, Geneva
Ireland's stand on abortion is reviewed.

FRANCE

SWITZERLAND

'02 Nice Treaty

'08 Lisbon Treaty
Protocol of Article 43.3.3 of Irish Constitution preventing European Institutions interfering with Irish pro life stance.

SPAIN



FIGHTBACK – ON THE STREETS AND IN THE COURTS

Over 37,200 women and girls left Ireland and registered for abortions in England during the 1980s – 10 journeys daily. While they and their families privately bore the brunt of Article 40.3.3, it had hardly registered in the public consciousness. The gradual weakening of its grip was in evidence during the 1990s.

In November 1990 Mary Robinson was elected seventh President of Ireland, the first woman to hold the office. Friend to the fledgling Irish Women's Liberation Movement, the former senator had supported a wide range of social justice issues in the 1970s, chief among them contraception. Her early attempt to introduce the first bill to liberalise the law on contraception was thwarted in the Seanad by being denied a reading so that it could not be discussed. She was denounced from the pulpit for her efforts. Robinson's surprise election victory represented profound change – especially for women.

The European Court of Justice judgment in 1991 on Society for the Protection of the Unborn Child v Grogan ruled that abortion was a service, therefore no member state could stop agencies with a commercial link to foreign abortion clinics from advertising it – and by extension anyone travelling to obtain it. It was not entirely what the students wanted to hear (they earned a permanent injunction for their efforts), but their courage helped to establish abortion as a legally available service abroad.

Later that year, the Dublin Council of Trade Unions stated publicly that banning information was "a grave denial of basic democratic rights and causes enormous distress to women faced with a crisis unplanned pregnancy". It wanted the reopening of pregnancy counselling services in the State and called on the Irish Congress of Trade Unions to campaign for abortion access.

On February 12th, 1992, The Irish Times after considerable deliberation ran a short, page-one article on a 14-year-old, later known as X, who had been raped and made pregnant by a family acquaintance. A High Court injunction initiated by the attorney general had forced the girl and her parents to return from England where they had sought an abortion. The girl had told her mother she wanted to throw herself down a flight of stairs and had contemplated jumping under a train. The level of protest that erupted on the streets over the teenager's treatment was unprecedented and impossible to ignore. The injunction was appealed and on March 5th the Supreme Court provided a breakthrough moment by finding the real and substantial threat of suicide was grounds for an abortion in Ireland. The girl later miscarried.

A tragedy such as X had been forecast during the anti-amendment campaign of the early 1980s. The teenager became the exemplar of a harsh reality: only the physical, emotional and mental suffering of women, played out in court and circulated through the media, would help to dislodge Article 40.3.3.

In 1992, independent women's publisher Attic Press launched Choices in a Crisis Pregnancy by Noreen Byrne. It also published Ailbhe Smyth's groundbreaking collection of essays, The Abortion Papers Ireland (Dublin: Attic Press, 1992).

With June 18th, 1992, came a 69 per cent referendum victory for the Maastricht Treaty on the European Union. An attached protocol, secured by the Government and inserted quietly when it signed the treaty earlier in 1991-92, protected Ireland from any EU interference in the constitutional protection of the right to life of the unborn.

A more heartening outcome was the European Court of Human Rights judgment that helped copper fasten access to information. It found that Ruth Riddick's Open Door Counselling and the Well Woman Centre were entitled to dispense material freely available in another member state (The Society for the Protection of the Unborn Child v Open Door Counselling and the Well Woman Centre 1992). To do otherwise would pose a risk to women's lives.

The first legislation allowing sale of contraceptives was in 1979, but strictly limited to prescription only. This was fully liberalised with the Health (Family Planning) Amendment Act in 1992 and provision of contraceptives without prescription was allowed to a person of any age.

Facing page: A pro-choice rally held at the GPO, O'Connell Street, Dublin, on July 11th, 1994. Photo by Derek Speirs.

Taking their lead from the Irish Women's Liberation Movement, the Women's Coalition Group organised "Sistership". The event on May 6th, 1992 involved 150 women boarding the Dun Laoghaire ferry to Holyhead, Wales, to highlight the State's abortion ban.

On November 25th, 1992, citizens seized an opportunity to soften the Eighth's impact after three referendums. On a turnout of just over 68 per cent, they gave a comprehensive victory to the anti-amendment movement. Sixty-two per cent voted for the constitutional right to travel for an abortion abroad. Almost 60 per cent voted for access to and distribution of information. And over 65 per cent rejected the Government's attempt to further restrict the grounds for abortion by removing the risk of suicide. Now, at least in theory, when a pregnant woman's life was under threat she could seek a termination in Ireland. Women then spent decades trying to exercise that right through the courts.

The result showed the electorate had moved on and no longer viewed the "substantive issue" as a simple matter of for or against.

The erosion of another discrimination arrived with the Criminal Law (Sexual Offences) Act 1993 that decriminalised consensual gay sex.

In autumn 1993, a disturbing find at High Park convent in Drumcondra, Dublin, run by the Sisters of Our Lady of Charity of Refuge, revealed the unmarked graves of at least 133 Magdalene Laundry residents. These asylums were part of a Catholic network designed to intern and punish unmarried mothers, many of whom were themselves children. Discovery of the graves brought these practices to international attention sparking, a campaign that continues to this day.

The anti-D blood scandal erupted in 1994 when it was discovered that thousands of women had been infected after or during childbirth with contaminated blood – causing hepatitis C. The victims had to organise to get recognition and formed Positive Action. In 1977 the Hepatitis C Compensation Tribunal was set up and heard 4,000 claims. One who did not survive was the late Brigid McCole of Donegal, mother of 12 children and profoundly missed by her husband Brianie.

In 1995, abortion information was finally legalised albeit in restricted fashion. The Regulation of Information Act allowed doctors and others to answer questions on services outside the State. But this could be done only in a one-to-one counselling environment along with obligatory advice on parenting and adoption. Appointments or referrals for abortion were out of the question.

In the meantime, the IFPA produced publications that had begun a significant shift in thinking away from the "unborn" and from women as potential doers of harm to a foetus. Instead women were framed as autonomous rights holders who were themselves harmed by the denial of abortion.

The Catholic Church was the recipient of more bad news in 1996 when the Fifteenth Amendment of the Constitution of Ireland – otherwise known as divorce – was signed into law.

In Louth in 1998 the wickedness of an obstetrician came to light. Michael Neary had performed unnecessary surgeries on women while delivering their babies at Our Lady of Lourdes Hospital, Drogheda, then under the management of the Medical Missionaries of Mary.

The Northern Ireland peace process culminated in the signing of the Good Friday or Belfast Agreement in spring 1998. Voters across the island had secured the deal to end a 40-year conflict in two referendums, north and south, held that May.

Building on the Catholic Church's defeats on abortion and divorce, the late Mary Raftery (1958-2012) ramped up the pressure with her pioneering States of Fear TV series on RTÉ. She revealed how the organisation's religious orders treated vulnerable individuals in its care. Her work elicited an apology to victims from then Taoiseach Bertie Ahern and the appointment of the Commission to Inquire into Child Abuse (1999).

Responding to the implications of the X Case ruling, then Health Minister Brian Cowen had commissioned a Green Paper on Abortion. Published in August 1999, the discussion document explored Government options for dealing with the Supreme Court outcome of 1992. Among its many suggestions lay mention of another referendum.

During the boom of the mid 1990s Ireland had become a destination for displaced and asylum-seeking populations. The Government instituted a system in 1999 to provide accommodation for them that became known as Direct Provision. Under the terms of their entry asylum seekers, with few exceptions, were refused the right to travel – a denial of social and economic rights that became hugely problematic for women and girls with crisis pregnancies living in these centres.

In 1999 historian Jacqueline Morrissey wrote about the obstetric practice of symphysiotomy and put a new word into the vocabulary of protest. This was an operation during or after childbirth to cut the pelvic bone as an alternative to a Caesarean section. Symphysiotomy caused subsequent pain, incontinence and difficulties with giving birth. The 1,500 survivors formed a protest group – SOS Survivors of Symphysiotomy – and finally a tribunal was set up to make ex gratia payments to some of the women concerned. There was considerable disappointment when the Government published Judge Maureen Harding Clark's report, Surgical Symphysiotomy Ex Gratia Payments, on November 22nd, 2016. The report alleged that 30 per cent of applicants did not undergo symphysiotomy or did not claim any disability.

In 1999, trade union UNISON's leader Inez McCormack (1994-2013), herself a choice activist, became first woman president of the Irish Congress of Trade Unions. Women such as McCormack and Mary McAleese, who succeeded Mary Robinson as President of Ireland in 1997, were challenging the dominance of men in certain powerful arenas.

Meanwhile, throughout the 1990s, 48,346 women and girls gave Irish addresses in British abortion clinics – 13 each day.

Youth for Choice demonstrating on November 11th, 1992, for the right to information and travel, and to lift the ban on abortion. Photo by Derek Speirs. Press cutting from The Irish Times.

Magazine drops abortion piece for Irish issue

From Ella Shanahan, London Editor

THE publisher of *Company* magazine, the National Magazine Company Ltd, has withdrawn eight pages from its March issue to be circulated in the Republic because of court injunctions banning the dissemination of information, medical or otherwise, about abortion.

The injunctions do not apply to *Company* specifically, but lawyers advising the company have told the publishers to pull the eight-page supplement before some 6,000 copies of the magazine are sent to Ireland.

Company, which is aimed at women in their mid-twenties is distributed in the Republic by Easons, News Brothers, of Cork, and Newspread, and in Derry by John Menzies, the British company, all of which have advised the company about the legal situation in the Republic.

Next month's issue, which goes on sale today, will be distributed in the Republic minus the "offending" pages, but with a note inside the cover explaining this.

However, advertisements for abortion advice and clinics still appear in this magazine, unlike *Cosmopolitan*, which now carries blank spaces in its classified advertisements columns where the outlawed advertisements would have appeared.

Ms Jo Thomas, a spokeswoman for *Company*, said yesterday that the supplement did not advocate abortion or give anything other than the medical facts. There were a few case histories, both of women who did not have abortions and of those who did, and the situation in several countries was detailed. There were pictures of foetuses from six to 24 weeks, and there was a page dealing with the "abortion pill".

Ms Thomas said the Irish wholesalers of *Company* could not accept the magazine as it was in Britain because they believed they were breaking the law. The magazine's legal advisers were London-based.

Irish Times 6·2·90

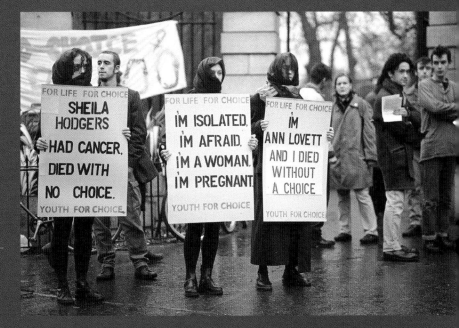

DEFENDING THE CLINICS

IFPA fined for selling condoms at Virgin Record Store

In May 1990, the IFPA was convicted by the District Court of selling condoms without a licence in the Virgin Record Store. A fine of £400 was imposed. Richard Branson flew in to defend the clinic. On appeal the fine was increased to £500 and U2 stepped in to pay it on behalf of the association.

Open Door and Well Woman v Ireland 1992

The European Court of Human Rights ruled that Ireland violated Article 10 of the European Convention on Human Rights guaranteeing freedom of expression. The court found that the injunction against the clinics from receiving or imparting information on abortion services legally available in other countries was disproportionate and created a risk to the health of women seeking abortions outside the State.

This 30-page pamphlet was published in May 1992 by the Cork Abortion Information Campaign.

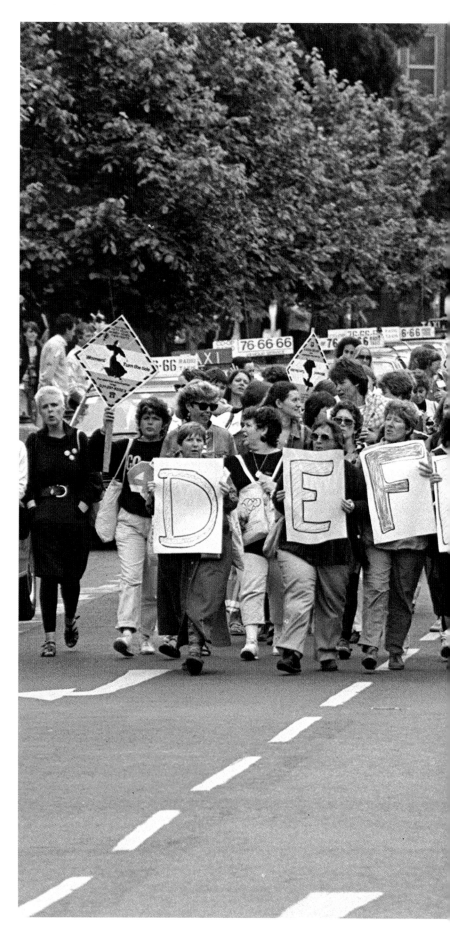

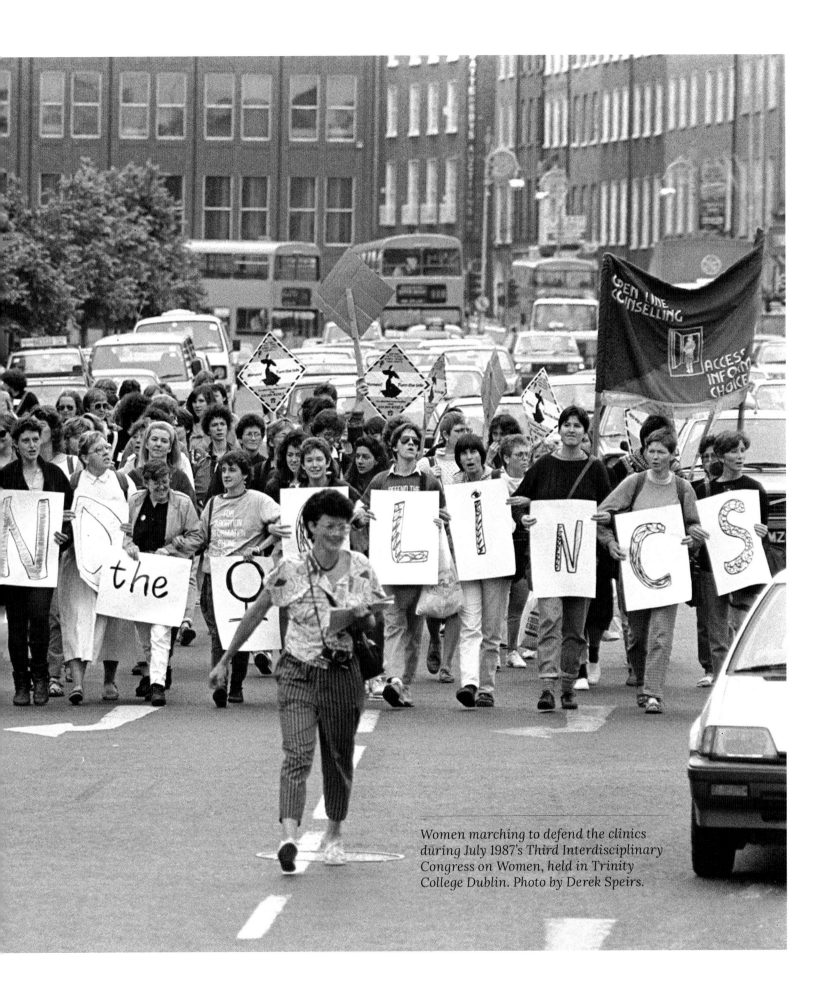

Women marching to defend the clinics during July 1987's Third Interdisciplinary Congress on Women, held in Trinity College Dublin. Photo by Derek Speirs.

SPUC v GROGAN

On the request of the High Court in relation to the 1989 case to prevent student groups distributing information on abortion services in the UK, the European Court of Justice ruled in the case of SPUC v Grogan that abortion could constitute a service under the Treaty of Rome (Treaty of the European Economic Community) and therefore a member state could not further prohibit the distribution of information by agencies having a commercial relationship with foreign abortion clinics.

However, the court ruled that since the student groups had no direct links with abortion services outside of Ireland, they could not claim protection under European Community Law.

USI president Stephen Grogan, addressing a meeting in 1990. Photo courtesy of Stephen Grogan.

THE STUDENT DEFENCE FUND

c/o TCD SU, Mandela House, No 6, TCD, Dublin 2. Tel 776545.

SPONSORS

Dear

Since 1986 SPUC through legal action have closed Open Line Counselling and censored the Well Woman Centre denying women access to non-directive pregnancy counselling.

SPUC's attempts to censor information on abortion has had little if any effect on the number of women travelling to Britain for abortions, approx. 4,000 women a year continue to take this option. The lack of proper counselling and information has only increased the trauma and stress for these women.

As part of the campaign to defend the women's right to information U.S.I., Trinity College Dublin, Students' Union and U.C.D. Students' Union continued to make information on all options available to their members and also to other women who had difficulty obtaining this information elsewhere. This resulted in a continuation of SPUC'S witch hunt through the Court Cases of 1988/89.

The case itself has been referred to the European Court of justice and a judgement is expected in July or August. The students involved however, are faced with Court costs of £30,000, for which they are personally liable.

A series of events have been planned for mid-May (see flyer) to raise money for these Court costs and to publicise the issue itself.

Any support, publicity, involvement or ideas would be greatly appreciated, particularly attendance at the Concert and participation in the fun run/walk. In order for the fun run/walk to be a success it is vital to organise sponsorship cards. If you could undertake to distribute sponsorship cards, please contact the Student Defence Fund as soon as possible.

Support the Student Defence Fund !
Defend the Women's Right to Information !

We look forward to a favourable response and your support.

Yours sincerely,

Martina Murray. Eamon O Mordha.

SPONSORS

AIDS Action
Alliance
Brian Anderson
Mavis Arnold
Louise Asmal
Kader Asmal
Robert Ballagh
Monica Barnes TD
Belfast R.C.C.
Tony Benn MP
Bernard Browne
Dr. Noel Browne
Cllr. Jane
Dillon Byrne
Cllr. Eric Byrne TD
Clodagh Corcoran
Dr. Mary Cullen
(Maynooth)
Nuala Fennell TD
Eamonn Gilmore TD
Dr. Mary Henry
Michael D. Higgins TD
Cathy Honan
(PD Spokesperson on Women's Rights)
Prof. D. O'B
Hourihan (TCD)
Gemma Hussey
IUS
Jim Kemmy T
Labour Youth
Dr. Jim Loughran
Bernadette McAliskey
Vincent McCabe
Nell McCafferty
Eamon McCann
Catherine McGuinness
Sylvia Meehan
NCS
Nat. Gas Federation
Sen. David Norris
Northern Ireland
Women's Rights
Movement
Dr. Conor Cruise
O'Brien
Marr O'Brien (DAG)
May O'Brien
Nuala O'Faolain
Eoin O'Murchu (CPI)
Michael O'Reilly
Hilary Pratt
Ruairi Quinn TD
Ruth Riddick
Sen. Shane Ross
Clare Short MP
Annie Speed
Emmett Stagg TD
1-41
Dr. A. Watts
Women's Information
Network
Workers Party Youth
Young Fine Gael

ABORTION PLEA

STUDENT leaders last night begged the Government to pay the legal costs they have incurred to provide abortion information.

The Union of Students in Ireland now face a bill of more than £28,000 incurred since a court case with the Society for the Protection of the Unborn Child in 1989.

SPUC took the national union to court to try to stop them from providing information on abortion and referral to agencies in Britain.

Students billed over SPUC case

The Union of Students in Ireland (USI) and the students' unions in TCD and UCD have received a bill of more than £6,000 from the receiver appointed to collect legal costs on behalf of the Society for the Protection of Unborn Children (SPUC). The legal costs, which amounted to £39,000, were incurred in the *SPUC v Grogan* abortion information case.

The president of USI, Ms Helen O'Sullivan, said last night that the three unions would consider appealing against the amount.

Student Welfare Officer Pregnancy Counselling –
Held on Saturday 28th September 1991 at the Young Traveller
Parnell Square, Dublin. 11 am to 5.30 pm
-***

11.00 <u>Introduction</u>: History and Policy of Women's Information Network
 by two members of the W.I.N. who were present to
 guide Student welfare Officers through the day's
 programme.

 (Refer W.I.N. Media Policy for details)

11.10 <u>Name Game</u>: Questions – 1. What Do You Like About Yourself
 2. A Person You Admire
 3. What are your Expectations for the day
 4. Why are you interested in giving
 Pregnancy Counselling

 Outcome: Opportunity for participants to meet one another and
 discuss their expectations for the day and why they
 were interested in giving pregnancy counselling.

 Participants expressed their wish to improve counselling
 skills and confidence to reassure people of their right
 to information/women's right to choose.

11.30 <u>Hopes & Expectations</u> for the day –
 <u>Fears & Difficulties</u> about this kind of work –

 Hopes:
 * Skillful enough to give non-judgemental, non directive support.
 * To be able to distance yourself.
 * Clearer about own feelings,
 * Confidence to reassure people of their right to information.

 Fears:
 * Coping with distress calls
 * Male callers (Refer to Notes on Male Callers)
 * Calls from Parents (Refer to Notes on Calls from Parents)
 * Danger associated with legal situation
 * How to make our service known whilst coping with hostile forces.
 * Pre and Post counselling

Telephone: 693244 & Exts:
President – 7342 or 691897
General Office – 7328 or 691897
Education Office – 7300
Welfare Office – 7369
Social & Cultural Office – 7299

STUDENTS' UNION

University College Dublin

TEMPORARY UNION CENTRE
BELFIELD
DUBLIN 4.

STRICT EMBARGO UNTIL 11.00AM TUESDAY JULY 5TH

NOTICE OF PRESS CONFERENCE

UCD STUDENTS TO FIGHT SPUC ACTION

On Friday, July 1st, UCD Students Unions Sabbatical Officers received a letter
from SPUC's Solicitors announcing their intention to initiate legal
proceedings against the officers if the Union continued with publication
of their Welfare Manual. The Welfare Manual contains information
on abortion referral and as such is in contravention of the recent
Supreme Court decision taken against the Clinics. The Students Union
Officers intend to continue publication of the Welfare Manual, as
they are under a mandate from their members to do so.

A full Press Conference will be held at Buswells Hotel at 11.00am
on Tuesday July 5 in the Kildare Room.

For Further details contact Keren Quinlivan – 786366 – Monday

THE X CASE

THE IRISH TIMES

Sweeping Cabinet changes risk prolonging FF rifts

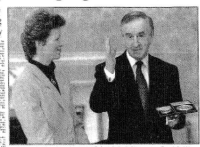

The article by Irish Times reporter Niall Kiely breaking details of the X Case on February 12th, 1992.

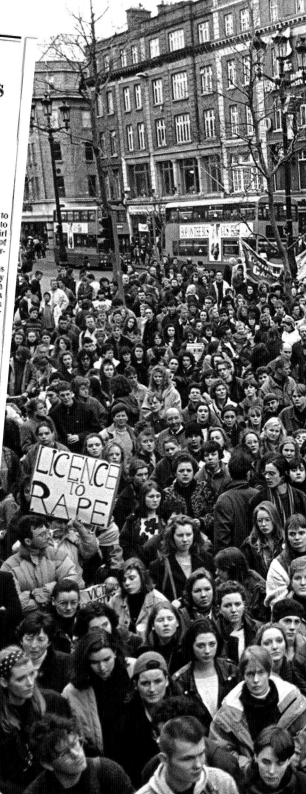

State attempts to stop girl's abortion

By Niall Kiely

THE State is understood to be engaged in a legal action to prevent a 14-year-old Irish girl who is allegedly the victim of a rape from having an abortion in Britain.

An interim injunction was granted to the Attorney General following a High Court hearing held in camera late last week. This injunction restricted the teenager or her parents from procuring a termination of her pregnancy in the UK.

It is believed that by the time the order was served, the girl and one or both of her parents were already in Britain, but that they returned home without having the abortion performed.

It is further understood that counsel for the Attorney General, acting on the basis of the Constitution's right-to-life provision, then sought an interlocutory restraining order during High Court proceedings held in camera on Monday and yesterday. Judgment was reserved until later this week or early next week.

The case arose, it is understood, because the girl's parents sought Garda advice on whether to have the foetus tissue-tested for DNA or other genetic evidence which might be useful in any subsequent criminal proceedings.

The Gardai, in turn, sought State guidance on the feasibility or applicability of any such action. The attention of the Attorney General's office was thus drawn to the matter.

17th FEBRUARY 1992. ..the introduction of internment in Ireland...........for 14 year old girls....

Illustration by Martin Turner, courtesy of The Irish Times

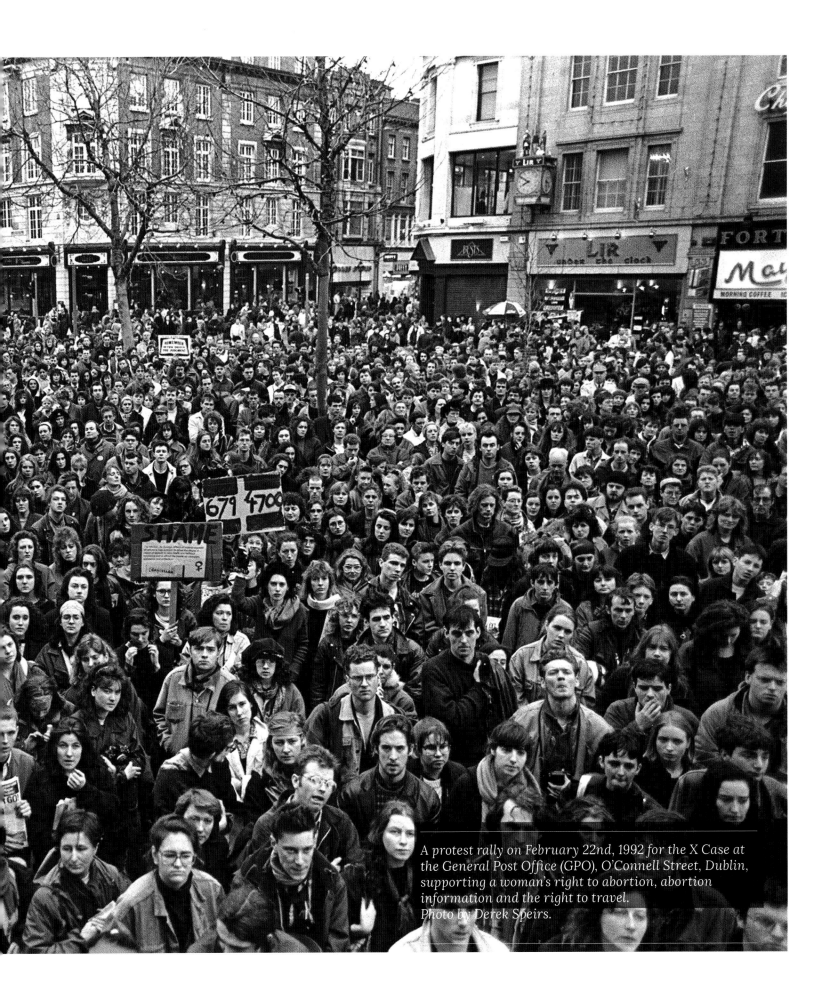

A protest rally on February 22nd, 1992 for the X Case at the General Post Office (GPO), O'Connell Street, Dublin, supporting a woman's right to abortion, abortion information and the right to travel.
Photo by Derek Speirs.

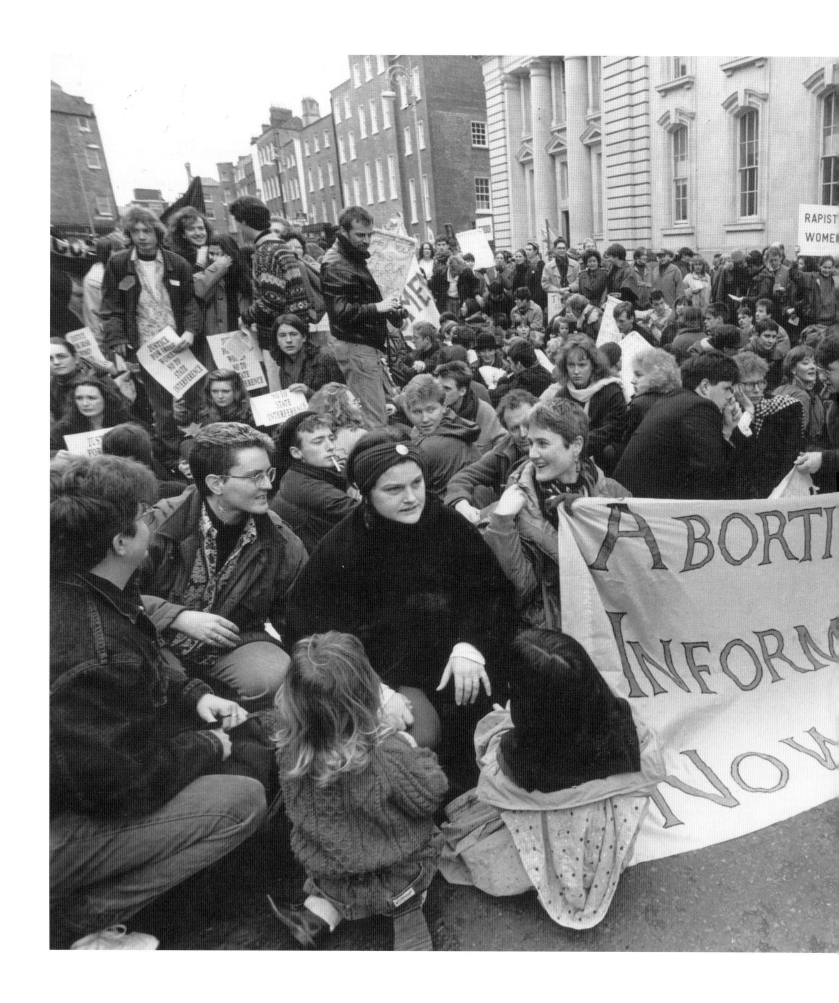

Road to Repeal

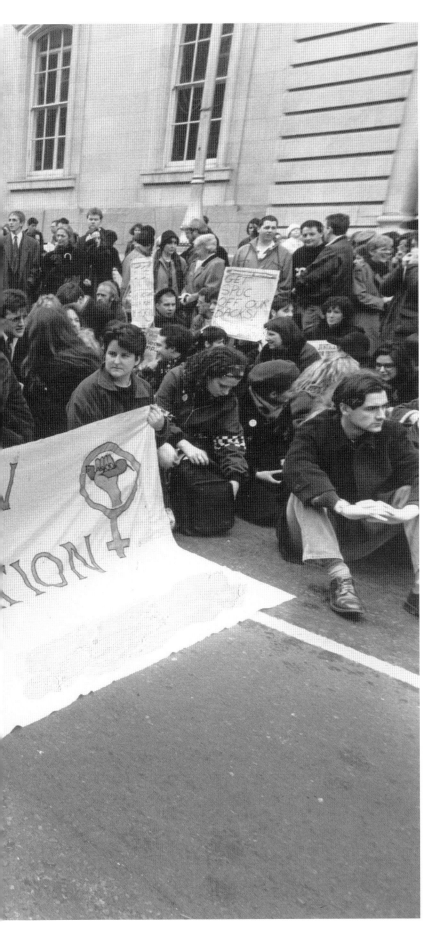

The original caption to this censored Irish Times photo in February 1992 was as follows: "A demonstration yesterday outside Government Buildings against the High Court injunction forbidding a 14-year-old alleged rape victim from obtaining an abortion in Britain. The banner includes a telephone number which has been deleted by The Irish Times in compliance with the High Court ruling of December 1986, which found that the provision of assistance, including information, to a pregnant woman seeking an abortion was in breach of Article 40 of the Constitution. This judgment was upheld by the Supreme Court in February 1988." Photo courtesy of The Irish Times.

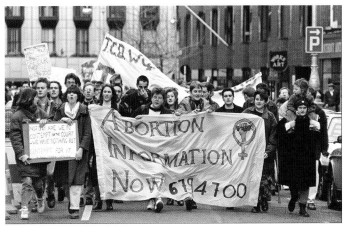

Above: The banner with the Women's Information Network phone number intact. Photo by Derek Speirs.

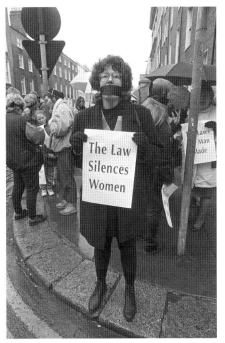

Playwright Melissa Murray.
Photo courtesy of The Irish Times

SISTERSHIP
PROTEST

Journalists Nell McCafferty and June Levine (1931-2008), author of Sisters - The Personal Story of an Irish Feminist, with writer and historian Máirín Johnston, protesting at Dun Laoghaire ferry port on May 6th, 1992, in support of a woman's right to abortion and abortion information. Photo by Derek Speirs.

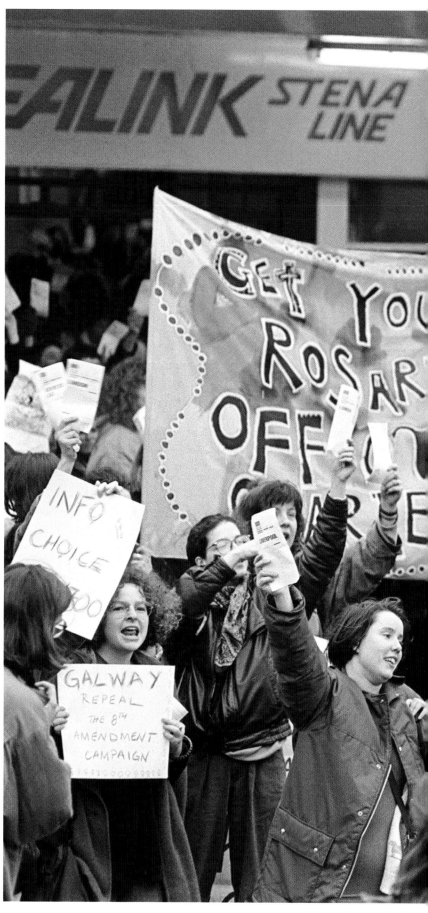

Cutting from the
Evening Press.

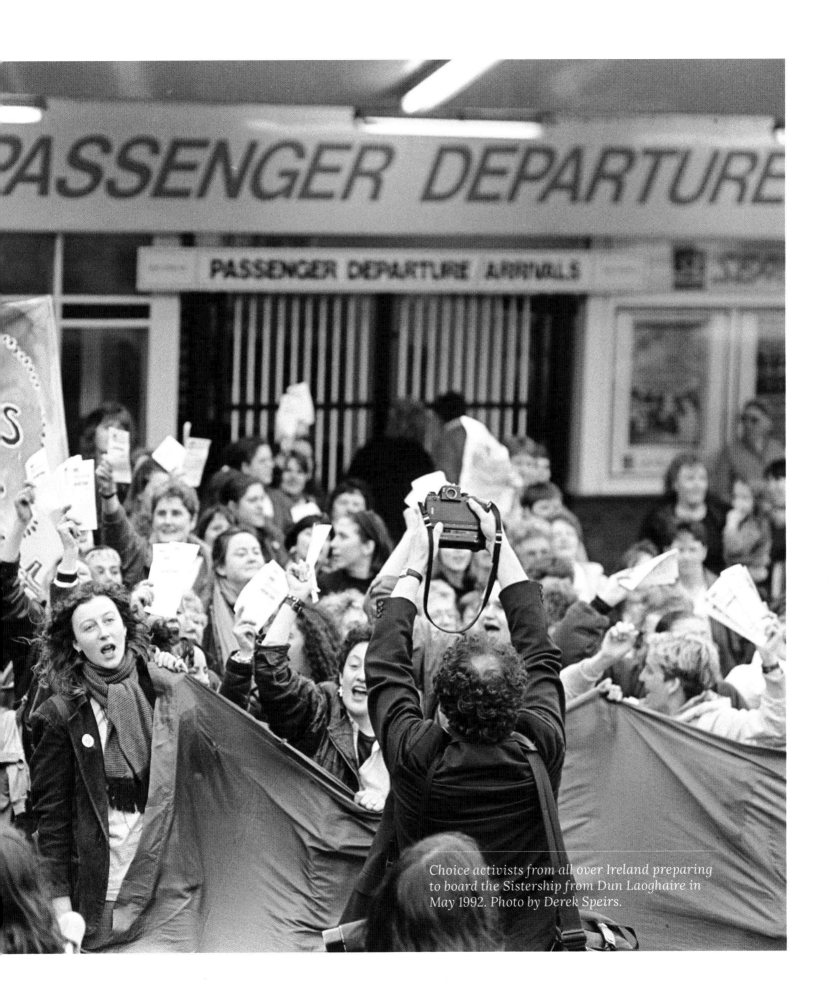

PASSENGER DEPARTURE

PASSENGER DEPARTURE ARRIVALS

Choice activists from all over Ireland preparing to board the Sistership from Dun Laoghaire in May 1992. Photo by Derek Speirs.

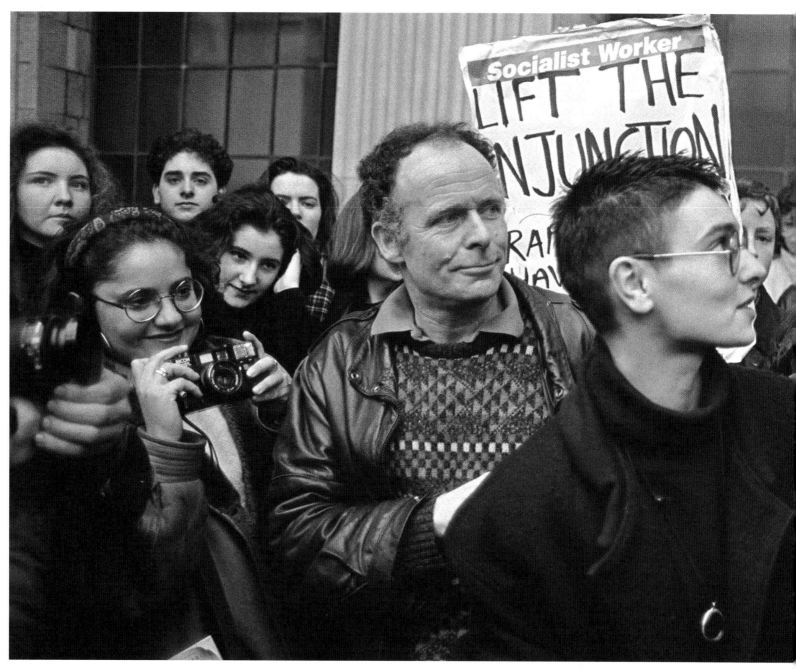

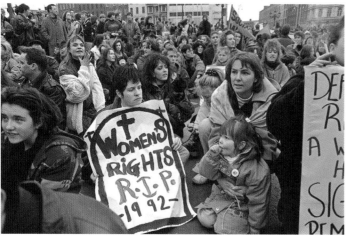

Journalist and abortion rights activist Eamonn McCann, left, with singer songwriter Sinead O'Connor at the GPO, O'Connell Street, Dublin on February 22nd, 1992, supporting a woman's right to abortion, travel and abortion information. Photos by Derek Speirs.

Road to Repeal

12TH, 13TH & 14TH AMENDMENTS

As a result of the Supreme Court Ruling on the X Case and popular outrage, the Government put forward three possible amendments to the Constitution via referendum on November 25th, 1992.

12th: To roll back the X Case judgment in order to remove suicide as a grounds for abortion in Ireland.

13th: The freedom to travel outside the State for an abortion.

14th: The freedom to obtain or make available information on abortion services outside the State, subject to conditions.

Strasbourg to debate Irish policy on abortion

By Tim Coone in Dublin and Andrew Hill in Brussels

THE European Parliament will press ahead with a debate on Ireland's abortion policy today, despite the Irish Supreme Court's decision yesterday to overturn a High Court ruling preventing a 14-year-old rape victim from terminating her pregnancy in Britain.

The parliament's legal affairs committee will debate the issue on the grounds that it has raised important issues of principle for the European Community.

Mr Willi Rothley, the German socialist MEP who called for the debate last week, said that the supreme court's decision was "only an individual solution".

Mr Geoffrey Hoon, the British Labour MEP and a member of the committee, added: "I hope the court has decided the case on the principle that it cannot interfere with the right of Irish citizens to travel freely to other parts of the Community".

Mr Gerhard Schmid, a German socialist MEP, was emphatic. "We must redefine conditions for EC membership. I propose that only states which have experienced the Age of Enlightenment could be members of the Community. I doubt whether, in fact, Ireland can stay in the Community".

Ireland's Supreme Court registrar said the injunction against the girl had been set aside but the legal reasoning would not be given for several days, leaving open the possibility that the controversy may be far from over.

The decision was cautiously welcomed by Irish politicians.

The government is paying the estimated £50,000 cost of the family's appeal and Mr Albert Reynolds, the Prime Minister, said last night that the decision "may have other implications and I want to examine the judgment in detail before commenting on it. But if the appeal has been allowed, then this case is now out of the way."

COUNSELLING AND INFORMATION REFERENDUM

THE TRUTH

ABORTION information is now legal in Ireland.

Rathmines College recently voted by over 90% to provide abortion information.

■ Student Union officers receive basic training in pregnancy counselling from qualified professionals

■ If the referendum is passed, women requiring counselling will be referred to the Irish Family Planning Association, which is a nationally recognised and respected organisation. There women will receive professional counselling on all pregnancy options.

■ Anti-abortion groups claim that women suffer long-term psychological and physical problems after abortions. We accept that some women can experience problems if they don't get full counselling. The way to deal with this, however, is not to refuse to provide women with information and counselling, but rather to provide more.

VOTE **YES**

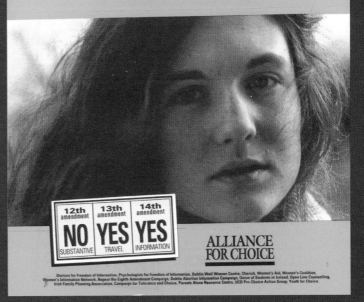

She's fourteen, raped and pregnant. Go on, tell her to kill herself.

12th amendment	13th amendment	14th amendment
NO SUBSTANTIVE	**YES** TRAVEL	**YES** INFORMATION

ALLIANCE FOR CHOICE

Doctors for Freedom of Information, Psychologists for Freedom of Information, Dublin Well Woman Centre, Cherish, Women's Aid, Women's Coalition, Women's Information Network, Repeal the Eighth Amendment Campaign, Dublin Abortion Information Campaign, Union of Students in Ireland, Open Line Counselling, Irish Family Planning Association, Campaign for Tolerance and Choice, Parents Alone Resource Centre, UCD Pro-Choice Action Group, Youth for Choice.

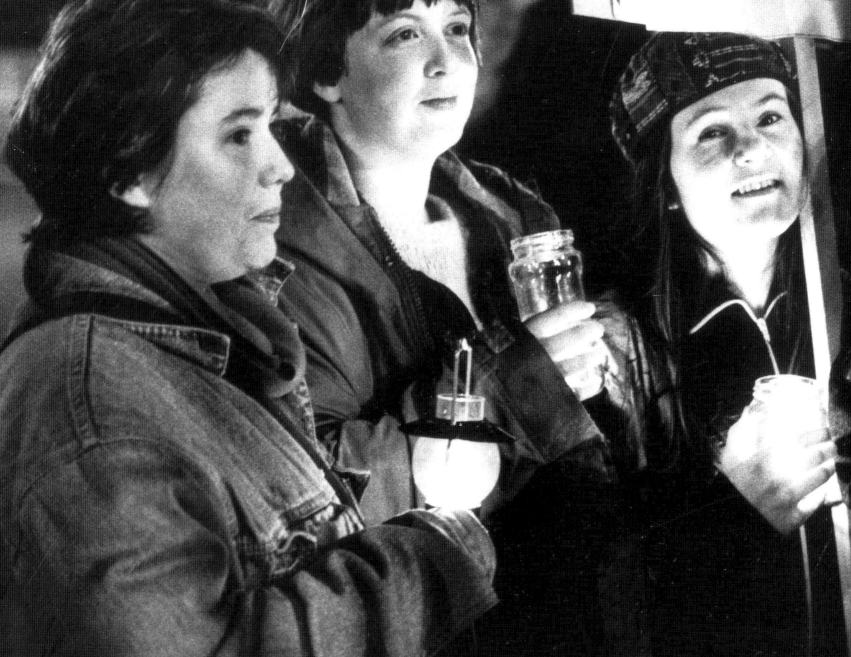

Student protesters taking part in a 1995 candlelight event outside the Dáil to highlight Government inaction on provision of abortion information. Photo courtesy of The Irish Times

REGULATION OF INFORMATION ACT

Regulation of Information (Services outside the State for the Termination of Pregnancies) Act 1995 allowed doctors, advisory agencies and individual counsellors to supply information on abortion services abroad if a woman wanted that. But this had to be accompanied by data on parenting and adopting – and the only context in which the exchange could take place was one-to-one counselling. Service providers (including doctors) could not make appointments for clients wanting terminations abroad.

Above: Five founder members of the Irish Family Planning Association – Michael Solomons, Yvonne Tim, Robert Towers, Joan Wilson, Máire Mullarney at the tenth anniversary celebrations in Tara Towers hotel, Dublin on October 11th, 1979. Photo by Derek Speirs.

PRO LIFE?
THE IRISH QUESTION

MICHAEL SOLOMONS

Victoria White talks to the distinguished obstetrician and gynaecologist, Dr Michael Solomons, whose memoirs will be published next week.

The wisdom of Solomons

I WANTED to let the present generation know about a past of which they're unlikely to be aware," says Michael Solomons, the distinguished obstetrician and gynaecologist, whose personal account of nearly 50 years of Irish obstetrical practice, *Pro-Life? The Irish Question*, is published next Tuesday by Lilliput Press. "It's that past that's the background to what's happening about abortion today.

"It's a terrible thing for the Catholic Church to say that every sex act must be open to conception. They preach that 'Every child must be welcomed'," says Dr Solomons, landing an imaginary spit on the ground. "Every child must be *wanted* and welcomed."

The late 1930s and '40s, when he was a medical student and young doctor, saw the reign of the "grand multiparas", a term coined in Dublin for women who had had seven or more pregnancies. When he was working as assistant Master of the Rotunda Hospital, he saw a 26-year-old woman on her sixth pregnancy go blind, only to return pregnant again the following year. In three years in the late '40s, 23 women and 800 babies died in the hospital.

Continual child-bearing often had horrible consequences for women's health. They could die of anaemia for lack of a blood transfusion — the National Blood Transfusion Service was not operational until 1948. The uterus could become stretched so that the baby was in the wrong position at birth. Often the afterbirth would lie in front of the baby, blocking its exit from the womb.

Women might haemorrhage after birth as the uterus would be so floppy as to fail to contract. High blood pressure and eclampsia (convulsions) were potential killers. But the laws of Church and State prevented many women taking any effective steps to prevent pregnancy.

"For them," writes Dr Solomons, "pregnancy was to be a death sentence." As no mechanical method of preventing conception was available, writes Solomons, people improvised. A colleague attended the birth of a baby who was born with the top of a Guinness bottle on his head. The mother had hoped it would act as a contraceptive.

It is worth stressing, as he points out, that this savage state of affairs would still exist if the wishes of fundamentalist Catholics — some of whom are still with us — had been fully respected. But there were some who were willing to swim against the tide on the contraceptive issue. When as assistant gynaecologist at Mercer's Hospital, Dr Solomons began advising public patients on contraception with the support of the International Planned Parenthood Federation, it was to his knowledge the first time Irish public patients had access to contraceptive advice.

In 1963 Michael Solomons broke into print with *Life Cycle*, which contained no contraceptive advice, but was the first Irish sex education book ever. But real cracks didn't start to form in the walls of secrecy until 1968 when he was called by GPs James Loughran and Joan Wilson to a meeting in Buswell's Hotel which led to the establishment of Ireland's first family planning clinic, the beginnings of the Irish Family Planning Association.

The frontline troops included Yvonne Pim, who with Joan Wilson had been giving sex education talks in Dublin's Protestant secondary schools — they became known as "the sex ladies". Other participants included Robert Towers, editor of *The Irish Medical Times* and pathologist Dermot Hourihane, who were Catholics, as was Maire Mullarney, the mother of 11 who had experienced a conversion to family planning while visiting a clinic in Portugal.

Taking the advice of senior counsel Noel Peart, they navigated the twists and turns of Irish law to set up their clinic — just as nowadays the IFPA has managed to set up its non-directive counselling service. The Fertility Guidance Company Ltd opened its doors, with the help of a grant from the IPPF, even though it could not advertise, and could not sell contraceptives.

The only contraceptive legally available was the pill, but there were discreetly packaged mailorders and "contraceptive couriers", friends and relations of the clinic staff who smuggled condoms, spermicides and diaphragms into the country — Dr Solomons's mother and mother-in-law, women in their late seventies, played their part. The clinic was never without supplies for long, and in an emergency Maclean's children's toothpaste was used as a spermicide.

In 1983 Michael Solomons found himself removing his glasses to receive a punch at a meeting of the Institute of Obstetricians and Gynaecologists called to discuss the implications of the proposed constitutional Amendment to outlaw abortion here. The amendment movement began, he says, with the Catholic doctors getting together, and when asked why he answers: "With the ability to control their fertility, women came out of the house, and many men didn't like losing their authority."

Dr Solomons was deeply unhappy about the first antiabortion Amendment and very worried by the wording. In Roget's Thesaurus, "unborn" is considered synonymous with "uncreated", "unconceived" and "in the womb of time": it is thus not impossible that it could be used to outlaw contraception. He worried about the lives of women in life-threatening situations, and feared that vigilantism could become rampant in Irish hospitals.

He accepts that there are allowable social reasons for a woman to have an abortion, but does not support abortion on demand. He thinks the British agencies are too relaxed in their idea of what constitutes an indication. "The counselling is positive," he says, "but the numbers would be much less in the kind of abortion provision I could envisage." He agrees, however, that it would be exceptionally difficult to judge who should or should not have an abortion: "I'm not God. My thoughts and conscience are completely opposite to other people's. To set oneself up as a dictator is mad."

Michael Solomons is from one of the oldest continuous lines of Jews in Ireland, who came over from England in 1824; his grandfather Maurice is mentioned in *Ulysses*, his father Bethel in *Finnegans Wake*. Bethel Solomons was the famous Master of the Rotunda who strongly supported the Republican side in 1916. Stunning looking and theatrical, he wore a stetson hat and a black velvet tie.

Michael Solomons, who retired from practice in 1988, is a liberal, rather than an Orthodox Jew, yet he agrees that his Church's teaching has had a big effect on him: on abortion, Jewish opinion would be in favour of any action to save the life of a pregnant woman and although male methods of contraception are banned, Solomons says "There isn't the *persuasion* that there is in Catholicism." He wants to make clear however that his Jewishness is not relevant here: "I'm speaking in this book as a doctor, and from medical experience.

He feels that the proposed wording for the December referendums are a step in the right direction, because they may ensure travel and information, and prioritise the life of the mother in life-threatening situations — although this is of course contentious.

But he is worried about the exclusion of suicidal tendencies as an indication for abortion, having seen, no doubt, what a trauma unwanted pregnancy can be for a woman. "Without truth and reasoned debate 1992 is going to be a repetition of 1983," he says wearily. "I do not plan to get involved this time."

Pro-Life? The Irish Question, by Dr Michael Solomons, is published next Tuesday by Lilliput Press. Price, £3.95.

Dr Michael Solomons: "I'm not God . . . To set oneself up as a dictator is mad." Photograph: Joe St Leger.

Dublin-based gynaecologist Dr Michael Solomons (1919-2007), seen in The Irish Times press cutting above, was author of the book Pro Life? The Irish Question, published in 1992 by Lilliput Press. Solomons was a pioneer of family planning and a vigorous campaigner to prevent the insertion of the Eighth Amendment into the Constitution. He was instrumental in setting up the Irish Family Planning Association, which marked its 50th anniversary in 2019.

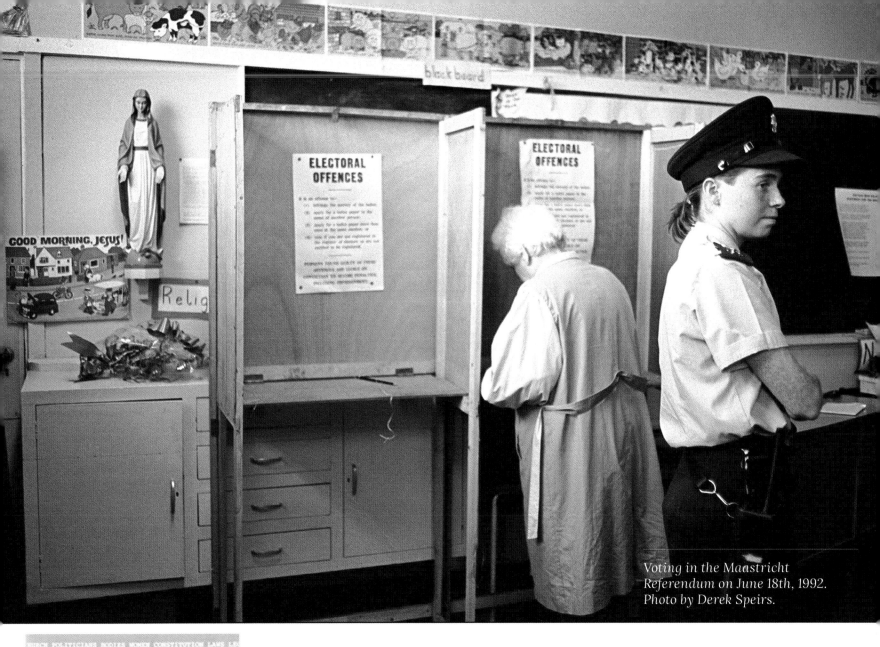

Voting in the Maastricht Referendum on June 18th, 1992. Photo by Derek Speirs.

In 1992, women's publisher Attic Press launched Choices in a Crisis Pregnancy by Noreen Byrne. It also published Ailbhe Smyth's groundbreaking collection of essays, The Abortion Papers Ireland (Dublin: Attic Press, 1992). The sequel, Abortion Papers Vol 2, edited by Aideen Quilty, Sinead Kennedy and Catherine Conlon et al followed in 2015 (Cork: Cork University Press, 2015).

MISS C

In 1997 the Eastern Health Board took a 13-year-old girl into its care. She was pregnant and wanted a termination. The District Court permitted the health board to take the teenager abroad for that medical treatment. Her parents challenged the order in the High Court – A and B v Eastern Health Board. As the girl was suicidal and likely to take her own life if forced to continue the pregnancy both District Court judge Mary Fahy and the High Court's Hugh Geoghegan considered Miss C entitled to an abortion in Ireland under the Supreme Court X Case ruling.

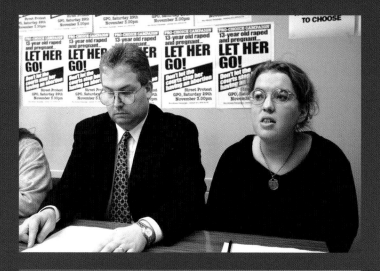

Pictured at a C Case press conference in Dublin on November 28th, 1997 are choice activist and academic Dr Sinéad Kennedy and then IFPA chief executive and longtime choice activist Tony O'Brien. Photo by Derek Speirs.

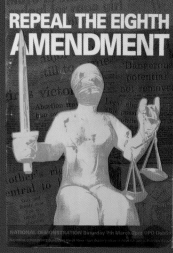

PRO-CHOICE CAMPAIGN
13-years old, raped and pregnant
LET HER GO
Don't let the courts stop her having an abortion

A 13 year old has been raped and is pregnant — yet the Irish courts are discussing if she has a right to travel to Britain for an abortion.

This debate is outrageous. If the girl had come from wealthy family, she could have gone to Britain quietly and there would have been no media attention.

It is because she is poor and dependent on the state because of her circumstances, that she is being denied here rights.

No judge, politician or Bishop has a right to tell this girl or anyone else that she must be a mother because of *their* morality.

It is time to end the hypocrisy that is going on here,. Each year 5,000 Irish women travel to Britain to have an abortion. They have made that decision themselves despite the countless words of condemnation.

The real issue is why are Irish women being forced to travel? Why should we be forced to raise £300-£400 to pay for travel and accommodation just to suit other people's hypocrisy.

Twenty years ago women had to travel to Belfast and Britain to get the pill. Hypocritical politicians knew then that women wanted to control their bodies — but they did not want the pill sold in Irish shops and chemists.

It is the same today. Everyone must know someone who has had or has at least thought of having an abortion. But again the politicians want to export these problems to Britain.

Fanatical groups like Youth Defence have tried to set the agenda on this issue. Yet they don't represent most people. Thousands came on to the streets at the time of the X case in 1992 to defend the rights of a rape victim. Yet the Dail politicians have still not legislated abortion rights in Ireland.

The Pro-Choice Campaign has called a street protest outside the GPO on Saturday 29th November at 3pm to defend this girl's right to travel to Britain for an abortion. Get along and show your outrage at what is happening.

Protest GPO Saturday 29th November 3pm

Petitions, leaflets, posters and details contact the Pro-Choice Campaign on (01) 878 8170

THE REPEAL THE 8th AMENDMENT CAMPAIGN

Presents

MARY STOKES
ÉILÍSH MOORE & FRIENDS
+
DISCO

The Teachers' Club, Parnell Square, Dublin 1.

THURSDAY 20th August
at 8.30pm – till late

Tickets £5.00 Unwaged £2.00

REPEAL THE EIGHTH AMENDMENT

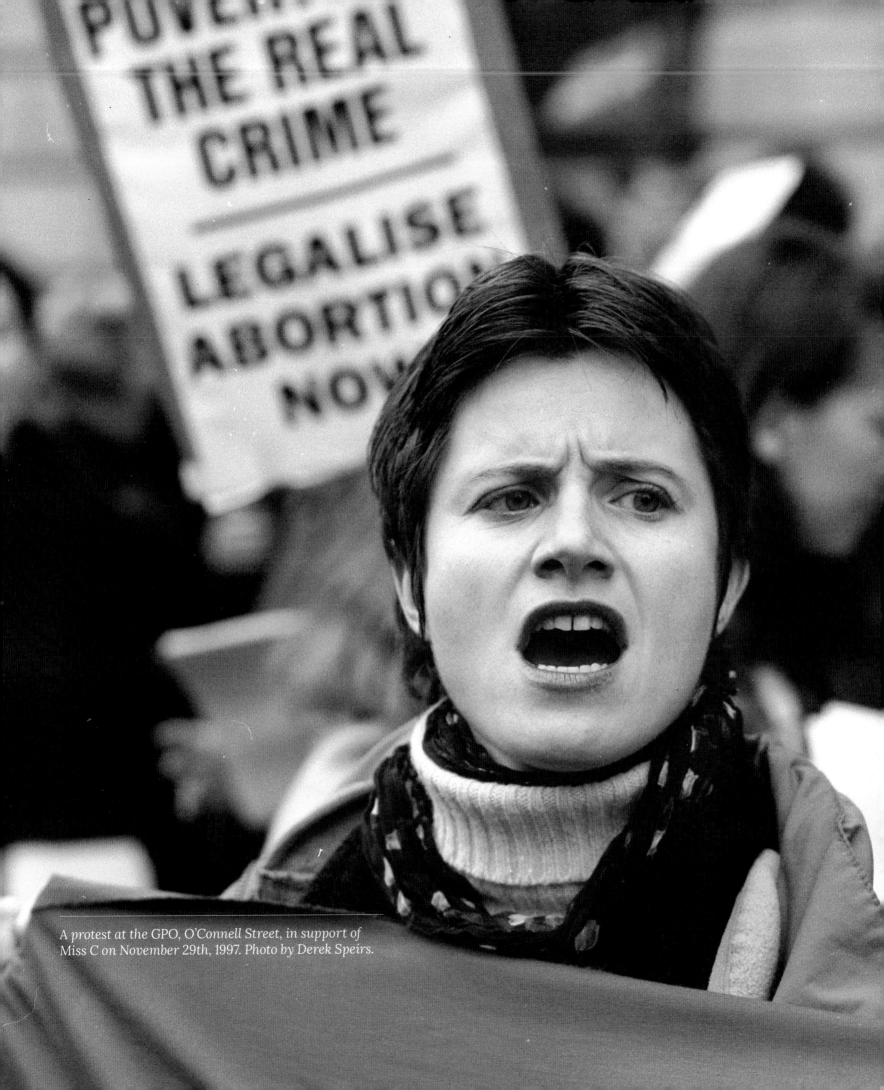

POVERTY THE REAL CRIME

LEGALISE ABORTION NOW

A protest at the GPO, O'Connell Street, in support of Miss C on November 29th, 1997. Photo by Derek Speirs.

Protesters rally for Miss C at Leinster House on November 29th, 1997. Photo by Derek Speirs

Country mind Choice

PRO-CHOICE CAMPAIGN
**13-year old raped
and pregnant...
LET HER
GO!**
Don't let the
courts stop her
having an abortion
**No more
X cases**

r let the
rts stop her
ing an abortion
**No more
X cases**
Choice Campaign, contact (01) 873 8170

GARDA

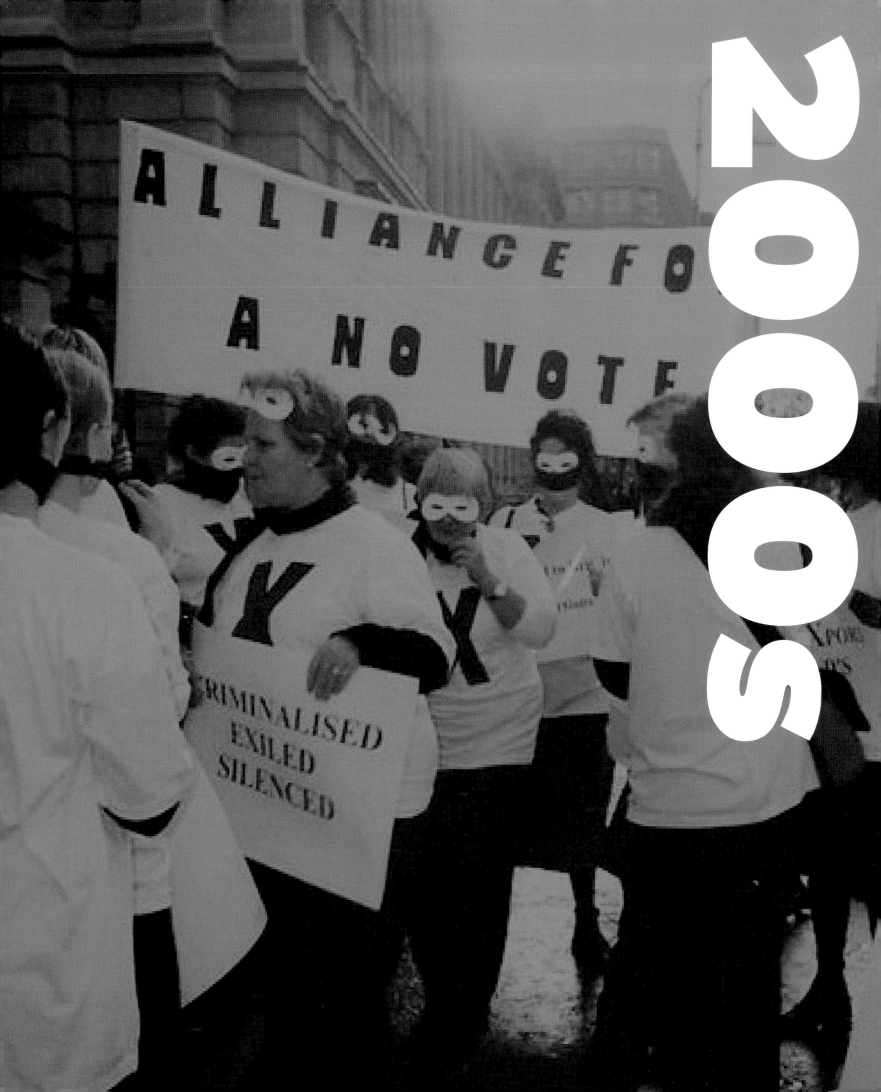

ALLIANCE FO
A NO VOTE

2000s

FROM GRASSROOTS TO MAINSTREAM

The new millennium delivered rollercoaster years of boom and bust with the State's low income and growing migrant populations enjoying little other than the effects of austerity policies spawned by the financial crash.

There were many referendums – Bertie Ahern's Government ran four alone to get the Nice (2001, 2002) and Lisbon (2008, 2009) treaties over the line.

As Al-Qaeda's September 11th attacks on New York's World Trade Center and the Pentagon, Virginia, convulsed the western world, Ireland was yet again focusing on abortion. The All-Party Oireachtas Committee on the Constitution, chaired by Brian Lenihan TD, had reported back in 2000 on 1998's Green Paper. While assessment of many submissions and hearings could be found in this Fifth Progress Report on Abortion, absent from its 700 pages were the views of the women and girls directly affected by the ban. Political consensus on the substantive legal issues eluded the committee and another referendum was seen as a way to resolve the issue. Members agreed, meanwhile, that a new agency charged to reduce crisis pregnancies should be set up under the Department of Health and Children.

In 2001, the Crisis Pregnancy Agency set out its goal:

- Education, advice and contraceptive services;

- Offering women who chose abortion other more attractive services and supports;

- Providing counselling and medical services after crisis pregnancy.

Ireland used this programme to defend the abortion ban at international human rights forums.

As more women turned to the legal system to secure their rights and the second ballot on the X Case ruling was set for 2002, the Irish Council for Civil Liberties and the Irish Family Planning Association continued their public support for legalisation of abortion. Amnesty Ireland and the National Women's Council of Ireland joined them. A new resistance was emerging as groups sprang up or reactivated around the State: Choice Galway, Choice Mayo, Choice Belfast, Choice Ireland and Cork Women's Right to Choose.

The Alliance for a No Vote (ANV) launched in Dublin a week after the Government published the Twenty-Fifth Amendment (Protection of Human Life in Pregnancy) Bill, 2001 in October. It was narrowly rejected on March 6th, 2002.

Another referendum in June 2004, described by journalist Fintan O'Toole as a disgrace to Irish democracy, passed with a 79 per cent majority. The incoming law meant Irish-born children were not entitled to Irish citizenship unless one parent had Irish citizenship at the child's birth.

In the North, campaigning to undermine the restrictive abortion law continued with a High Court challenge by the Family Planning Association in 2007. That same year 1,300 women from Northern Ireland had pregnancy terminations in England.

Global exposure of the Catholic Church's hidden histories continued with its own responses doing further damage to its public status and influence. And the anti-choice lobby continued to argue without irony that Ireland was one of the safest places in the world to give birth.

Tania McCabe (34) was six months' pregnant when she went into labour early and attended Our Lady of Lourdes Hospital, Co Louth, on March 6th, 2007. She was discharged, readmitted 24 hours later and had twins by Caesarean section. Two days later she died of sepsis. Her inquest delivered a verdict of death by medical misadventure.

At the time, the Health Information and Quality Authority (HIQA) inquiry into her death and that of her son, Zach, made 27 recommendations to be standardised across the State's public maternity units to prevent more such losses. Seven years later, the authority found parallels between Tania McCabe's death and that of Savita Halappanavar. It then ascertained through the HSE that only a handful of maternity units had implemented its earlier advice.

Similarly, Jennifer Crean (35), Co Wicklow, was admitted to the National Maternity Hospital on June 29th, 2008, complaining of abdominal pain. Fears for her own health caused her such concern that she insisted on naming her unborn child Adam. She went into septic shock on

Facing page: taking part in an X Case demo at the Dáil on November 29th, 2001 are choice activists Cathleen O'Neill and, behind her, Catherine Naji (1939-2017) gearing up for the 2002 referendum on the Supreme Court's groundbreaking X Case ruling in 1992.
Photo courtesy of Sandra McAvoy.

July 2nd and had a heart attack as doctors performed a Caesarean section. While the baby was safe Jennifer Crean was brain damaged and remained in a coma for seven months until her death in St Vincent's hospital on February 10th, 2009. Her inquest concluded death by medical misadventure. Her husband Francis McCabe said: "I hope that Jennifer's death was not in vain... [and] that Holles Street will learn some lessons from this and that new protocols are put in place to make sure this never, ever, happens again to anybody else."

On October 30th, 2008, Ailbhe Smyth and Therese Caherty launched Feminist Open Forum in Wynn's Hotel, Dublin. A packed meeting asked, Is Feminism Still Necessary? Ivana Bacik, Sinead Kennedy, Cathleen O'Neill and Anne Speed took part. Over several years, the forum offered a space for feminists to share views and experiences.

The banking crisis deepened and in January 2008 the Irish Stock Exchange lost €4 billion in one day. Finance Minister Brian Lenihan's €440 billion bank guarantee led to a raft of harsh cost-saving policies.

Meanwhile, the Lisbon Treaty finally made it in 2009 with its original and mysterious Maastricht abortion addendum, now Protocol 32, prohibiting European institutions from interfering with the Irish Constitution's Article 40.3.3.

On December 10th, 2009, the European Court of Human Rights began hearings on a challenge to the abortion ban by three women – A, B and C. The Government energetically endorsed the Eighth Amendment, saying it was underpinned by "profound moral values embedded in Irish society".

In December, an appeal by Mary Roche to have access to three frozen embryos was rejected by the Supreme Court. Under the Constitution, the court stated, embryos were not recognised or protected as "unborn".

During this decade, 56,458 women and girls left Ireland for abortions in Britain and The Netherlands – 15 per day. Statistics were absent for a growing migrant population stranded in the State's Direct Provision centres, denied their social and economic rights and prohibited from travelling outside the State.

On June 14th, 2001, choice activists from Women on Waves arrived into Sir John Rogerson's Quay, Dublin, to highlight Ireland's abortion ban. Dr Rebecca Gomperts, her Netherlands crew and the reproductive services clinic they ran on board the 100ft Aurora hit the world's headlines. During their stay in Dublin and Cork, WoW provided education and advice on crisis pregnancy and abortion. Up to 300 women availed of the pro bono service. Photo courtesy of Albert Lesegang.

Women on Waves

Search

Language: English

Who Are We?

Campaigns

Press

Media about Women on Waves

Documentaries

Photos & Logos

Become Active

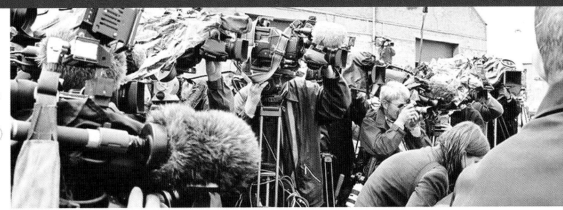

Media Abortion ship Ireland 2001

More than 200 Irish and international journalists attend the press conference. The ship Aurora is front page news all over the world. BBC Worldnews, CNN, ABC, NBC and numerous other networks and news agencies cover this groundbreaking event.

Positive press coverage appears in several Irish newspapers. One journalist even apologizes for her middle-class mentality as she had assumed in an earlier article that all Irish women could easily travel to England and that there would be no need for the ship. Another surprise is the CNN online opinion poll. Of the 16,500 participants, 49% are in favor of the ship's activities.

Due to the overwhelming amount of media all over the world, the press list that follows is incomplete.

Women on Waves

Search

Language: English

Who Are We?

Our Team

Awards

Legal Position of Women on Waves

Financial information

Activities per year

Campaigns

Press

Become Active

Sex, Abortion, & Birth

Resources

Contact

Donate!

Sign up for newsletters

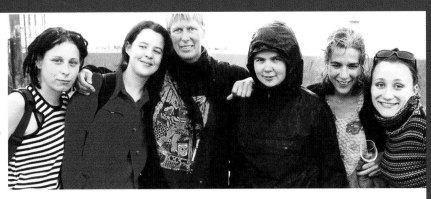

Screengrabs from the Women on Waves website.

Who Are We?

Women on Waves aims to prevent unsafe abortions and empower women to exercise their human rights to physical and mental autonomy. We trust that women can do a medical abortion themselves and make sure that women have access to medical abortion and information through innovative strategies. But ultimately it is about giving women the tools to resist repressive cultures and laws. Not every woman has the possibility to be a public activist but there are things we can all do ourselves.

Women on Waves was founded in 1999 by Rebecca Gomperts. After completing her training as an abortion doctor, Rebecca Gomperts worked as a physician on board Greenpeace's ship, the Rainbow Warrior II. In South America she met many women who greatly suffer both physically and psychologically due to unwanted pregnancies and lack of access to safe, legal abortion. Their stories were all heart wrenching. There were women who were raped. There were women who had no means of support. And there were women who were ostracized from their communities. These women and their stories are the inspiration for Women on Waves.

With a ship Women on Waves can provide contraceptives, information, training, workshops, and safe and legal abortion services outside territorial waters in countries where abortion is illegal. In international waters (12 miles off the coast of a country) the local laws do not apply.

Working in close cooperation with local organizations, Women on Waves wants to respond to an urgent medical need and draw public attention to the consequences of unwanted pregnancy and illegal abortion. Women on Waves supports the efforts of local organizations to change the laws in their country.

Women on Waves is registered in the Netherlands as a charitable organization under Article 24, lid 4 of the Successiewet 1956. As a result, donations to its Postbank account 3316 are fully tax deductible to the extent allowable by Dutch law. The activities of Women on Waves are supported by private and philanthropic funding. We depend on your contributions (which you can make on-line via a secure server) to continue our activities.

TWENTY-FIFTH AMENDMENT: REJECTED

TCD law professor Ivana Bacik, a supporter of Alliance for a No Vote (ANV), described the Twenty-Fifth Amendment (Protection of Human Life in Pregnancy Bill, 2001) as "dangerous, strange and unfeasible". The referendum aimed to remove the threat of suicide as a ground for abortion and increase the penalties for helping a woman to have one. This attempt to insert a criminal act into the Irish Constitution was a first.

The ballot on March 6th, 2002 had a voter turnout of 42.89 per cent and, with the narrowest of margins, retained suicide as grounds for abortion: 629,041, or 50.4 per cent, against to 618,485, or 49.6 per cent, in favour.

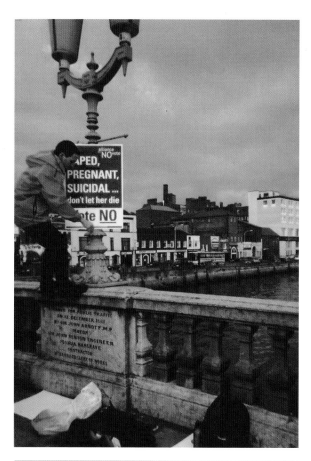

Fintan Lane postering Patrick's Bridge, Cork. Photos courtesy of Sandra McAvoy.

Chrystel Hug and Sandra McAvoy with a Cork Women's Right to Choose Group poster outside Cork City Hall count centre, March 7th, 2002.

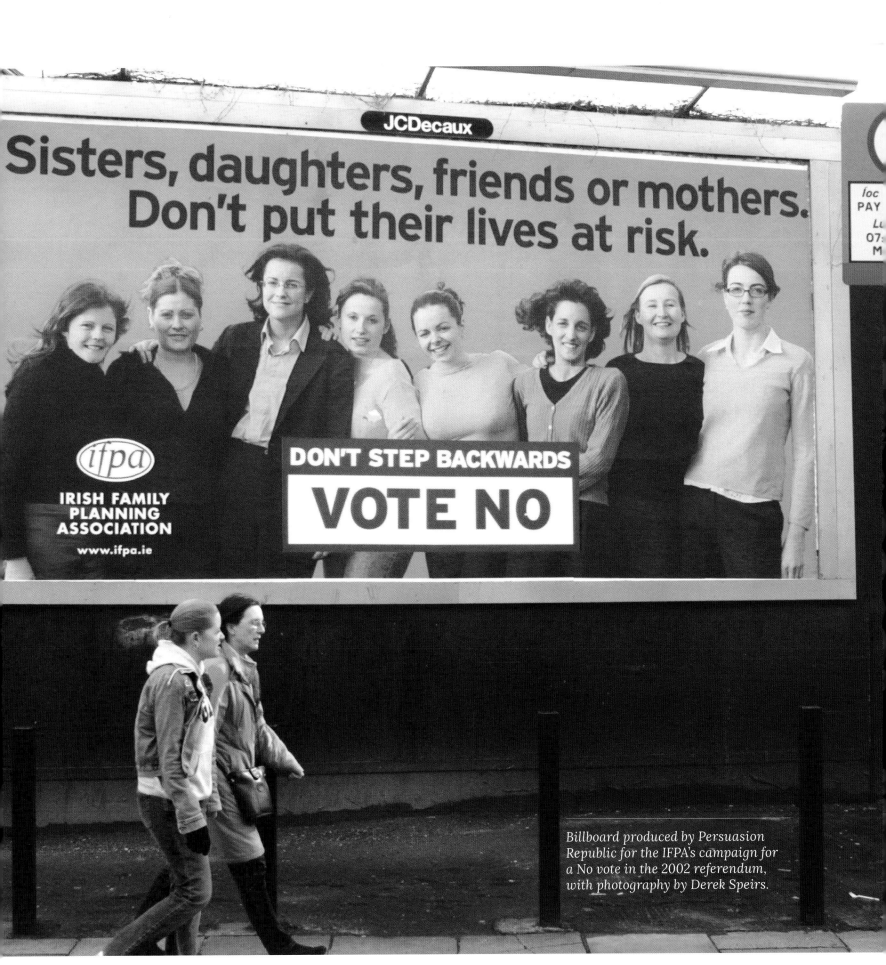

Billboard produced by Persuasion Republic for the IFPA's campaign for a No vote in the 2002 referendum, with photography by Derek Speirs.

REFLECTIONS ON THE EIGHTH

20 YEARS of the 8th Amendment

HomeNews

Campaigners say over 100,000 Irish women have gone to UK for abortions since 1983

Call for liberalisation of abortion law

SUZANNE BREEN needs of women and charge the

Twenty years to the day after Article 40.3.3 was voted into the Irish Constitution (September 5th, 2003), Alliance for Choice launched its Reflections on the Eighth in Dublin's Shelbourne Hotel. Youth Defence disrupted proceedings with cries of "Abortion is murder" as Alliance supporters sang We Shall Overcome.

Ms Cathleen O'Neill and Prof Ivana Bacik of Alliance for Choice at a press conference in Dublin yesterday to mark the 20th anniversary of the eight amendment to the constitution. The meeting was disrupted by members of the anti-abortion organisation Youth Defence. Photograph: Graham Hughes/Collins

Anti-abortionists in Shelbourne Hotel fracas

SUZANNE BREEN

The Shelbourne Hotel isn't the sort of establishment where one expects a fracas. So when Youth Defence came screaming into a pro-choice press conference yesterday, staff and guests looked horrified.

With pictures of blood-covered foetuses and accusations of murder, they yelled personal abuse at Prof Ivana Bacik of Alliance for Choice. Gardaí were called but, by the time they arrived, Youth Defence had gone.

"It's not often you see the guards in here," one worker confided. It had all

started very differently. Pro-choice groups had gathered in an upstairs suite to mark the 20th anniversary of the 1983 abortion referendum.

There were dignified speeches about the reality of women's lives, especially the 100,000 who have travelled to England for abortions since 1983. And then came Youth Defence.

Ten young men and women ran into the press conference, shouting at the tops of their voices, "Abortion is murder! Bacik has no right – to sacrifice a life!" they chanted, glaring at Ms Bacik, who is Reid Professor of Criminal Law at Trinity College.

They stood behind the pro-choice campaigners, waving their placards. "This is what they want to legalise", read one, accompanied by a picture of a blood-stained foetus. Others said "Abortion is murder" and "Labour the pro-abortion party".

A placard was shoved into Prof Bacik's face but she pushed it away. Labour MEP Mr Proinsias de Rossa, who was in the audience, came and stood at her side, placing an arm around her. Then the pro-choice campaigners rose to their feet, singing We Shall Overcome.

Youth Defence shouted louder so the pro-choice campaigners raised their

voices, too. They held up posters demanding the legalisation of abortion. The commotion could be heard all over the hotel. A porter politely asked the anti-abortionists to leave. They refused so he departed. The frantic-looking manager ran along the corridor, asking everyone in sight what was going on.

Eventually Youth Defence left and the press conference restarted. Mr de Rossa condemned the group's "bully-boy tactics" and said it wanted to deny women choice. Ms Bacik received a standing ovation. She said she wouldn't be intimidated from demanding safe, legal abortion in the Republic.

Press cuttings from The Irish Times

Magdalene laundry, Seán McDermott Street, Dublin 1. Photo by Derek Speirs.

CHURCH IN CRISIS

The Government's Ferns Report (2005), published on October 25th, logged over 100 allegations of child sexual abuse against 21 priests in the diocese between 1962 and 2002.

Ten years after it was set up in 1999, the Commission to Inquire into Child Abuse Report (sometimes known as the Ryan Report 2009) shed light on practices in 60 Catholic church-run but Government-funded reformatories and industrial schools. It recorded its

revulsion at the decades-long terror inflicted by the religious on thousands of children who had been treated as prisoners for being born out of wedlock or failing to attend school.

The Commission of Investigation into the Catholic Archdiocese of Dublin (the 720-page Murphy Report) concluded in 2009 that "in dealing with cases of child sexual abuse, at least until the mid-1990s" the Archdiocese was preoccupied with "the maintenance of secrecy, the avoidance of scandal, the protection of the reputation of the Church, and the preservation of its assets. All other considerations, including the welfare of children and justice for victims, were subordinated to these priorities..."

A series of resignations followed: Bishops Donal Murray, Limerick; Jim Moriarty, Kildare and Leighlin; and in Dublin, Eamonn Walsh and Raymond Field. The Sisters of Mercy undertook to provide €128m in compensation and the Irish Bishops' Conference apologised.

State inquiries into clerical sexual abuse

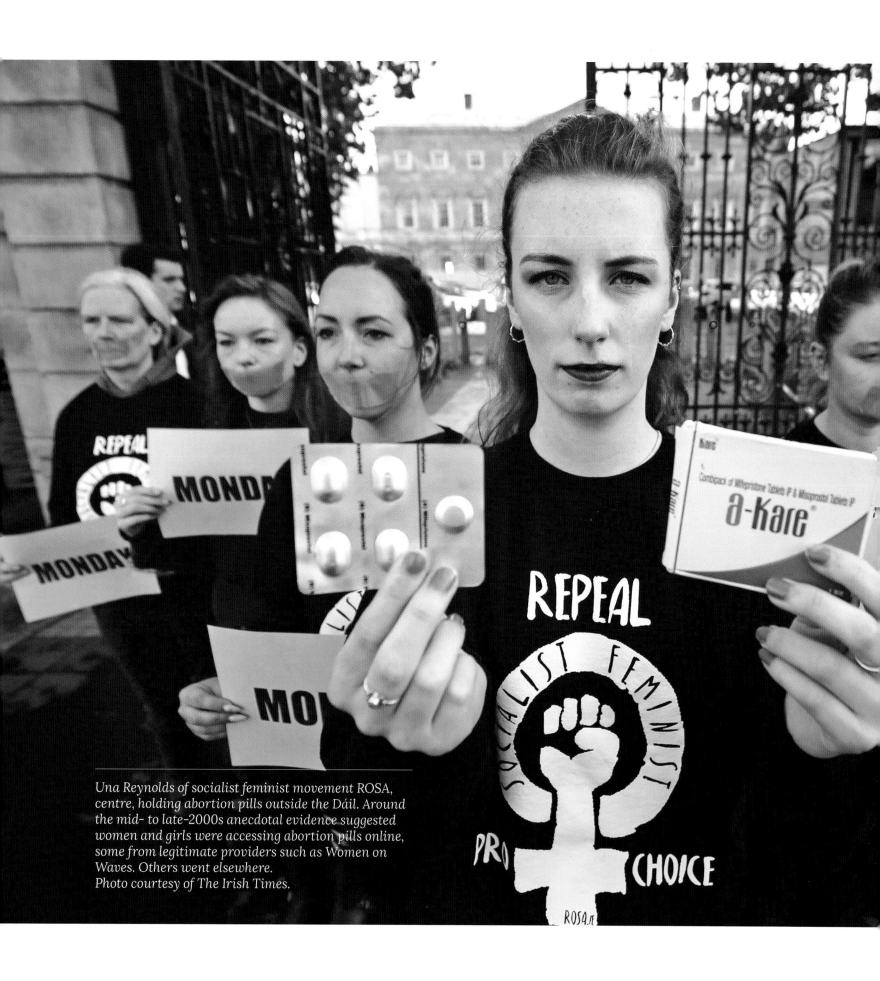

Una Reynolds of socialist feminist movement ROSA, centre, holding abortion pills outside the Dáil. Around the mid- to late-2000s anecdotal evidence suggested women and girls were accessing abortion pills online, some from legitimate providers such as Women on Waves. Others went elsewhere.
Photo courtesy of The Irish Times.

TERMINATIONS FOR MEDICAL REASONS

Deirdre Conroy.

D v Ireland

In 2002 when Deirdre Conroy learned that one of her twins had died in the womb and the other had a fatal anomaly, she went to Northern Ireland to end the pregnancy. She took her case anonymously to the European Court of Human Rights to highlight her own experience and that of others similarly affected by unsound law. She argued that the Eighth Amendment had violated the European Convention on Human Rights in cases of foetal impairment by restricting doctors' ability to advise on termination for medical reasons. Bizarrely, the Government said Conroy could have been legally entitled to a termination in Ireland had she used the domestic court system. It was not at all apparent to which court process they were referring. In June 2006, the European Court of Human Rights ruled that D v Ireland was inadmissible because domestic remedies had not been exhausted.

Amy Dunne.

Photos courtesy of The Irish Times.

Miss D

In 2007, 16-year-old Amy Dunne (Miss D) was pregnant and in State care. When she learned the foetus she had carried for 18 weeks would survive only three days outside the womb, she wanted a termination. Against the urging of her advisers, Dunne refused to say she was suicidal in order to get that medical treatment abroad. The Health Service Executive (HSE) tried to restrain her from leaving the island. Finally, she went to the High Court where on May 9th, Liam McKechnie upheld the teenager's right to travel. He criticised the HSE for its attempts "to shoehorn her case into the grounds set out in the X Case".

THE ABORTION SUPPORT NETWORK

Founded in London in 2009 by Mara Clarke, the Abortion Support Network continues to provide vital solidarity, support and funding to women and girls with crisis pregnancies. Advising on clinics, travel and accommodation, its remit extends beyond Ireland to Northern Ireland, the Isle of Man, Malta, Gibraltar, Poland among others. ASN's director Clarke describes the network as a highly specialised travel agency, one supported since its early days by veteran choice activist Dr Ann Rossiter, author of Ireland's Hidden Diaspora.

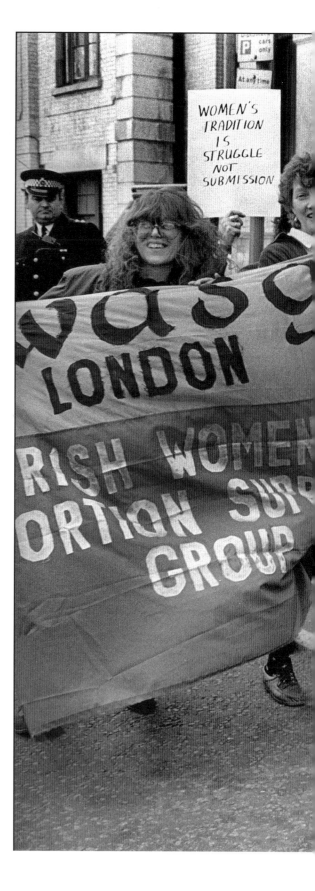

Mara Clarke (above), Abortion Support Network; and Anne Rossiter, author and IWASG supporter, both speaking at the formation of the Coalition to Repeal the 8th Amendment in September 2014.

Ireland's Hidden Diaspora by Ann Rossiter published in 2009 by IASC, the Irish Abortion Solidarity Campaign.

All photos by Joanne O'Brien.

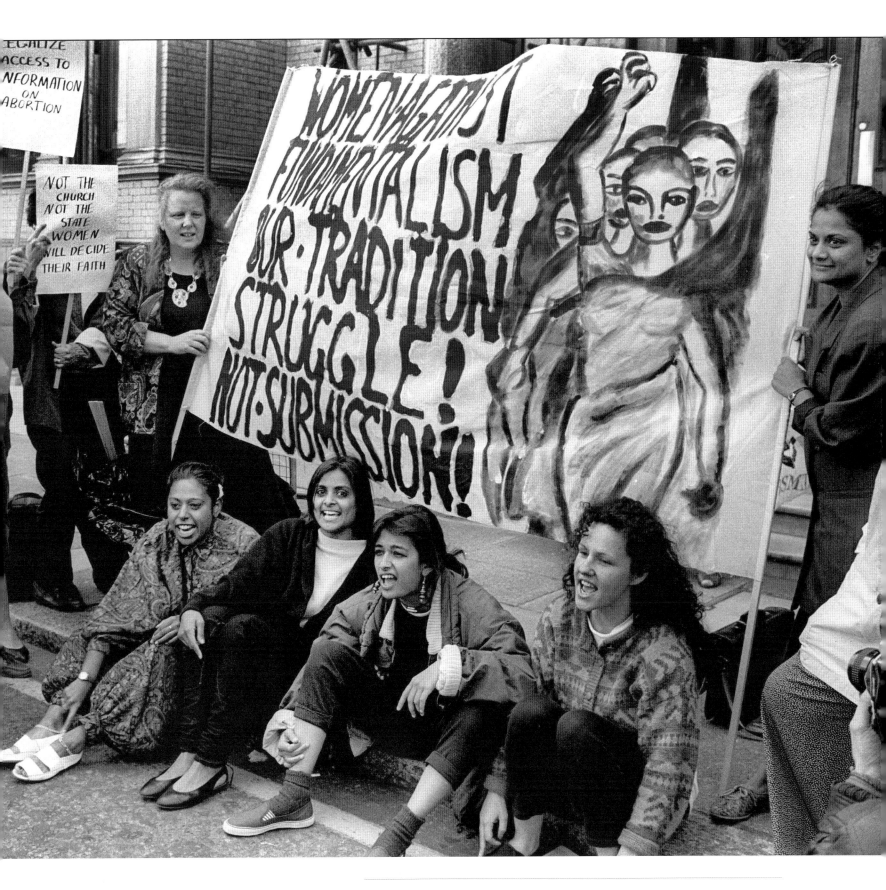

The Irish Abortion Support Campaign's first outing, a picket at the London Irish Embassy in May 1980, with Ann Rossiter (standing, centre) of the Irish Women's Abortion Support Group, with solidarity from Asian women. Photo by Joanne O'Brien.

ON THE DAY: ABORTION IN LONDON

During the 1980s-90s, the atmosphere created by the Eighth Amendment made crisis pregnancy an even harsher ordeal for women and girls in Ireland. Failure to extend the 1967 Abortion Act had the same effect in Northern Ireland. To ease the burden of those travelling to Britain for terminations, an Irishwomen-only collective set up the Irish Women's Abortion Support Group in London in the early 1980s. It provided practical non-judgmental support for the women, some of whom were travelling abroad for the first time. Many did so anonymously. All faced great stigma and the threat of criminalisation. Joanne O'Brien's powerful images illustrate their experience of abortion in London at that time.

IWASG, often referred to as Imelda for safety reasons, worked under the radar for over 20 years. A sister organisation, the Irish Abortion Solidarity Campaign (IASC), formed in 1990 to counter the ban on provision of information on service providers. The Abortion Support Network continues the work initiated by IWASG, which Ann Rossiter and Joanne O'Brien supported.

Right: An abortion clinic theatre, London, 1992.

All photos by Joanne O'Brien.

Above: Women entering an abortion clinic, 1992.

Waiting room for arrivals from Ireland and Europe (Italy, Spain and France) at an abortion clinic in London, 1992.

FROM X TO ABC

On July 15th, 2005, three women living in Ireland, known as A, B, and C, challenged the State's abortion ban in the European Court of Human Rights, Strasbourg. A hearing took place on December 9th, 2009.

The judges rejected A's and B's complaints that the ban had infringed their rights under article 8 of the European Convention on Human Rights. But C, who had cancer and wanted an abortion when she discovered she was pregnant, had her complaint upheld on grounds that she had no way to determine how to exercise her right to an abortion in the State.

The court's ruling, delivered on December 16th, 2010, put pressure on Government to legislate for 1992's X Case ruling and clarify how an abortion could be procured.

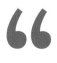 **Unfortunately once again, Ireland is shown to be lacking in its domestic legislation and it takes an international body to highlight this to us.**

Irish Times letters page, December 17th, 2010, Andrea Pappin, European Movement Ireland.

THE IRISH JOURNEY

Women's Stories of Abortion

Introduction by medb ruane

Leaving the European Court of Human Rights in Strasbourg, France, after responding to questions from the Grand Chamber sitting on the case of A, B, C v Ireland in December 2009 are, from left: IFPA chief executive Niall Behan; IFPA director of counselling Rosie Toner; IFPA chair Anthea McTeirnan; lead legal counsels for A, B and C Julie Kay and Carmel Steward; legal consultant Mercedes Cavallo. Photo courtesy of Paul O'Driscoll.

Road to Repeal

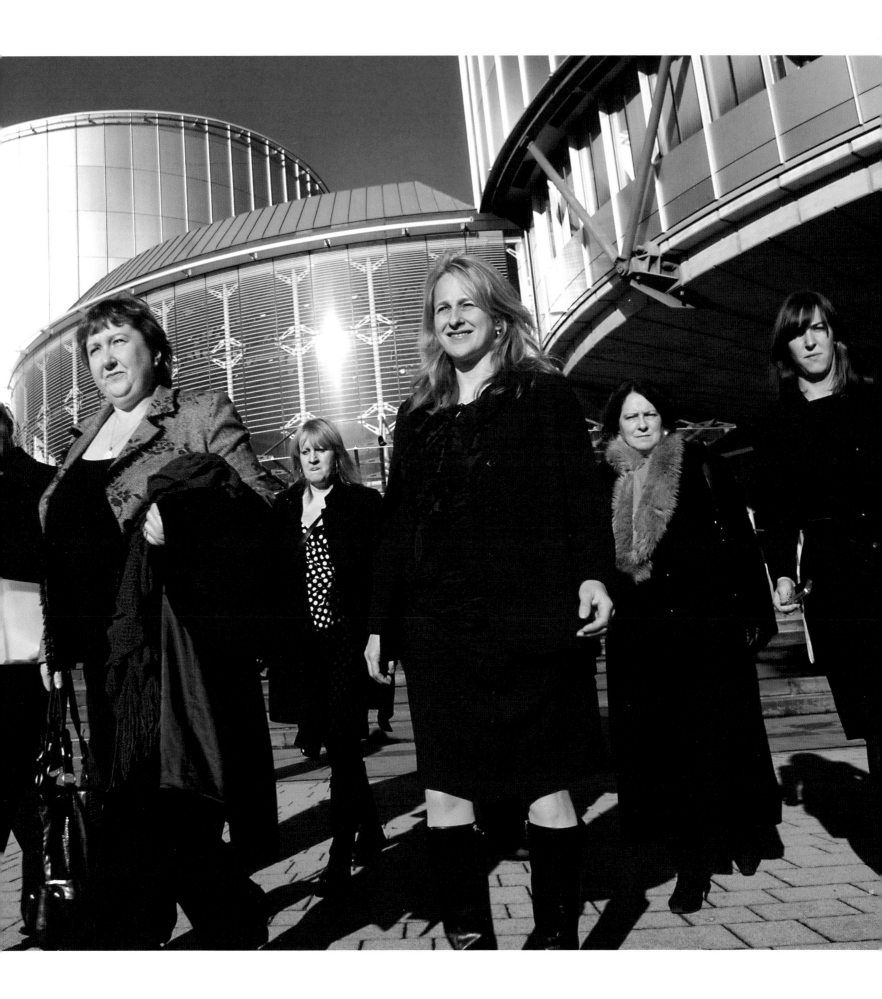

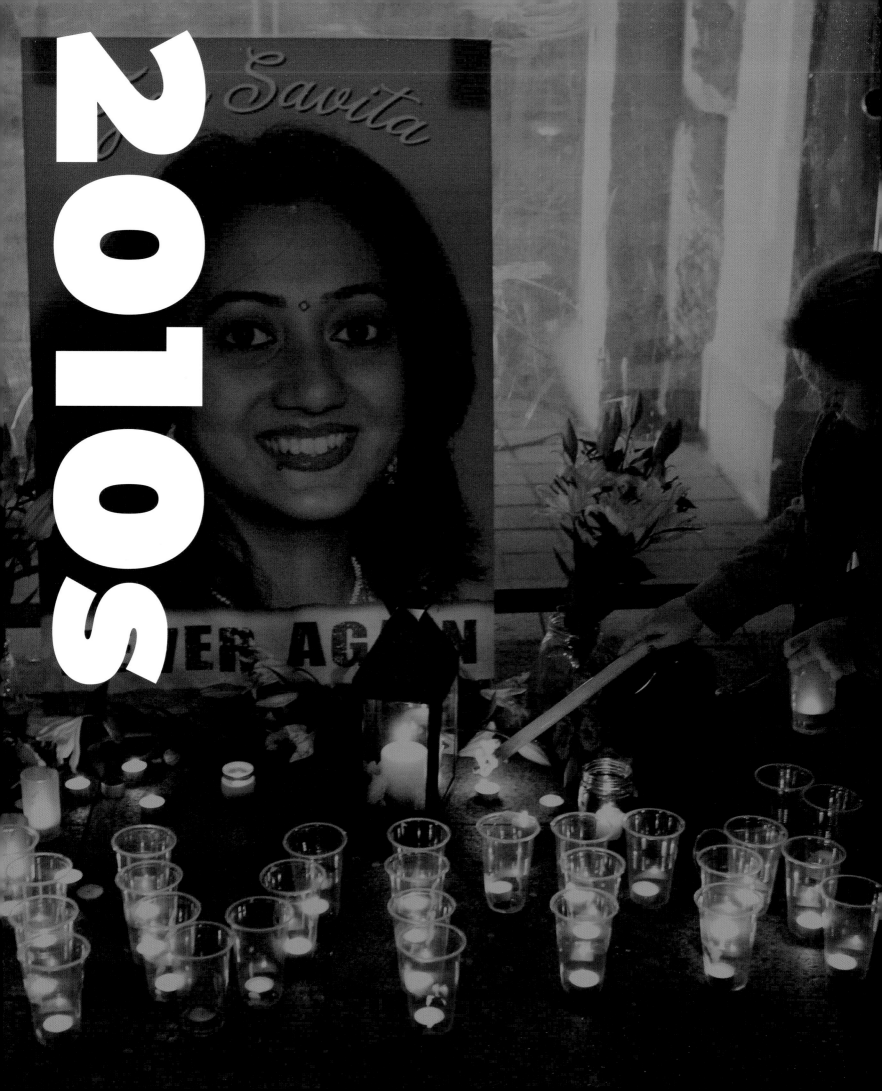

2010s

MOVEMENT FOR REPEAL

The banking crisis of 2007 cast a shadow over the incoming decade. The so-called Troika (comprising the European Commission, European Central Bank and International Monetary Fund) arrived in late 2010 with a loan of €65 billion conditional on a penal economic adjustment programme. Socialisation of bank debt and austerity policies caused anger. But the attempted introduction of water charges unleashed a powerful grassroots movement whose street protest verged on the unmanageable.

Meanwhile, the repeal movement was gaining momentum. Young women who had not been born when the Eighth was voted in were impatient for change and in 2011, a year ahead of the 20th anniversary of the X Case, Action on X formed to highlight decades of Government inaction on the Supreme Court ruling.

In a May 2010 letter, Pope Benedict XVI apologised for his organisation's response to the sexual abuse of children in its care. Clerical resignations followed. That summer, the church paid out-of-court damages of over €250,000 to a woman abused by paedophile priest Brendan Smyth.

In spring 2010, the unmarked graves of 40 children from the Bethany Home were found in Dublin's Mount Jerome Cemetery. Academic Niall Meehan helped the Bethany Survivors Group to identify over 200 children from the Church of Ireland-run facility that served more as a detention centre than as a mother and babies home. Its survivors sought parity with their Catholic counterparts.

The Health Service Executive rolled out its nationwide cervical cancer vaccinations in 2010 as austerity cuts pushed the Crisis Pregnancy Agency into the HSE.

In October 2012, Savita Halappanavar died in Galway after being refused an abortion while miscarrying. Her death evoked a strong reaction across Ireland and the world.

In Galway, historian Catherine Corless was quietly researching practices in the Bon Secours Mother and Baby Home (1925-61) in Tuam. She named 796 babies who had died there but could find no burial records. She believed their bodies had been secreted in a septic

tank. In the absence of a State response, people raised funds to erect a memorial there. On May 25th, 2014 the front page of the Irish Mail on Sunday took up the story. An excavation of the grounds followed and confirmed Corless's research. Minister for Children Katherine Zappone set up a Commission of Investigation that published a 3,000-page report in spring 2021 that satisfied few. A disappointed Corless said survivors had hoped for some insight into what actions might follow. No exhumation or any other action is as yet apparent.

On June 15th, 2010, the Saville Inquiry report into Bloody Sunday events in 1972 confirmed civilians targeted by British paratroopers had been wrongly killed. British premier David Cameron issued a historic apology.

Catholic bishops intervened in the Government debate on the Civil Partnership Bill in 2010, asking for a free vote for all politicians saying Government was trying to make same-sex relationships "as similar as possible to marriage". The Bill passed without a vote.

In December 2010, Strasbourg's European Court of Human Rights ramped up the pressure with its landmark ruling on A, B, C v Ireland: the Constitutional right to a termination in the State should have been clearly signposted. It referred to the "significant chilling" effect of the Eighth Amendment and the difficulties C had met in trying to exercise her right to an abortion – a violation of her rights under Article 8 of the Convention on Human Rights. The other two cases were dismissed.

The general election of 2011 brought five far left TDs into the Dáil, among them Clare Daly and Joan Collins who were joined by Independent TD Mick Wallace on November 27th, 2012 in proposing the Medical Treatment (Termination of Pregnancy in Case of Risk to Life of Pregnant Woman) Bill 2012 to implement the X Case ruling. It was defeated by 101 votes to 27.

In April 2011, four years after Tania McCabe died in the National Maternity Hospital, her family received an apology from the HSE in the High Court.

In January 2012, the Government set up an expert group to examine the European Court of Human Rights ruling on A, B and C v Ireland. Eleven months later, the British Guardian newspaper leaked a draft of the 108-page guidance on how the Protection of Life During Pregnancy Act 2013 should be implemented. The report detected a gap in the theory and implementation of the right to a lawful abortion in Ireland (X Case 1992)

where risk to a woman's life was grounds for termination of pregnancy. It offered Government four options: to introduce (i) non-statutory guidelines; (ii) statutory regulations (iii) legislation only; (iv) legislation plus regulations.

The Medical Treatment (Termination of Pregnancy in Case of Risk to Life of Pregnant Woman) Bill was defeated on November 27th, 2012. There were some surprising political reversals in the Dáil: after decades of supporting repeal of the Eighth in the most trying times, many Labour Party members voted against or abstained, while Sinn Féin voted in favour.

The Protection of Life During Pregnancy Act, 2013 that resulted directly from Savita Halappanavar's death was not a move for the better. It was instead a replacement of the penal Offences Against the Person Act 1861 with an equally restrictive law, including a new offence of "destruction of unborn human life" with a maximum penalty of 14 years' jail. Access to abortion on grounds of suicide was made more difficult.

Chaired by Jerry Buttimer TD, the Oireachtas Committee on Health and Children in January 2013 began three days of public hearings on the Government's proposed new legislation on abortion. Master of the National Maternity Hospital Dr Rhona O'Mahony said she was "offended by some of the pejorative and judgmental views that women will manipulate doctors in order to obtain a termination on the basis of fabricated suicidal ideation" and the assumption that "psychologists can't tell the difference when someone is really suicidal or not".

After Savita's death, Deirdre Conroy (formerly Ms D) went public to argue for the automatic right to abortion in cases of fatal foetal anomaly.

A 2013 report into the Magdalene asylums found the State complicit in allowing thousands of women and girls being taken into institutions to be abused and treated as slave labour. The then Taoiseach Enda Kenny issued a State apology to survivors and promised to set up a redress scheme.

The Abortion Rights Campaign was formed in 2012 at a conference in Dublin's Teachers' Club. ARC campaigns for abortion across the island and was arguably the State's first choice organisation to use the A word so publicly. It included members of the Irish Choice Network and Action on X. The group's first March for Choice in 2012 became an annual event.

The Coalition to Repeal the Eighth Amendment, led by Ailbhe Smyth and Sinéad Kennedy, was set up in 2014 and gained the support of almost a 100 organisations, including the Irish Congress of Trade Unions, the island's largest civil society movement. Many newer groups fashioned themselves on those set up in 1983. Notable among these was the Artists Campaign for Repeal of the Eighth led by 1983 activist Cecily Brennan – it gathered 1,000 signatures overnight. Lawyers, doctors and students were among other groupings.

The Campaign for Marriage Equality drew a 62 per cent Yes vote in the May 2015 referendum. While not providing for marriage between same sex partners – a disappointment to many – civil partnership was legalised. It had taken 27 years to get here from David Norris's ground-breaking court case against Government in the European Court of Human Rights in 1988.

The outcome was significant for choice activists as it signalled a major shift in attitude to sexual politics across the 26 counties. Repeal suddenly seemed winnable. Supporting this contention was condemnation of Ireland's anti-abortion laws by the United Nations Committee Against Torture (2017) and the UN Committee on the Elimination of Discrimination against Women (2017). Many wounded by the experience of repeated losses at the ballot box remained dubious.

In 1992, trans woman Lydia Foy wanted a new birth certificate to state her gender identity. The Registrar General refused and a 20-year battle with the State began. Twenty years later, Government finally dropped its challenge to a High Court ruling that found Irish law on transgender rights broke the European Convention on Human Rights – with no follow-up. The Gender Recognition Act 2014 was finally enacted in 2015.

In November 2011, Amanda Mellett had found her 21-week-old pregnancy was unviable. Her options under Irish law were to continue to delivery or book an abortion abroad. She went to Liverpool. Twelve hours later she returned, weak and bleeding, without aftercare or counselling. In 2016, the UN Human Rights Committee found Ireland had subjected Amanda Mellett to cruel, inhuman and degrading treatment, to discrimination, and to an arbitrary and as such unlawful interference with her right to privacy. The committee's conclusions for Siobhan Whelan who had a similar diagnosis in 2017 were similar. Both pregnancies were wanted – the Eighth had compounded their distress and violated their human rights.

With its Rise and Repeal slogan, ARC's March for Choice 2016 attracted 40,000 supporters. Bernadette McAliskey, veteran choice activist among many other things, addressed the rally.

A random selection of 66 voting-age adults and 33 reps selected by political parties became a Citizens' Assembly to deliberate over four, then five, weekends. Its outcome defied all expectation and endorsed views of the Marriage Equality outcome that public opinion was turning and that perhaps grassroots campaigns had had an influence. At the final vote in April 2017, the assembly urged repeal of Article 40.3.3. and recommended abortion rights in Ireland on a wide range

Sarah O'Toole, Elaine Mears and Mary McGill at the Galway Races, July 2015. Photo courtesy of Sarah O'Toole.

of circumstances with few restrictions. Again, activists dared to hope. The Oireachtas Committee on the Eighth Amendment to the Constitution agreed not to recommend full retention of Article 40.3.3.

A very sensitive issue was that of what law should follow a successful referendum. Irish women lawyers, some based in Britain, were among the first to draft a new pregnancy termination law and to provide analytical studies and speakers to many seminars and conferences.

In October 2017, Professor Veronica O'Keane of Doctors for Choice told the Joint Oireachtas Committee on the Eighth Amendment: "While any constitutional ban remains in place, doctors will be unable to practise medicine in line with the principles of best practice, and women's mental health will continue to be damaged."

Momentum was unstoppable as three organisations joined forces to form a tighter coalition for repeal on March 22nd, 2018. These were the National Women's Council of Ireland led by Orla O'Connor, the Abortion Rights Campaign (ARC) led by Grainne Griffin, and the Coalition to Repeal the Eight Amendment led by Ailbhe Smyth. It called itself Together for Yes.

Acting on the Citizens' Assembly outcome, the Government went to work on deciding a law to provide for pregnancy termination. It was rushed with indecent haste. A Policy Paper on the Regulation of Termination of Pregnancy was published just 12 weeks before the referendum. The Regulation of Termination of Pregnancy Bill was agreed on March 27th, 2018. The next day the scheme of the Bill appeared online. The electorate could view what they were voting for – or against.

On May 25th, 2018, 66 per cent (1,429,981 people) of the electorate rejected the Eighth Amendment. It had been a long time coming. Perhaps this was why the proportion was much higher than campaigners had projected. It revealed that theirs may have been a weak analysis based on the idea of a middle ground on abortion. Actually, there was not. A majority was in favour.

The historic win was quickly supplanted in the media by the cervical cancer scandal – one in a long line of scandals over women's fertility. It appeared that many women screened for cervical cancer received an incorrect result or their doctor got their bad result, but did not tell them. Among those who got the wrong result, some, like campaigner Vicky Phelan, later developed cervical cancer. The group of 221-plus women had to lobby and argue through several reports, audits, a tribunal and some in court cases. A familiar scenario.

According to the IFPA, The Health (Regulation of Termination of Pregnancy) Act 2018 had insufficient Oireachtas scrutiny, had an odd and inflexible mandatory waiting period on requesting a termination and retained draconian criminal provisions and an absence of a women's right to equitable access to health care.

The Act was signed into law by President Michael D Higgins on December 20th, 2018. Under the 36th Amendment of the Constitution abortion became lawful on request up to 12 weeks, when a woman's life was at risk or where there might be serious harm to her health and in cases of fatal foetal anomaly. In all other instances, abortion is now criminalised with crushing sanctions of 14 years in prison for terminations outside the conditions of the Act.

Review of the law was scheduled for 2021. Among the issues needing attention were the three-day waiting period, legal guarantees of unimpeded access and entry to service providers, and the closure of rogue agencies advertising abortion services but which were actually opposed to abortion.

On May 29th, 2018 State child agency Tusla said 126 births were incorrectly registered (1946-49) by the now closed adoption agency St Patrick's Guild. Owned by the Sisters of Charity it ran Temple Hill home for babies in Blackrock, Co Dublin. Tusla was committed to contacting the affected mothers with this new information.

On June 5th, Magdalene laundry survivors from Ireland, met for the first time with survivors from the UK, the US and Australia, and with President Michael D. Higgins.

During 2019, 375 women and girls travelled from Ireland to England for an abortion. 1,014 travelled from Northern Ireland to England.

ACTION ON X

In 2009, the Feminist Open Forum opened with a public discussion on "Is Feminism Really Necessary?". Attendance was unexpectedly large. Other feminist groups were similarly engaged and supported: Irish Feminist Network, anarcha feminist group Rag. An informal feminist alliance began to emerge that in late 2011 coalesced into Action on X. The 20th anniversary of the X case, in which the State injuncted a raped 14-year-old girl to stop her having an abortion, was approaching. The new group, whose aim was to highlight decades of political apathy on the X Case ruling, was a small initiative that would balloon into something much bigger.

In February 2012, Action on X staged its first demo outside Leinster House. A public meeting with high profile panelists in Dublin's Gresham Hotel followed on February 21st, marking the date that X appealed her case to the Supreme Court.

On April 18th, 2012, Independent socialist TDs Clare Daly, Joan Collins and Mick Wallace made history by reading their Medical Treatment (Termination of Pregnancy in Case of Risk to Life of Pregnant Woman) Bill 2012 into the Dáil records. The Bill was voted down.

After Savita Halappanavar's death in October 2012, the group had its final rally in March 2013 under the slogan Women's Lives Matter – exposing yet another 12-month legislative vacuum on abortion. Trade unions Unite, SIPTU and the Irish Congress of Trade Unions Women's Committee along with the Union of Students of Ireland, National Women's Council and migrant women's network AkiDwA endorsed the event and its rallying call. Over 100 organisations and individuals signed its petition.

The unsatisfactory Protection of Life During Pregnancy Act 2013 was finally enacted in early 2014 and Action on X became Action for Choice.

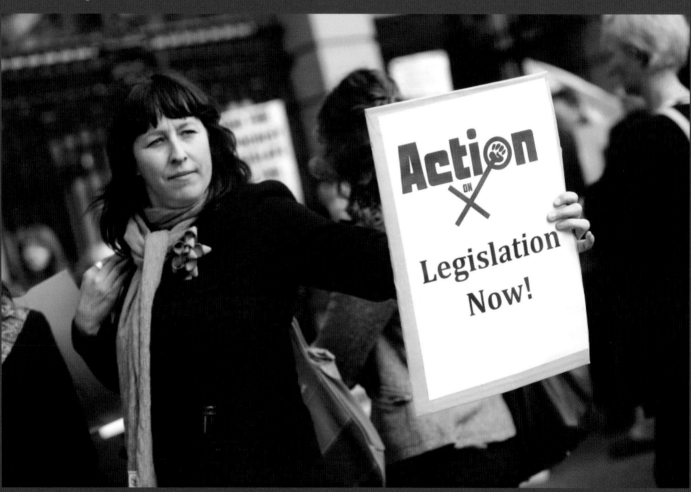

As the Medical Treatment (Termination of Pregnancy in Case of Risk to Life of Pregnant Woman) Bill is debated and defeated in the Dáil, Action on X activists gather outside Leinster House, Kildare Street, Dublin, on April 18th, 2012. Photo by Paula Geraghty.

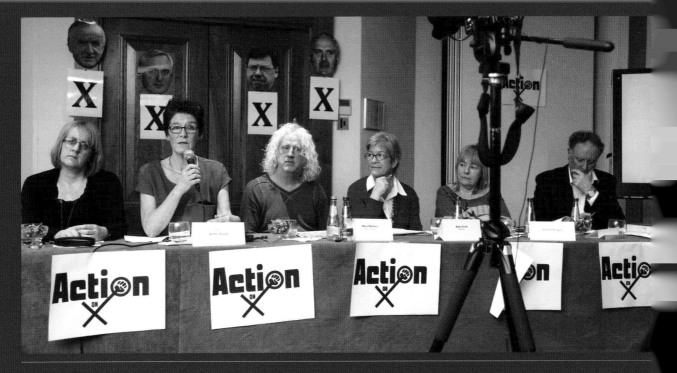

Pictured at an Action on X public meeting in Dublin's Gresham Hotel, demanding legislation on 1992's Supreme Court X Case ruling are, from left, Irish Times journalist Anthea McTeirnan, Ailbhe Smyth of Action on X, Independent TD Mick Wallace, Labour Party TD Anne Ferris, academic and activist Goretti Horgan with journalist Vincent Browne. Photo by Derek Speirs

 Make abortion accessible

Women's lives matter!

It's 21 years since the X Case, when the Supreme Court ruled that abortion is legal if pregnancy poses a risk to a woman's life.

As TDs debate the legislation on abortion, a vocal minority in Fine Gael, Fianna Fáil and outside the Dáil want to exclude the risk of suicide as grounds for abortion. Others want restrictions that would increase the risk to women's lives by including unnecessary obstacles to abortion.

We demand X legislation by the summer. It must include

- The risk of suicide as grounds for abortion
- No more than two medical practitioners' opinions to approve an abortion
- State-wide access
- Access to abortion if a foetus has a fatal abnormality and cannot survive
- Decriminalisation of abortion

A large majority support X legislation. The Dáil must act for the majority, not defer to a vocal minority.

Put women first. Demand legislation that makes abortion accessible.

Protest – May 18th
Central Bank plaza, Dame St. 4 pm

www.facebook.com/actiononx2012
email: actiononx@gmail.com
https://twitter.com/actiononx

Post-feminist era
No need for feminism anymore
What did feminism ever do for us?

IS FEMINISM REALLY NECESSARY?

Have you heard this lately? Has it made you wonder if the time for women-centred meetings is over? Or has it made you wonder if the time is right to begin again...

If you want to join in real debate and discussion
If you want a space to reflect with others on where our society is headed
If you believe in passionate feminist politics
If you want action
If you want to dance...

... then come and join us in creating the Feminist Open Forum with **IVANA BACIK, SINEAD KENNEDY, CATHLEEN O'NEILL, AILBHE SMYTH, ANNE SPEED** and others for plenty of debate on

THURSDAY OCTOBER 30TH AT 7.30PM IN WYNN'S HOTEL, MID ABBEY STREET, DUBLIN.

fof is a new space for feminists to get together to share views and experiences, to discuss current political issues, and to strategise and plan actions for change.

fof plans to meet monthly and is open to everyone interested in feminist politics and activism.

Fresh Perspectives, New Voices, Action

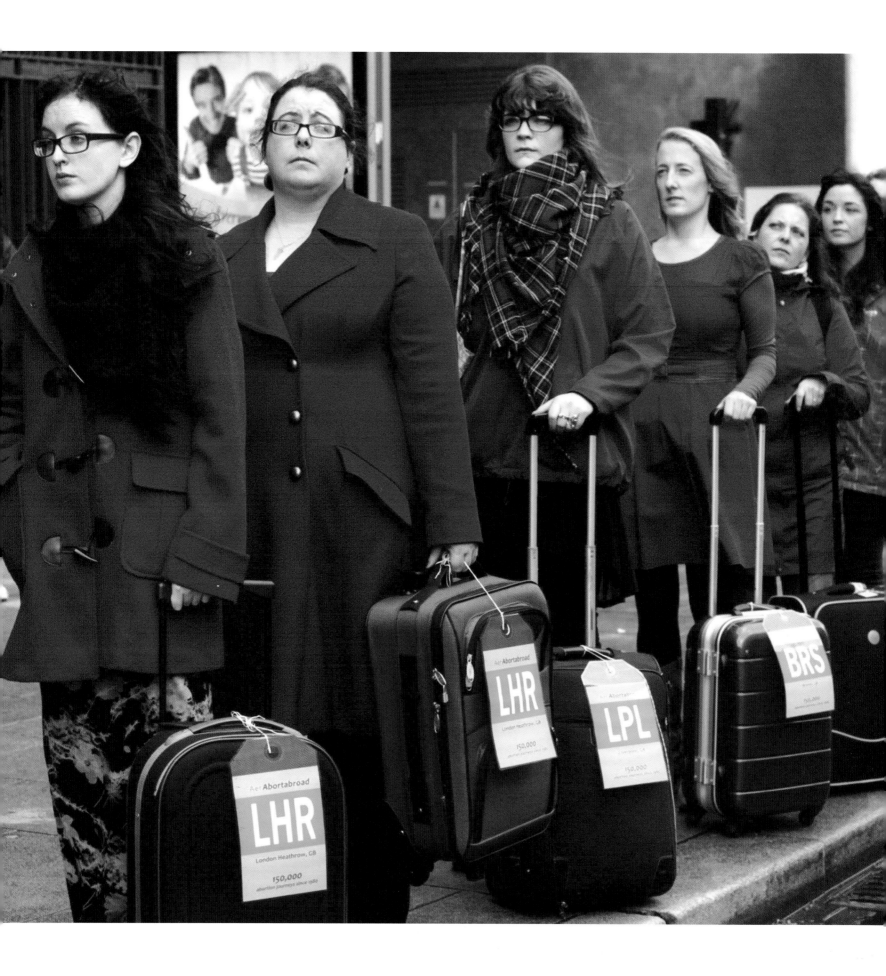

Road to Repeal

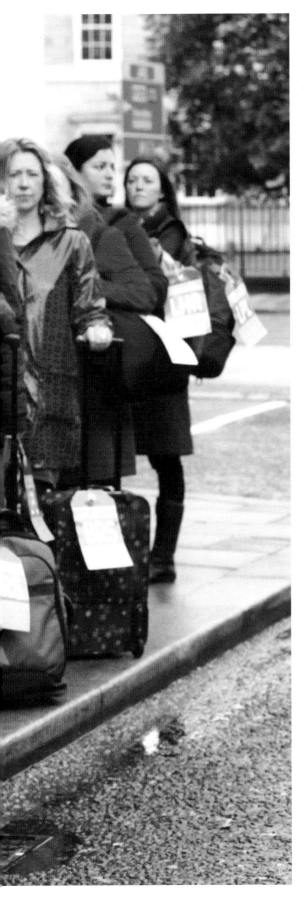

On September 26th, 2012, choice activists highlight that 12 women and girls leave Ireland every day for abortions abroad. Photo by Paula Geraghty.

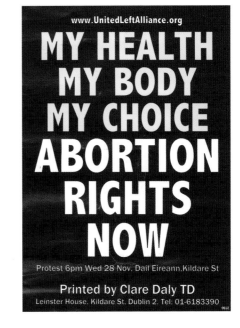

Independent parliamentarians Clare Daly, Joan Collins and Mick Wallace who managed to initiate a Bill for abortion in the Dáil in 2012.

SAVITA HALAPPANAVAR

Irish Times journalist Kitty Holland reported the death from sepsis of Savita Halappanavar on October 28th, 2012. Savita (31) was 17 weeks' pregnant and complaining of back pain on arrival at University Hospital Galway in autumn 2012. She was discharged. On readmission, her requests for termination after an incomplete miscarriage went unheeded: "We don't do that sort of thing in Ireland, dear." She died from sepsis on October 28th, 2012. Like the X Case of 1992, nationwide vigils and street protest followed.

The inquest delivered a verdict of death by medical misadventure. The coroner issued nine recommendations to improve the health system response in these circumstances. Reports into Savita's death by the HSE and Health Information and Quality Authority (HIQA) agreed that she would have survived had doctors focused on her rather than the foetal heartbeat (ie the Eighth Amendment).

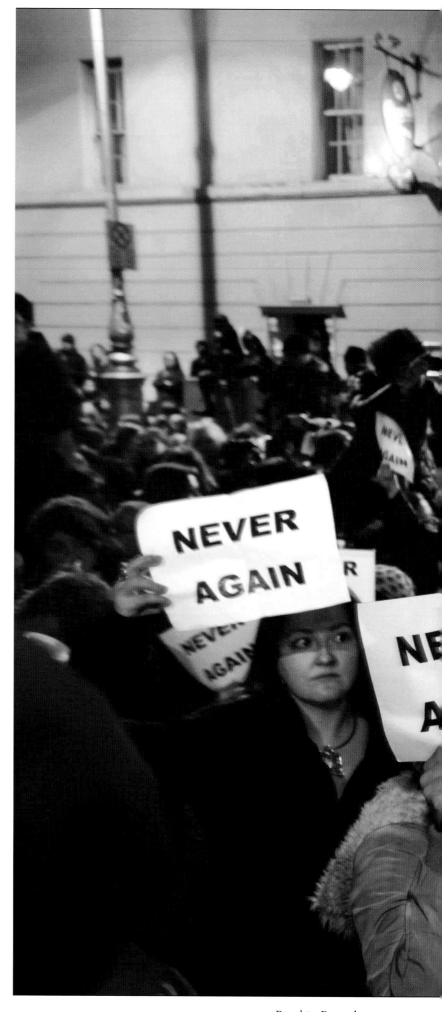

Protesters outside the Dáil, Kildare Street, Dublin, on November 14th, 2012, shortly after Savita Halappanavar's death. Photo by Derek Speirs.

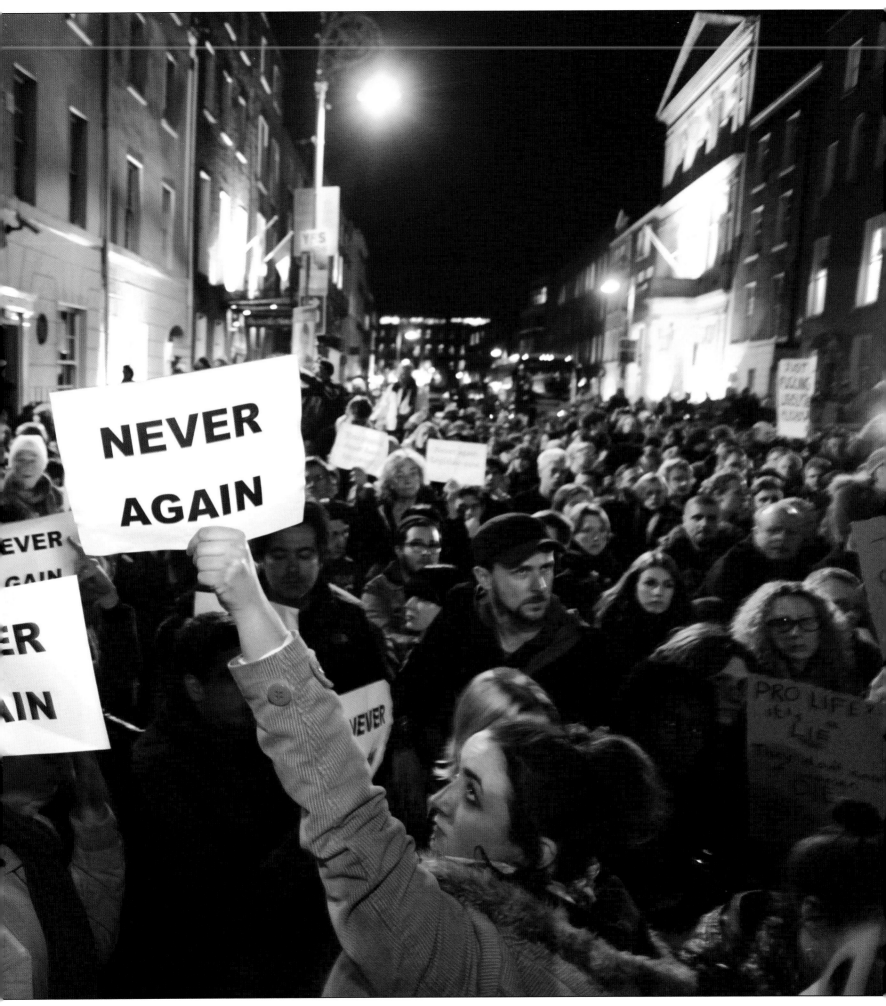

Below: On November 17th, 2012, demonstrators march from Parnell Square, Dublin, to hold a national vigil and rally outside Government Buildings, Merrion Street, to mark Savita Halappanavar's death.
Photos by Derek Speirs.

Right: A vigil for Savita Halappanavar outside the Dáil on Kildare Street, Dublin, November 14th.

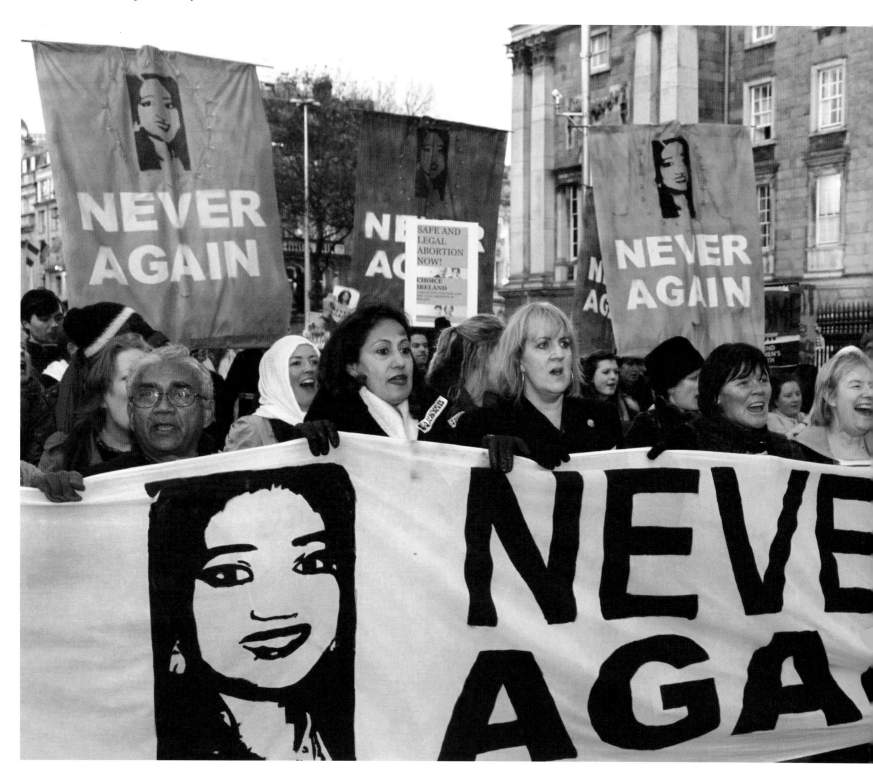

Road to Repeal

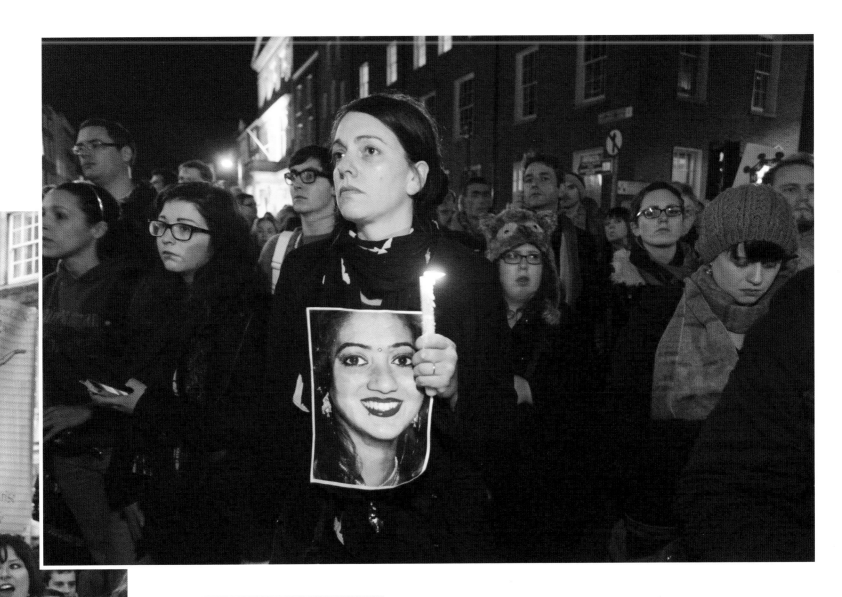

Irish Times journalist Kitty Holland broke the news of Savita Halappanavar's death and her book, Savita: The Tragedy that Shook a Nation, was published by Transworld Ireland in 2013.

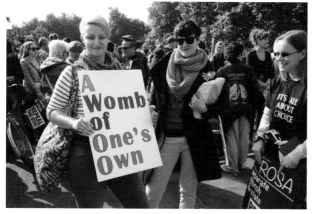

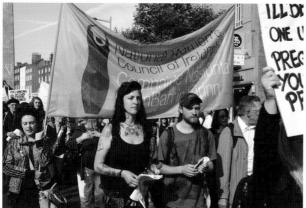

MARCH FOR CHOICE

On September 28th, 2013, the fledgling Abortion Rights Campaign launched what would become an annual national event in Dublin until repeal was won in 2018. During those years, the March for Choice was a magnet for abortion rights groups and activists of all ages from throughout the 32 counties. Photos by Derek Speirs.

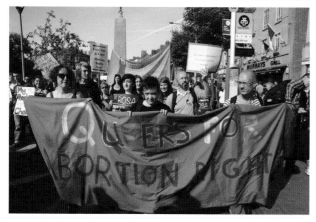

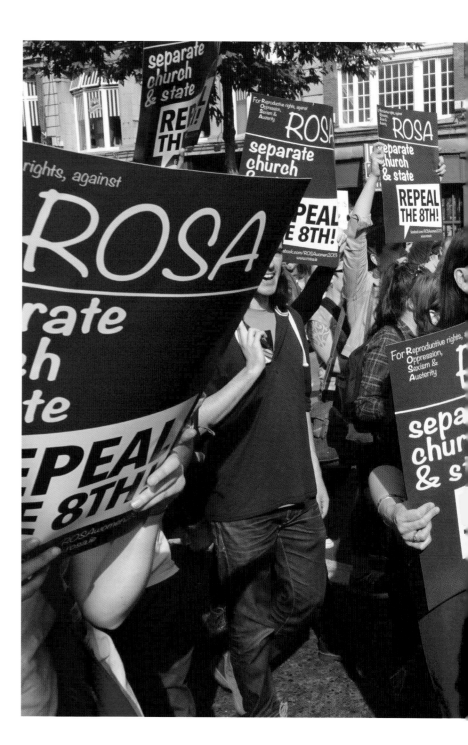

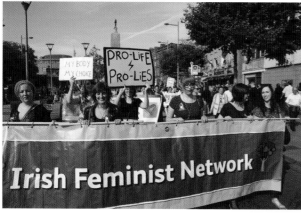

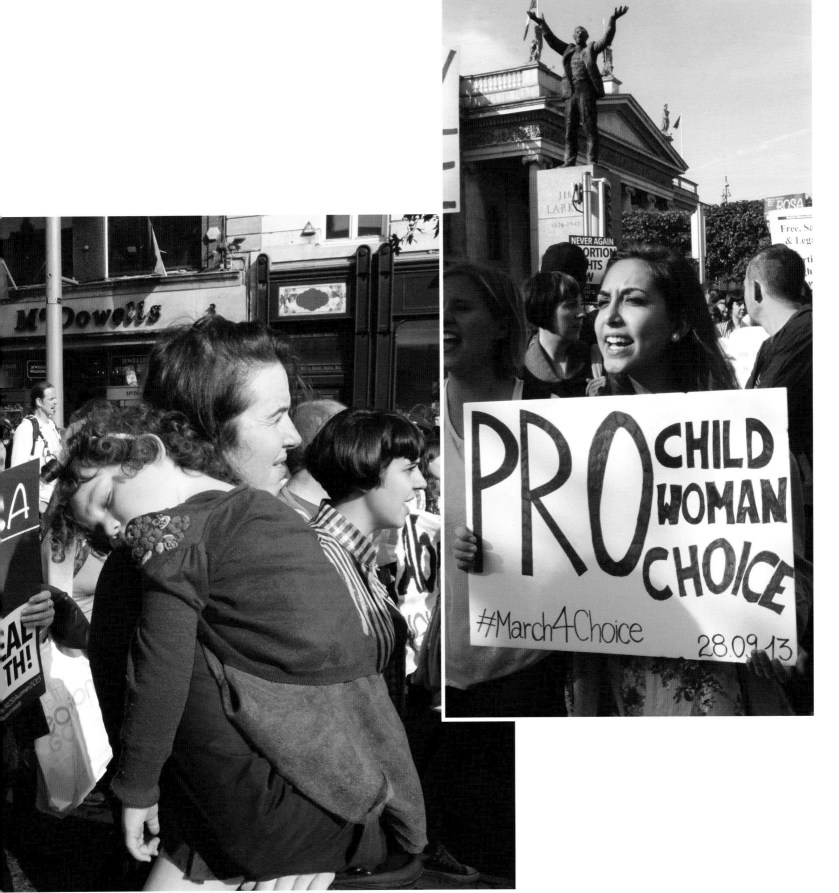

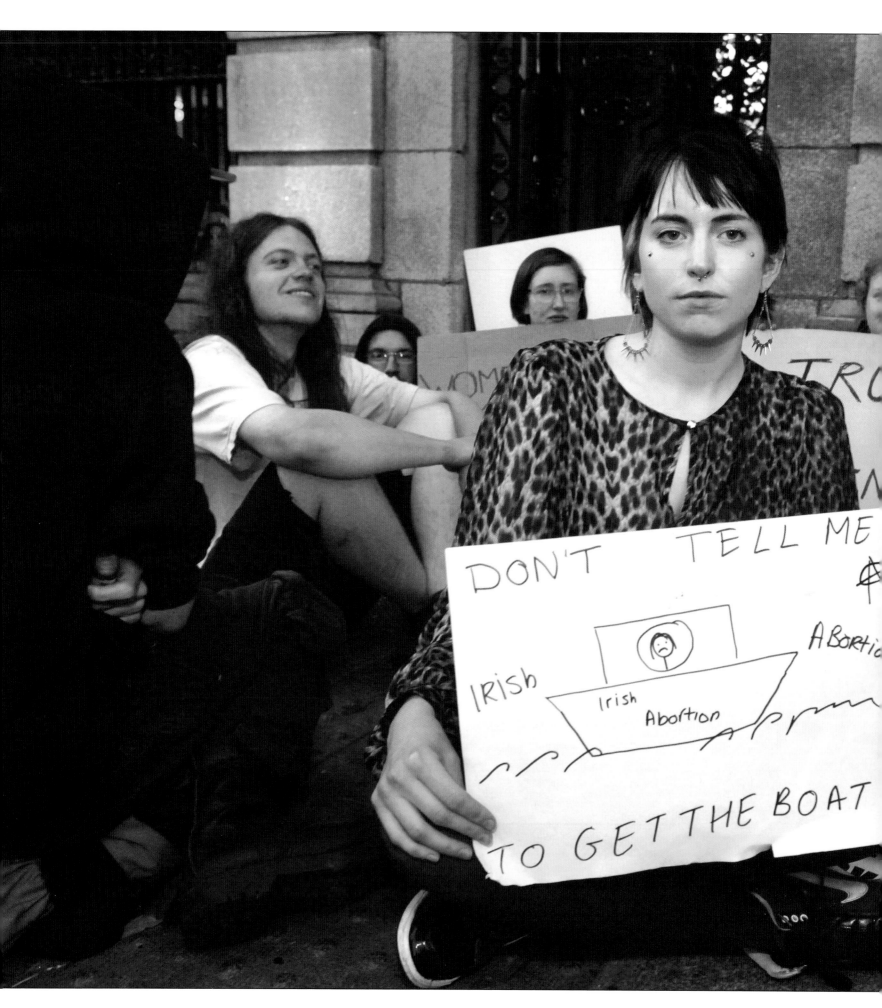

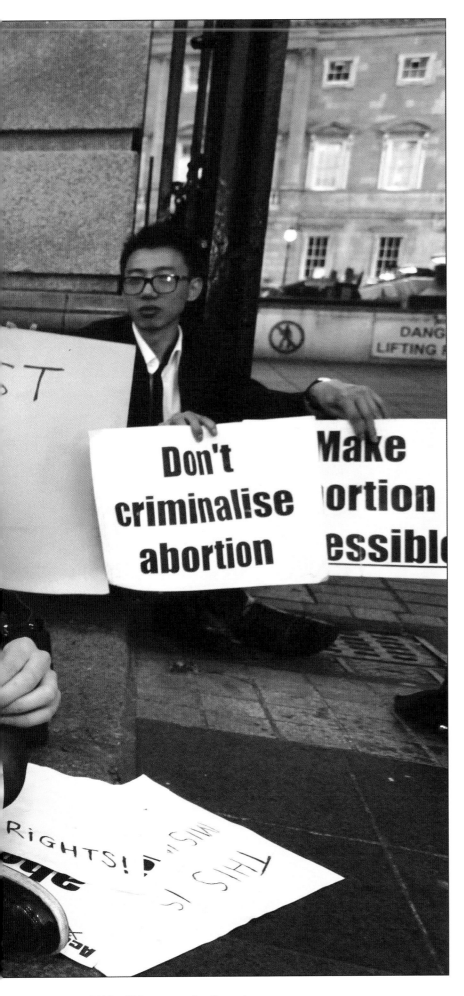

At 4am on July 11th, 2013, choice activists keep vigil on Kildare Street, Dublin, as behind them politicians in the Dáil debate the Protection of Life During Pregnancy Bill. Photo by Derek Speirs.

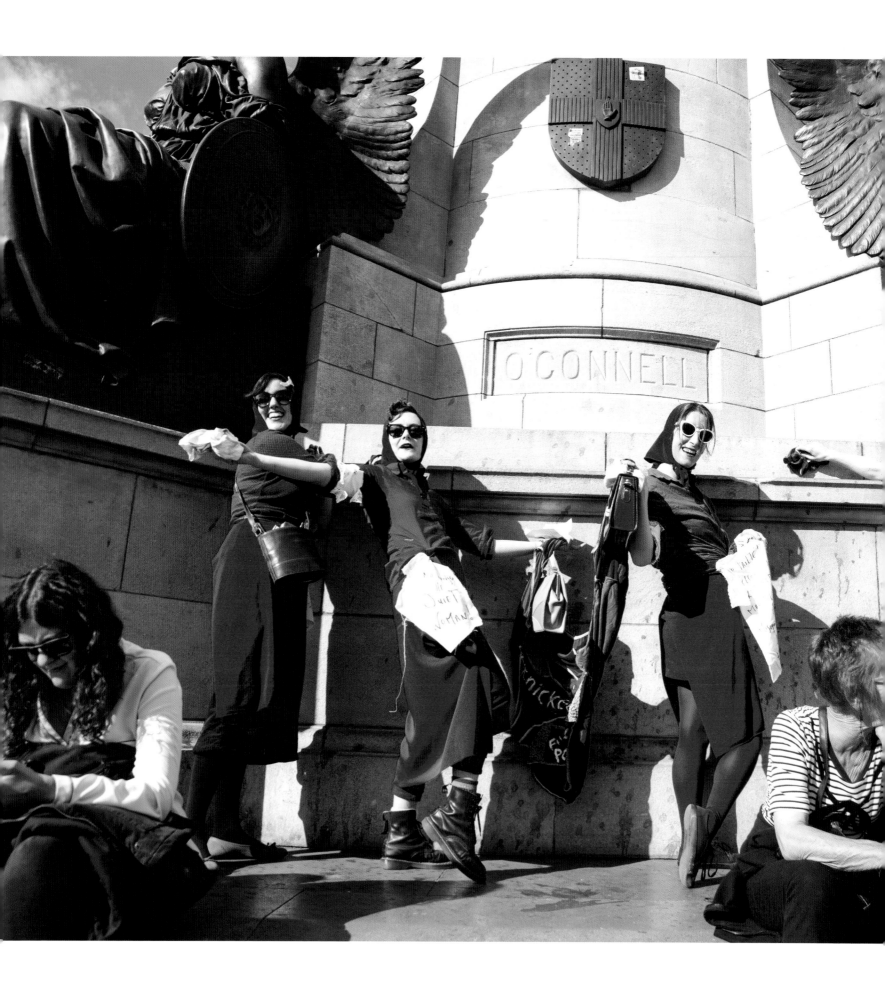

Road to Repeal

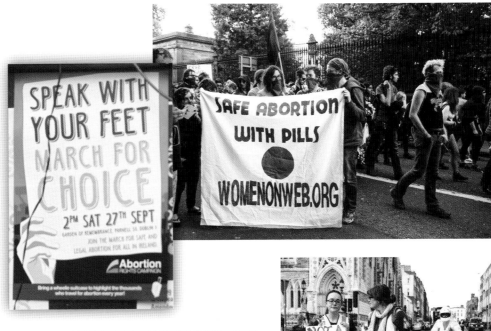

Left: Pictured on O'Connell Street, activists from the irrepressible Speaking of I.M.E.L.D.A taking part in the March for Choice 2014. This London-based direct action feminist performance group persistently challenged the ongoing problem of Ireland Making England the Legal Destination for Abortion. This and other photos of the March for Choice, September 27th, 2014 by Emma Loughran.

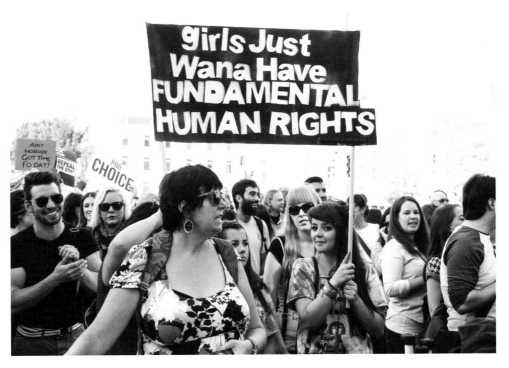

TRADE UNIONS AND REPEAL

As the island's largest civil society movement with a membership of over 719,000 (520,000 in the south), trade unions were an obvious place to circulate the repeal message. Taking their lead from the 1980s anti-amendment campaign, a handful of activists formed the Trade Union Campaign to Repeal the 8th in September 2014.

Unite the Union, already a member of the Coalition to Repeal the 8th, was joined by Mandate, the Communications Workers Union and Connect. The Irish Congress of Trade Unions issued a supporting statement consistent with its 1983 stance as did the Dublin Trades Council. Bray District Council and, further afield, Britain's Trade Union Congress, ASLEF train drivers union and UNISON publicly endorsed the TUCR8A. SIPTU did so in early 2018.

A modest initiative, the TUCR8A punched above its weight. In 2017 it had a role in producing the world's first-ever survey of worker attitudes to termination – Abortion as a Workplace Issue. As Road to Repeal demonstrates, abortion had created bitter division at every level in Irish society. Trade unions were not immune and old fears of lethal splits in the ranks persisted. But the survey established, once and for all, that women's reproductive rights were and remain a workplace concern.

Conducted by Ulster University under Dr Fiona Bloomer, the 32-county project with UNITE, UNISON, Mandate, the Communications Workers Union, the GMB, Alliance for Choice and the Trade Union Campaign to Repeal the 8th Amendment was launched in Buswells Hotel, Dublin, and in Stormont, Belfast in September 2018.

In the run-up to May 25th, union funding enabled the TUCR8A to publish a 20-page tabloid newspaper with contributions from major repeal supporters including Prof Sabaratnam Arulkumuran, Judge Catherine McGuinness, Prof Veronica O'Keane, Catholics for Choice, Dr Peter Boylan and union leaders Brendan Ogle, Steve Fitzpatrick and John Douglas among others.

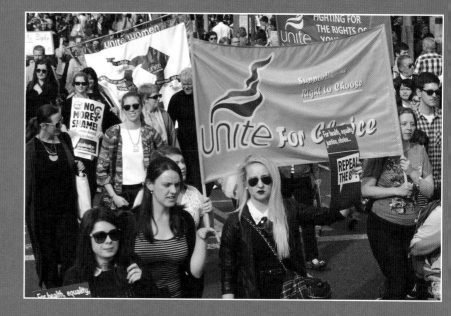

At the Dublin launch of Abortion as a Workplace Issue on May Day 2017 are, back row from left, Anne Speed, UNISON; Steve Fitzpatrick, CWU; Therese Caherty, TUCR8A; Taryn Trainor, UNITE the Union; front from left, Denise Walker, the GMB; Mandy LaCombre, Mandate and TUCR8A; study author Dr Fiona Bloomer; and Emma Gallen, Alliance for Choice.
Photo courtesy of Tommy Clancy.

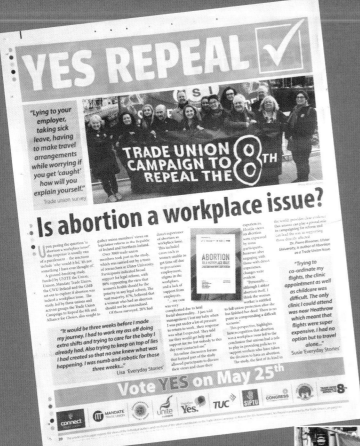

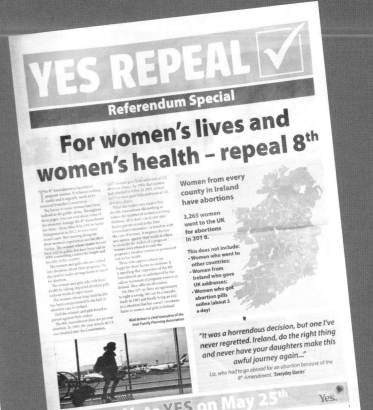

Trade unionists on the streets and in the office supporting repeal. Photos by Derek Speirs.

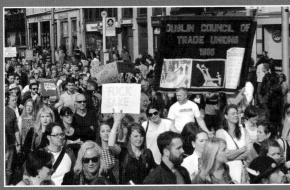

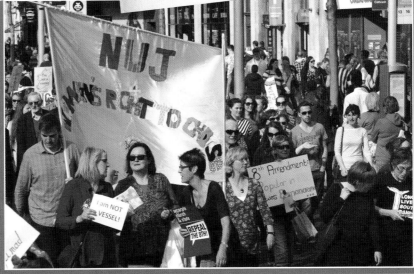

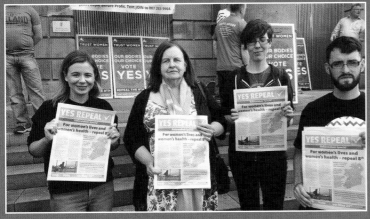

Bernadette McAliskey with trade unionists for repeal in Monaghan in May 2018. Photo by Eddie Conlon.

MS Y CASE

Recently kidnapped and raped in her conflict-ridden home country, Ms Y came to Ireland in March 2014 seeking asylum. A routine health scan showed she was eight weeks' pregnant. Despite her lack of English, she asked for an abortion and reaffirmed that choice up to her delivery by section five months later on August 6th.

Obviously traumatised by the rape, Y was not suicidal. Her only option was to travel abroad. But her migrant status meant time-consuming form filling for exit and entry visas from Britain and Ireland. In addition, she had no income.

In July 2014, she made a desperate journey to Britain to end the pregnancy. Entry was denied. The medical records stated she was a danger to herself. On her return, she was seen and referred by a GP to a hospital psychiatrist who deemed her suicidal. Y was later assessed by a panel of experts under the Protection of Life During Pregnancy Act (2013). Two psychiatrists agreed with their colleague, but an obstetrician said it was too late for abortion. The three found a Caesarean was the only option available under the PLDPA. At the news, Y refused all food and fluids, prompting the HSE to seek a court order to hydrate her.

At 26 weeks, she was delivered by section. Not to do so would have meant her going full term. Baby Y was later given up for adoption. Y's solicitor argued that her client had been given no choice in the matter as her suffering had put her beyond understanding what was happening.

To add insult, the HSE's subsequent inquiry into events was leaked before Y had been interviewed. Her solicitor had to request a copy because her client feared the draft's detail might identify her. Ms Y was later granted refugee status.

Defenders of Ms Y gather near the Spire on O'Connell Street, Dublin, in 2014. Photo by Emma Loughran. Press cuttings from The Irish Times.

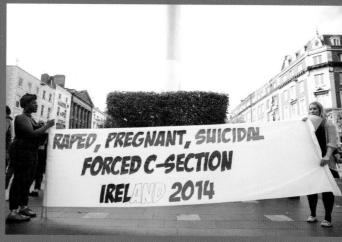

8 **News** Home

THE IRISH TIMES
Saturday, October 4, 2014

Ms Y became very distressed and stated she could not be pregnant, that she could not have a baby and that no one could know … Ms Y stated that she had been raped in her own country

Kitty Holland

HSE's first draft report on case of Ms Y tracks care to discharge from hospital after Caesarean section

documents "but cases such as Ms Y's were given priority" and it would take two to three weeks. Her application would be "processed as quickly as possible". The immigration council communicates this to IFPA by email and requests confirmation of the stage of Ms Y's pregnancy. The council gets no written response at this time but receives a call "sometime over the following couple of weeks".

May

Wednesday 14th
Ms Y attends clinic for second scan. Pregnancy now 14 weeks' gestation.

Tuesday 15th
Counsellor 2 returns call to staff nurse 1. Counsellor 2 is anxious Ms Y be put in touch with crisis pregnancy counselling at her new accommodation. She tells staff nurse 1 she had been waiting for Ms Y to return the completed travel documents. Staff nurse 1 says "she suspected that Ms Y had requested the move to … as she might have a termination of pregnancy arranged for her" at her new location.

Thursday 17th
Ms Y presents at her new GP for an appointment. She says she wants to see a psychologist as she wants an abortion. The GP refers her for an out patient psychiatric assessment. He contacts staff nurse 1 and learns Ms Y is 22 weeks

Saturday 26th
Ms Y continues to refuse fluids. A multidisciplinary team (MDT) is assembled.

Sunday 27th
Liaison psychiatric team and consultant obstetrician decide there are insufficient grounds for early delivery. Ms Y is told a meeting will discuss her case the next day. She continues to refuse food and fluids.

Monday 28th
She continues to refuse food and fluids. Consultant obstetrician X reviews her, explains the implications of her refusal to eat and drink, including cardiac arrest, renal failure and uraemia and says she would be medically unfit to undergo delivery of the baby.

MS P CASE

Ms P, a mother of two young children, became very unwell in 2014 while 12-14 weeks' pregnant. She was admitted to hospital where she fell and two days later was declared brain dead from a cyst on her brain. Against her family's wishes, she was placed on a life support machine in order to protect the right to life of the foetus until it was viable and could be delivered.

Ms P's family protested but to no avail. As her appearance and condition deteriorated, her father, partner and relatives went to the High Court asking for an order to remove the life support apparatus. The court determined that she was entitled to human dignity and that the continuing situation would only lead to further distress. A month after her hospital admission, life support was turned off and Ms P could be buried.

A subsequent inquest into her death delivered an open verdict. In 2016 her family issued legal proceedings against the Health Service Executive. They claimed, among other failings, that the cyst on her brain should have been diagnosed earlier by a scan and that her life could have been saved. The HSE conceded partial liability in 2019.

4 Home News

Right-to-die case

Woman's father says family united in wanting to bury her with dignity

Keeping woman on life support 'grotesque'

RUADHÁN Mac CORMAIC and MARY CAROLAN

The High Court has been told it would be "grotesque" to keep a brain-dead pregnant woman on life support given the chances of the baby being born alive.

The three-judge court will hear legal submissions this morning in the case of the woman, who was declared brain-dead on December 3rd, but remains on life support due to uncertainty about the legal consequences of switching it off.

The woman's father told the court her family were united in wanting the treatment stopped and to bury her with dignity. "My daughter is dead. The chances of the foetus surviving are minimal, we have been told," he said.

The woman's partner said he agreed with this.

The special out-of-term hearing, involving 17 lawyers, heard from seven consultants in obstetrics, neurology and intensive care. None argued that life support should be maintained. A former master of Dublin's Rotunda Hospital, Dr Peter McKenna, said doing so would mean "going from the extraordinary to the grotesque."

Brain trauma
Dr Brian Marsh, a specialist in intensive-care medicine, said the foetus was at 15 weeks when the woman was declared brain-dead. That was the relevant age because it was when the normality of the maternal-foetus relationship was severed as a result of the brain trauma and the subsequent life-support treatment.

The court heard that the woman's brain was rotting, that she was suffering from an infection and that her condition was deteriorating rapidly.

Consultant obstetrician Dr Peter Boylan said the viability of a foetus was generally regarded as 24 weeks, but only 25 per cent of babies born then survived. Of those, only 15 per cent were not disabled.

'Dignity'
The likelihood of a successful outcome in this particular case was "very low", he said. "In any other jurisdiction, this woman would be allowed die with dignity."

John Rogers SC, for the woman's father, argued the Eighth Amendment to the Constitution, which sets down the equal right to life of the mother and the unborn, was not applicable to this case. The purpose of the amendment was to protect the unborn from abortion and that was not at issue here, he said.

Conor Dignam SC, representing the interests of the unborn, said that if the medical evidence established no prospect of the unborn being viable if life support was maintained, the court should declare it lawful for those measures to be withdrawn.

A consultant neurologist who treated the woman said he had seen "dreadful things" in his professional life but never a situation like this.

The three presiding judges – Mr Justice Nicholas Kearns, Ms Justice Marie Baker and Ms Justice Caroline Costello – will make their decision known on St Stephen's Day.

➡ Woman's family united in wanting to bury her with dignity: page 4

BUILDING THE COALITION

A national conference held in Dublin's Gresham Hotel on September 6th, 2014 was the first public event hosted by the Coalition to Repeal the 8th Amendment, which at that point was one year old. At its height, the coalition had the support of over 100 groups that included many NGOs and others such as Tipp for Choice, the Sex Workers Alliance Ireland, Scottish and London Irish Abortion Rights Groups, transgender network TENI, British-based train drivers' union ASLEF and ICTU's sister organisation, the TUC, doctors, lawyers, students, artists, and future co-leaders of Together for Yes: Ailbhe Smyth, coalition convenor, Grainne Griffin of the Abortion Rights Campaign and Orla O'Connor of the National Women's Council of Ireland. Derek Speirs's photos show the breadth of the coalition's reach.

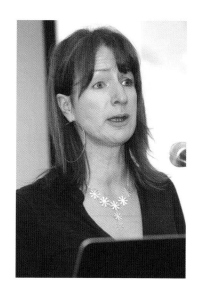

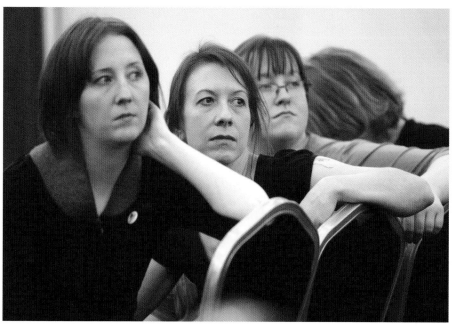

Left: Choice campaigners Grainne Griffin, future co-leader of Together for Yes, with solicitor Wendy Lyons and socialist feminist Rita Harrold of Rosa.
Above: Independent left TD Clare Daly.

Below right: law lecturer Mairead Enright; social policy analyst and writer Dr Pauline Conroy; Latifat Olagoke of AkiDwA; Edel McGinley, the Migrant Rights Centre of Ireland; and Dr Niamh Reilly, NUI Galway.

Below left: Niall Behan, IFPA; Dr Veronica O'Keane, Doctors for Choice; Amnesty Ireland's Colm O'Gorman; Mara Clarke, Abortion Support Network; and Dr Sandra McAvoy, Cork Women's Right to Choose. Photos by Derek Speirs.

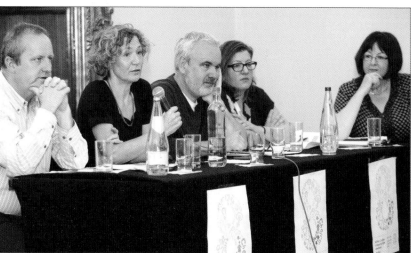

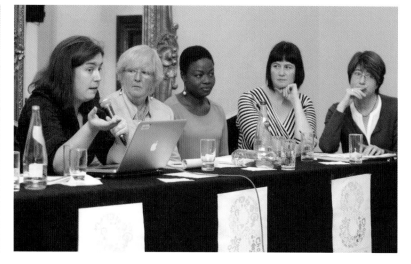

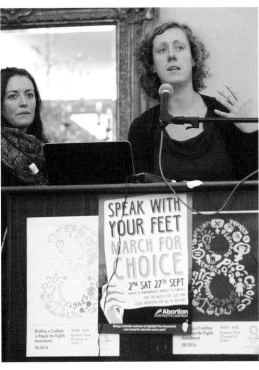

Clockwise from above: Writer and choice activist Ann Rossiter; Siobhan Clancy and Aoife Cooke, Abortion Rights Campaign; Catherine Murphy TD; Taryn Trainor of Unite the Union; and Dr Mary Favier of Doctors for Choice.
Photos by Derek Speirs.

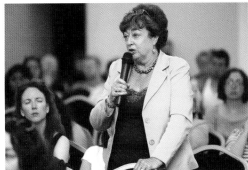

STRIKE4REPEAL

The women-led Black Protests, staged in over a 100 Polish cities and villages in October 2016, were a response to efforts to tighten Poland's abortion laws. Their success was a global inspiration, triggering the International Women's Strike movement.

Ireland's choice community took note. On International Women's Day, 2017 an ad hoc, non-affiliated group of activists, academics, artists and trade unionists staged a State-wide Strike4Repeal.

They had demanded a referendum by March 8th because "in the past 5 years, support for repeal has grown to a level [the Government] can no longer ignore" otherwise they would strike. It was not traditional industrial action so supporters were urged to be imaginative: take a day's leave, abandon housework, wear black, stage a lunch break walkout. Businesses were asked to give staff a day off - or just close – and some did both.

With its lightning blaze logo, Strike4Repeal was innovative in how it linked the profound anger of young women and men in Ireland about political cowardice on abortion with similar struggles elsewhere. The event, backed among others by the Coalition to Repeal the 8th, the Abortion Rights Campaign and Students Union of Ireland, was well peopled as Paula Geraghty's images demonstrate.

At time of writing, Poland All-Women's Strike was still actively resisting attacks on constitutional rights to abortion.

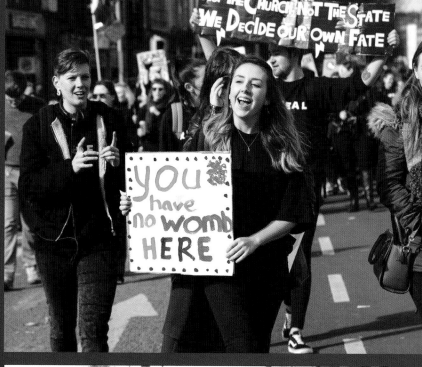

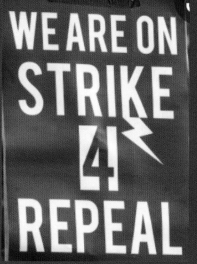

Strike4Repeal activists on the march, International Women's Day, 2017. Photos by Paula Geraghty.

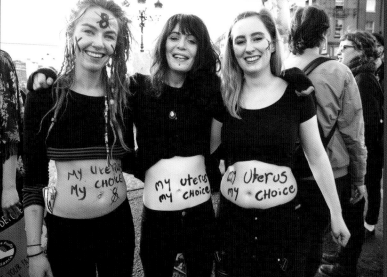

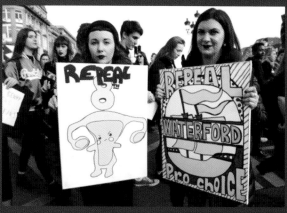

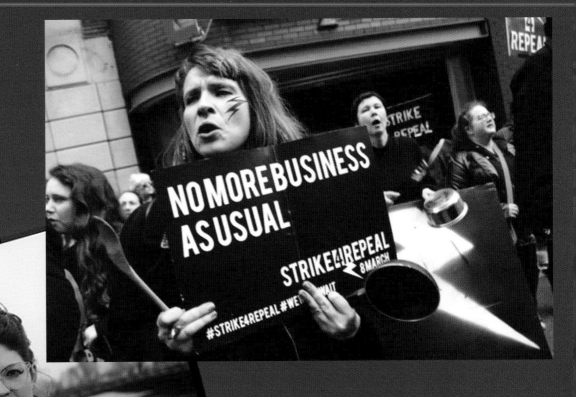

NOMOREBUSINESS ASUSUAL

STRIKE4REPEAL 8MARCH
#STRIKE4REPEAL #WE WON'T WAIT

WE HAVE ONE DEMAND TO THE GOVERNMENT

CALL A REFERENDUM BEFORE THE 8TH OF MARCH

OR THERE WILL BE A NATIONAL STRIKE

From top, Strike4Repeal activists Claire Brophy, Emily Waszak and Kerry Guinan. Screengrabs from the Strike4Repeal website.

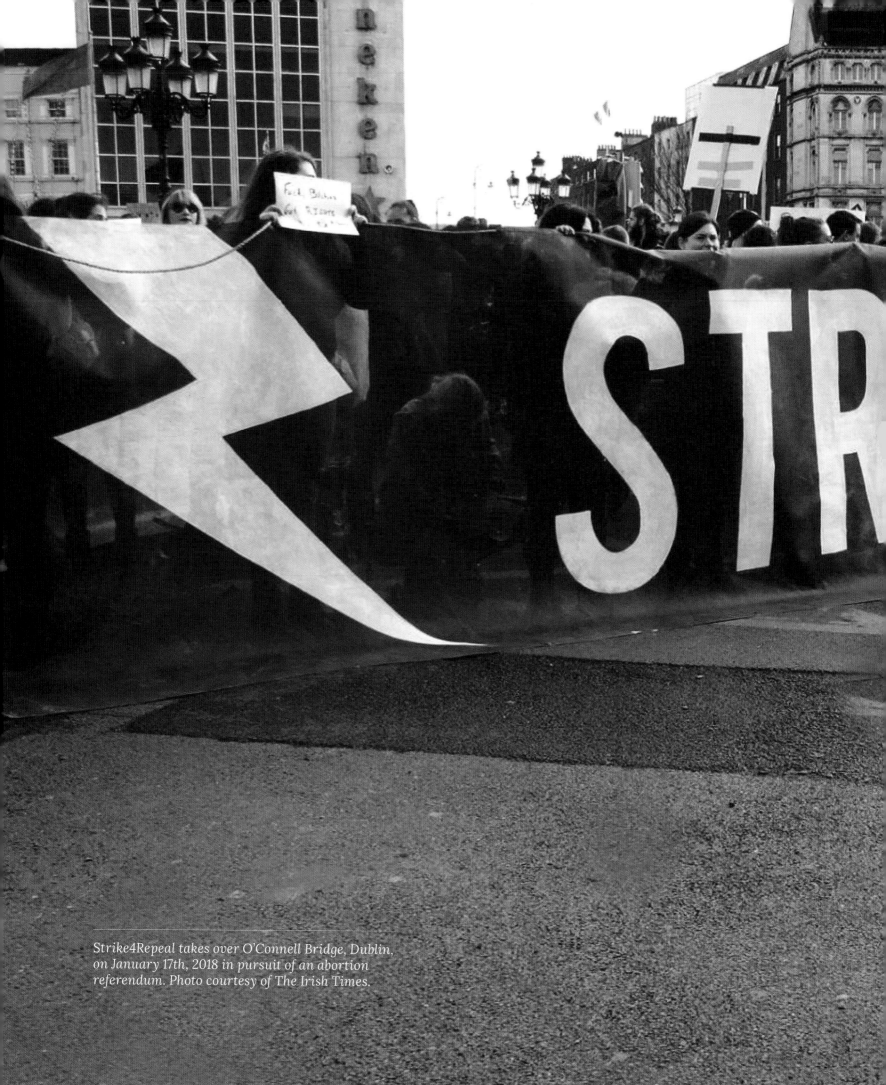

Strike4Repeal takes over O'Connell Bridge, Dublin, on January 17th, 2018 in pursuit of an abortion referendum. Photo courtesy of The Irish Times.

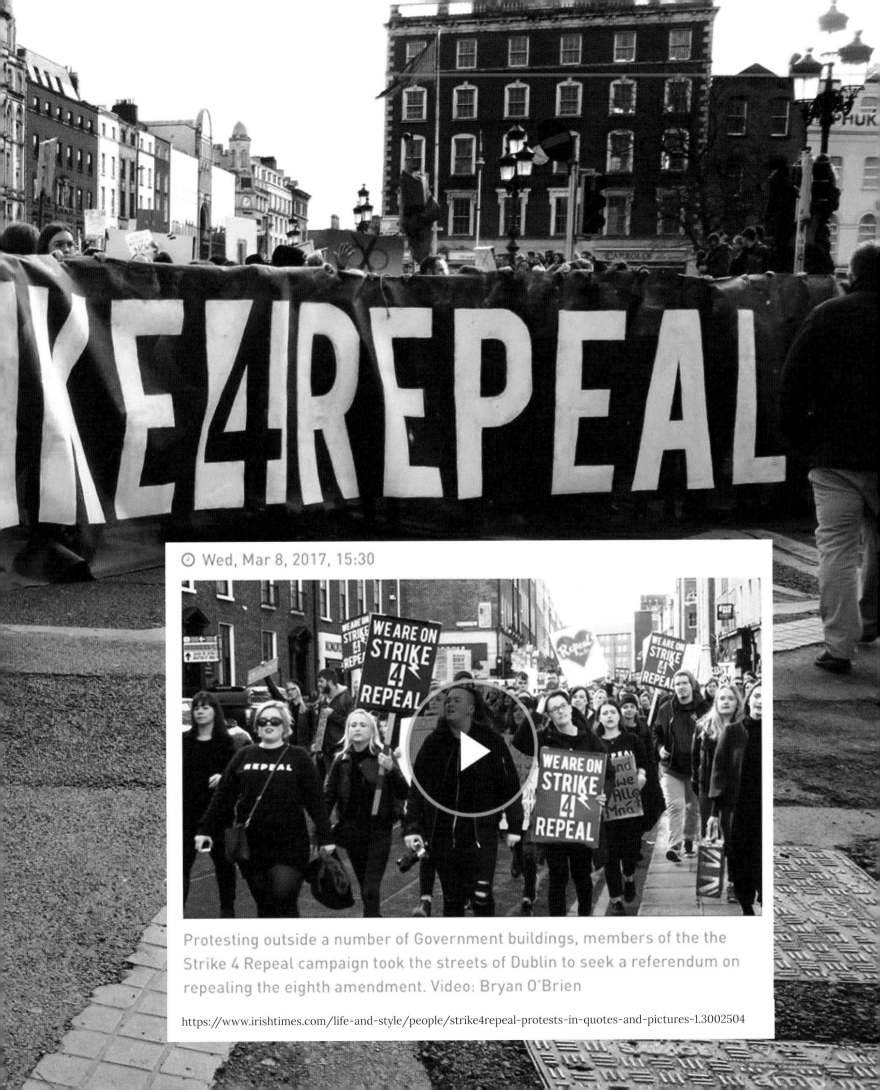

RE4REPEAL

Protesting outside a number of Government buildings, members of the the Strike 4 Repeal campaign took the streets of Dublin to seek a referendum on repealing the eighth amendment. Video: Bryan O'Brien

https://www.irishtimes.com/life-and-style/people/strike4repeal-protests-in-quotes-and-pictures-1.3002504

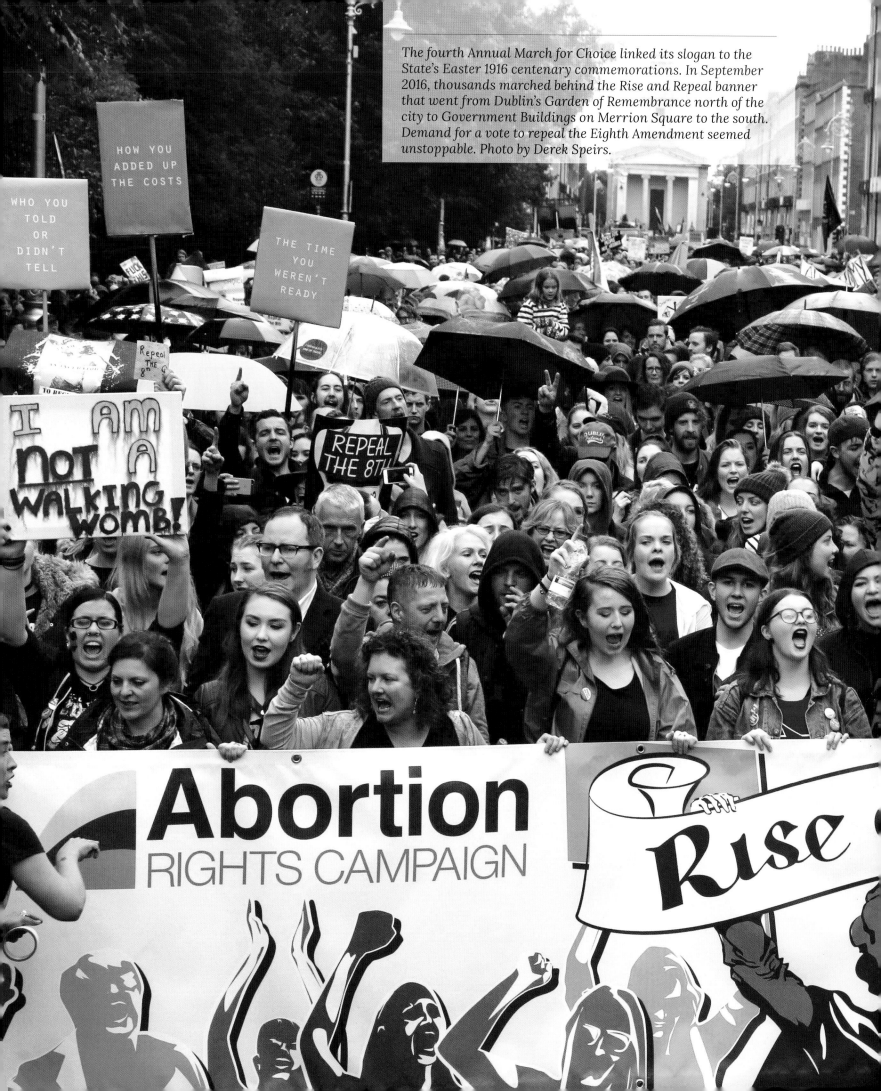

The fourth Annual March for Choice linked its slogan to the State's Easter 1916 centenary commemorations. In September 2016, thousands marched behind the Rise and Repeal banner that went from Dublin's Garden of Remembrance north of the city to Government Buildings on Merrion Square to the south. Demand for a vote to repeal the Eighth Amendment seemed unstoppable. Photo by Derek Speirs.

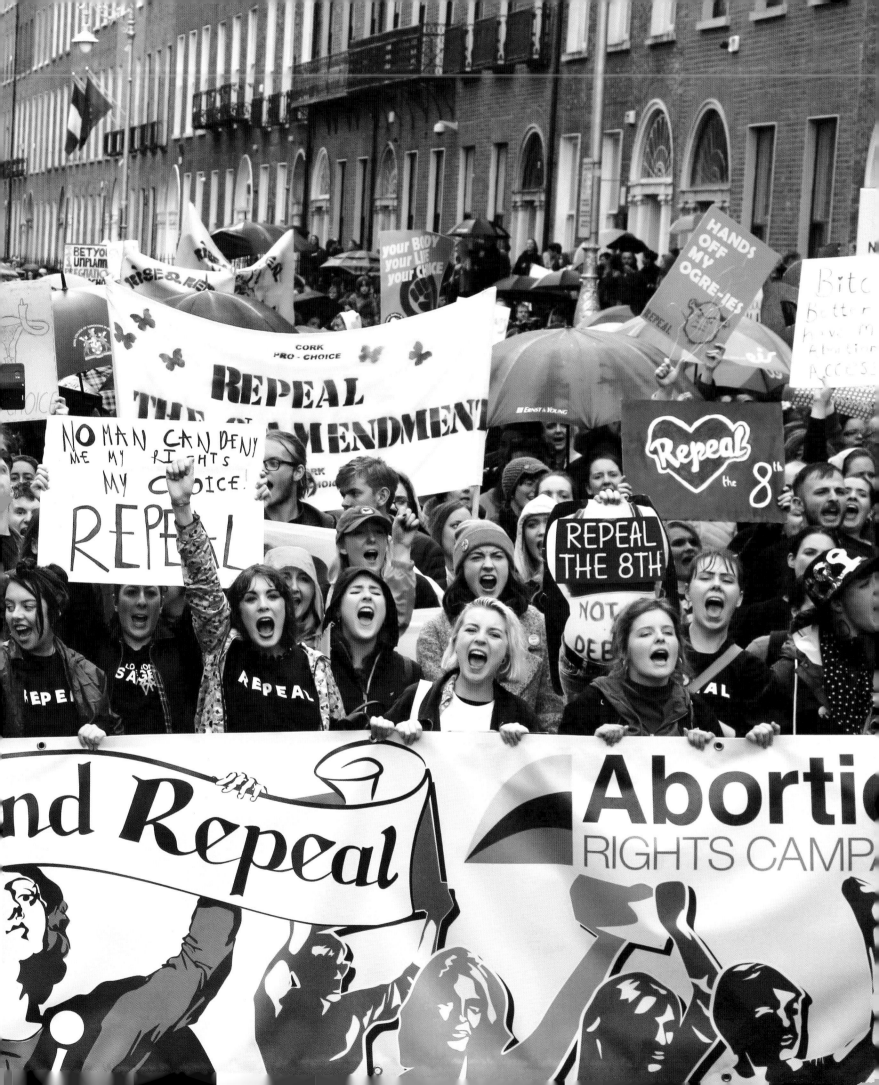

TIME TO ACT – FREE SAFE LEGAL

The push for a referendum to liberalise abortion laws intensified during September 30th, 2017's fifth March for Choice. Voices for Choice tuned up to tell the crowd it's "what we really want" as civil rights and feminist activist Bernadette McAliskey expressed her disbelief that "we're still here … demanding something we demanded almost 50 years ago … We expect, and we demand, and we are entitled to exercise the same bodily integrity as every other human being on the face of this planet". Speakers on the day included historian Catriona Crowe, Siobhan Donoghue of Uplift, and future Oireachtas member and first Traveller in the Dáil Eileen Flynn. Organisers claim up to 30,000 marchers took part.

Photos by Derek Speirs.

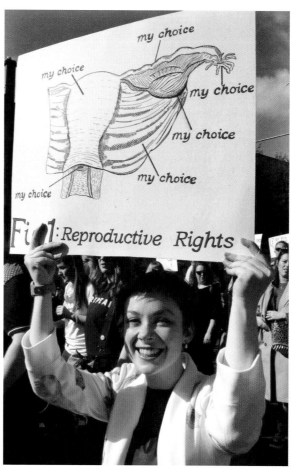

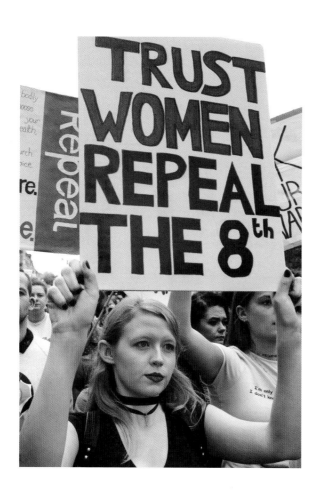

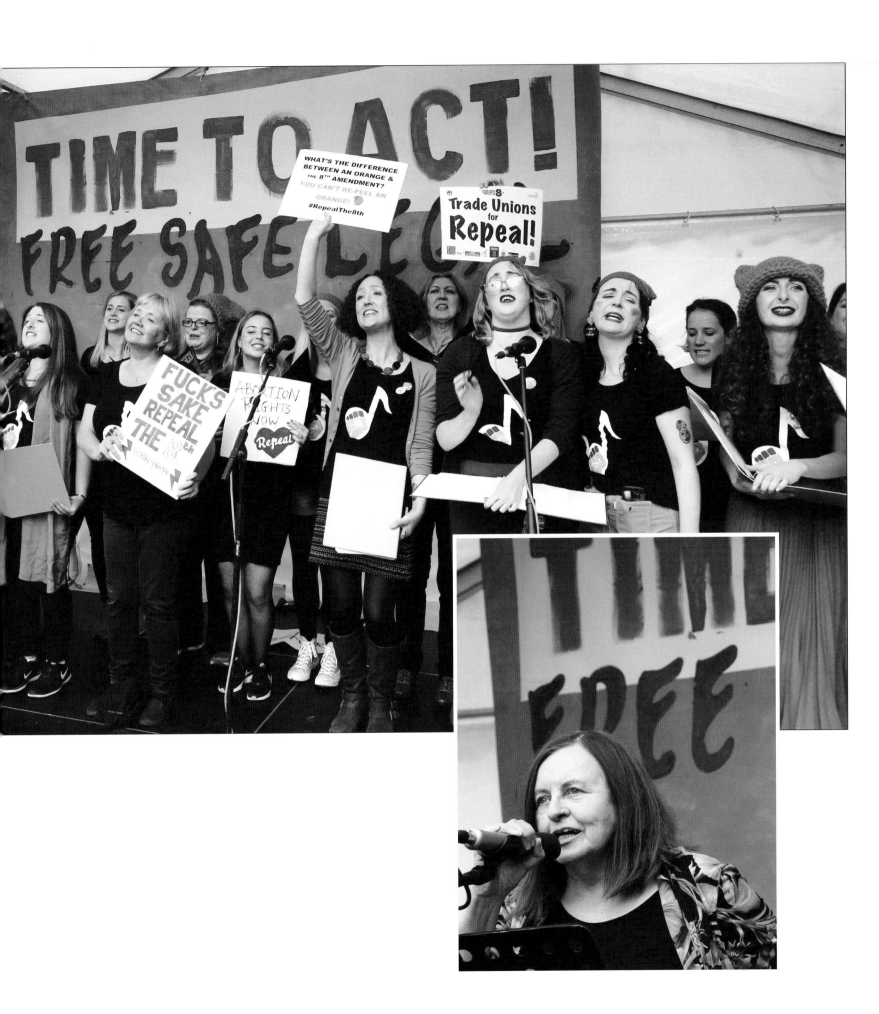

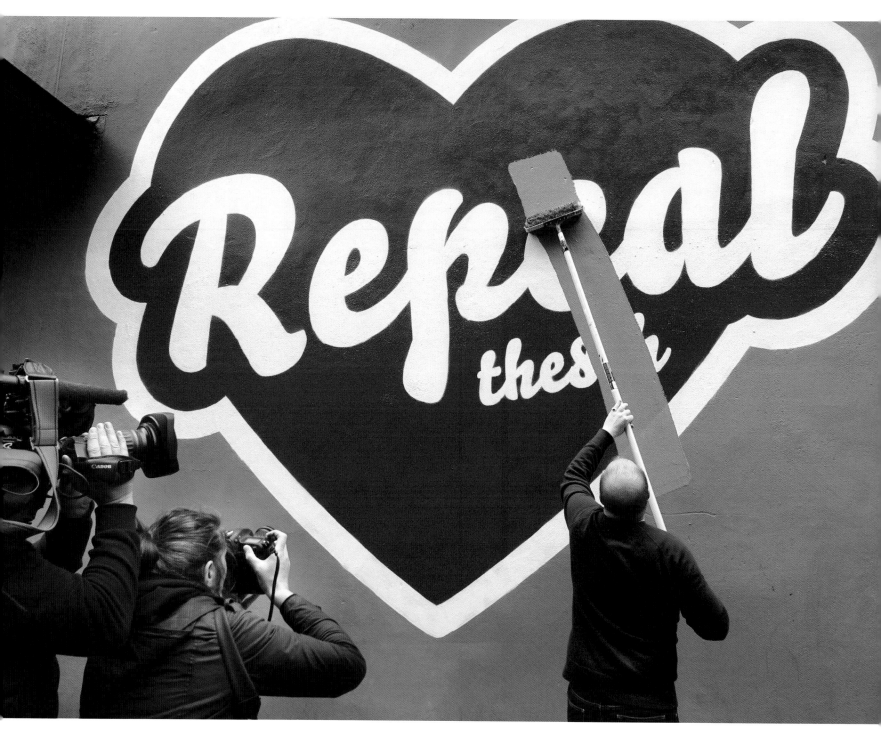

The Artists' Campaign to Repeal the Eighth Amendment hosted a Day of Testimonies in Dublin's Project Arts Centre on August 26th, 2017. Involving visual and performance art, film, documentary, poetry, music, and contemplation of the ban's impact, the day highlighted its danger to women's physical and mental health. The evening session, directed by Lynne Parker, honoured citizens directly affected by Article 40.3.3 and told their stories.

Cian O'Brien, artistic director, Project Arts Centre, painting over the iconic Maser mural on April 21st, 2018, on foot of instructions from the Charities Regulator who said that displaying the mural put the centre in breach of the Charities Act 2009. Photo by Derek Speirs.

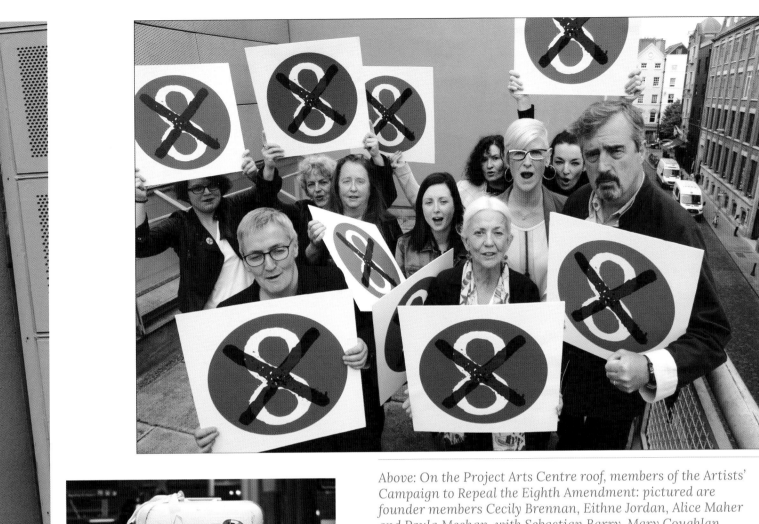

Above: On the Project Arts Centre roof, members of the Artists' Campaign to Repeal the Eighth Amendment: pictured are founder members Cecily Brennan, Eithne Jordan, Alice Maher and Paula Meehan, with Sebastian Barry, Mary Coughlan, Amy Walsh, Aideen Barry, Rachel Fallon and Natasha Waugh. The campaign's online archive is at
https://repository.dri.ie/catalog/gx421568w

The WIN

A poster for The WIN, a 2016 drama by Smock Alley Theatre, Dublin, about the Women's Information Network (1983-91), directed by Tara-Louise Morrison and Cara Brophy Browne, daughter of WIN founder member Imelda Brophy.

The Communications Workers Union, North Circular Road, Dublin, kits out its own headquarters in a banner demanding repeal. Photos by Derek Speirs.

TOGETHER FOR YES

One of Ireland's biggest social mobilisations ever on any issue was the campaign Together for Yes between 2016 and 2018. A true riot of colourful creativity and grassroots action exploded across the State. Together for Yes was the outcome of strategic planning between the Coalition to Repeal the Eighth Amendment representing over 120 organisations, the Abortion Rights Campaign with local groups in most counties and its Facebook and social media outlets, the National Women's Council with 190 member organisations and joined by the Irish Family Planning Association. Trade unionists, artists, doctors, lawyers had already been campaigning together to encompass ever widening support domestically and overseas. This was a movement capturing the imagination of thousands and a turning point in the longstanding campaign to remove Ireland's abortion ban under Article 40.3.3 of the Constitution.

Propaganda actions took place at the Galway Races, outside the Dáil, on bridges across the River Liffey and the River Lee. There were poster and placard-making workshops, badge design, T-shirt production. Personal testimonies of women and couples who felt obliged to seek a pregnancy termination accelerated the desire for change. Young people and students pushed the campaign forward with a determination to succeed and a leap into the future. #Together4Yes attracted a wide following in multiple languages.

Together for Yes with its formidable mandate was able to interact with debates and discussions inside and outside the Dáil and support those TDs uncertain about which path to take in their decision-making. Distributing leaflets outside a church, an activist recalled many older and elderly Mass-goers taking a leaflet and holding her hand tightly – and silently.

While the Catholic Church campaigned hard within its own ranks for a No vote, the institution's public voice was weakened terribly by the previous reports on its historical shortcomings, and unconvincing defences by its representatives.

Together for Yes launched a crowdfunding campaign with a target of €50,000. Within days it had raised €500,000 with the help of 12,000 donors. This financial

support enabled tens of thousands of leaflets and posters to be distributed through the campaign's Upper Mount Street headquarters manned and womaned by volunteers. This literature had the advantage of being professionally designed by Adam May and Language. Together for Yes attracted attention from international media outlets including Time magazine in the US with a circulation of 3.3 million.

Unlike the previous five referendums on the Eighth Amendment, this time a win seemed within reach. In the UK thousands of young emigrants flew back to Ireland to vote, raising the numbers of pro-choice voters.

At Dublin Castle on May 26th, 2018, the yard was packed to capacity awaiting the outcome of the vote. Tears of relief and a multitude of cheers and excitement greeted the victory's announcement. It had taken 35 years to get there and 100 years from the election of Constance Markievicz to Parliament in 1918. Incredible amounts of door-to-door canvassing and many women telling their own story publicly for the first time made a major contribution to the demise of the Eighth Amendment.

Above right: Judge Catherine McGuinness, and below, Gaye and Gerry Edwards of Termination for Medical Reasons speaking at the launch of the Together For Yes campaign, March 22nd, 2018, in the Round Room at the Rotunda in Parnell Square, Dublin. Their personal testimony encouraged others to come forward and tell their stories of the Eighth. Photos by Derek Speirs.

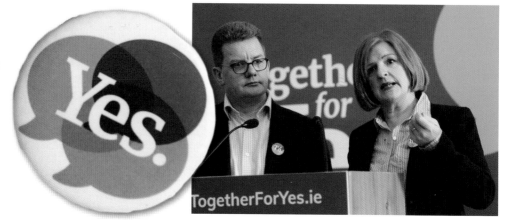

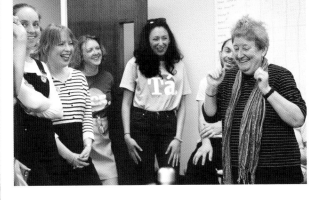

Inside the Together for Yes campaign HQ, based in 14 Upper Mount Street, Dublin, where an almost 24/7 operation was run, particularly as the May 25th referendum date neared. Just three days before the vote, TFY personnel can be seen hard at work.

Above: Katha Pollitt, US poet, feminist and author of the celebrated Pro: Reclaiming Abortion Rights 2014, paying a working visit while covering the referendum for US weekly, The Nation magazine.

Photos by Derek Speirs.

Dublin City Centre on the day of the vote, May 25th, 2018. Photo by Derek Speirs.

Road to Repeal

ROAD TO REPEAL

"Winning" and "Victory" were words rarely used for the outcomes of choice activism during the 1980s to the 2010s. That all changed with a new generation of focused campaigners at home and abroad ready for whatever had to be done to lift Ireland's constitutional ban on abortion. Many of their localised actions – knocking on doors, vigils, postering, coffee mornings, market stalls, hiring buses for marches, coordinating pickets of embassies across Europe and Australia not to mention their social media skills – galvanised the country. Two generations of activists were joined in a common cause to secure women's right to choose.

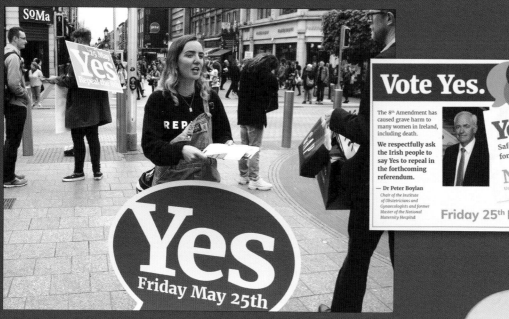

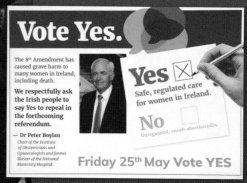

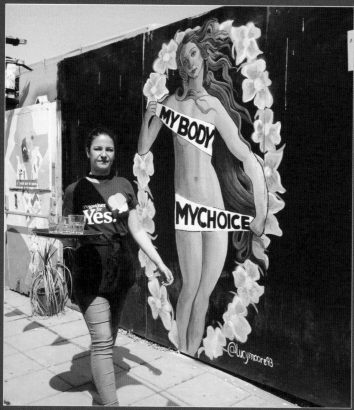

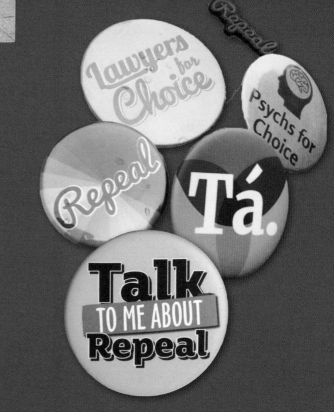

Last minute campaigning before the vote on May 25th, 2018. Photos by Derek Speirs.

Referendum campaign

Varadkar hopes Yes outcome will take away 'legacy of shame' in society

- Taoiseach says a No outcome would send out the wrong message to women
- Retain TDs promise to oppose legislation for abortion up to 12 weeks if repealed

SARAH BARDON
Political Reporter

Taoiseach Leo Varadkar has said a Yes vote in the referendum on the Eighth Amendment could help lift the stigma for 170,000 women who have travelled abroad to seek a termination of their pregnancy.

Mr Varadkar insisted he was not taking the outcome of the referendum for granted, but said he did not want to contemplate a No vote or what it would mean for women across the country.

There has been a legacy of shame in this country, and the passage of this referendum would assist those women, he added. "A No vote would send out the wrong message, not just to women but to society," he said. "There has been in Ireland a legacy of shame in many ways.

"The fact women have had to travel, sometimes in secret, to other jurisdictions to end their pregnancies, and I hope that a Yes vote would end that stigma, and help to take away that legacy of shame that exists in our society."

Fine Gael members advocating a Yes vote gathered for the final time to encourage people to vote Yes. Mr Varadkar was joined by Tánaiste Simon Coveney, Minister for Health Simon Harris, Minister for Finance Paschal Donohoe, and several others.

If there is a Yes vote the Government would publish the final Heads of a Bill to regulate the termination of pregnancy by the summer, and seek to legislate by the end of the year.

Regardless of the outcome Fianna Fáil TDs Mary Butler, Eamon Ó Cuív and Declan Breathnach were among a number of TDs to call for a No vote at their final press conference yesterday.

The three TDs indicated they would not support legislation to allow for abortion up to 12 weeks regardless of the outcome of the referendum. However, they said they may seek to amend the Government's Bill to allow for terminations in certain circumstances.

Mr Breathnach said he hoped it would not be a Yes vote, but if it was he would be looking to legislate for the hard cases. "Common sense should prevail in the cases of fatal foetal abnormalities, rape and incest," he said. "I would support that. Most people understand the hard cases. The Dáil should debate that ... we have reached a situation where people are in a crisis making their decision."

Ms Butler said she would not halt legislation in the cases of rape, incest and fatal foetal abnormalities.

Stressing his belief
However, she would "never be in agreement with abortion on demand" because "every child has a right to life".

Mr Ó Cuív declined to state whether he would support abortions in those cases, stressing his belief that "every human life is of equal worth".

It is understood senior members of Fianna Fáil have contacted individual TDs to "use their influence" to ensure members of the party who support a No vote do not threaten to block the legislation.

There have been a number of TDs who claim they will not support the legislation regardless of the outcome of the referendum.

One party source said there would be some TDs and Senators who would rush to the media to claim they can stop the legislation.

"The message was to try to curb that enthusiasm because it is bad for the party," the source added.

Meanwhile, party leader Micheál Martin urged people to vote Yes.

He said he understood this was not black and white, but urged people to vote Yes for women in "traumatic crises, and who want compassionate care in their own country".

■ 'Home to Vote' campaigners were welcomed and cheered as they entered the arrivals lounge at Dublin Airport yesterday. PHOTOGRAPH: NICK BRADSHAW

Together for Yes Retweeted

London-Irish ARC @LdnIrishARC · May 24, 2018

Just some of the gang coming #HomeToVote from Gatwick right now! #Together4yes

0:02 | 106K views

57 715 4.9K

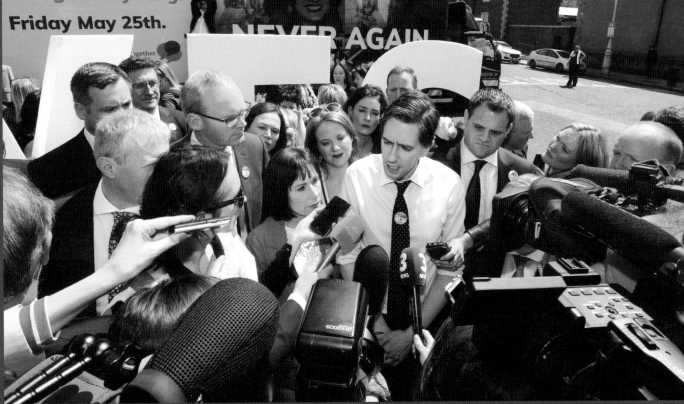

Health Minister Simon Harris giving a press briefing outside the Together for Yes campaign HQ on May 23rd, 2018. Photo by Derek Speirs.

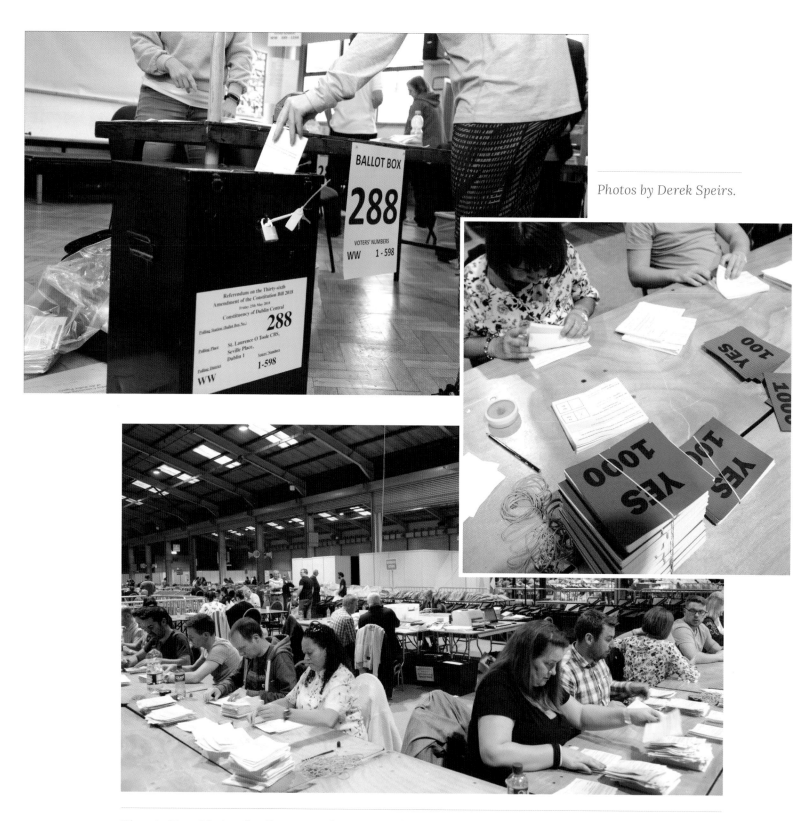

Photos by Derek Speirs.

Time to Vote: Voting finally gets under way on the 36th Amendment of the Constitution Bill.
Early exit polls suggest a comprehensive win. The following day the Dublin City count takes place
in the RDS south of the city and the vote tally gives it to the Yes side; campaigners for repeal begin
celebrating early in the RDS as the Yes result becomes clear.

Road to Repeal

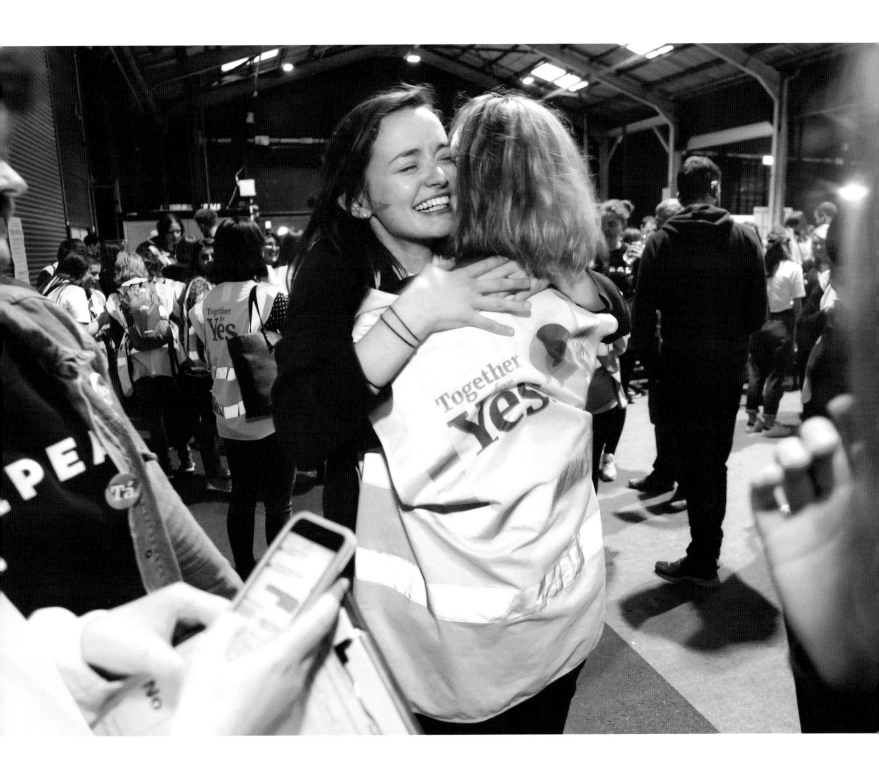

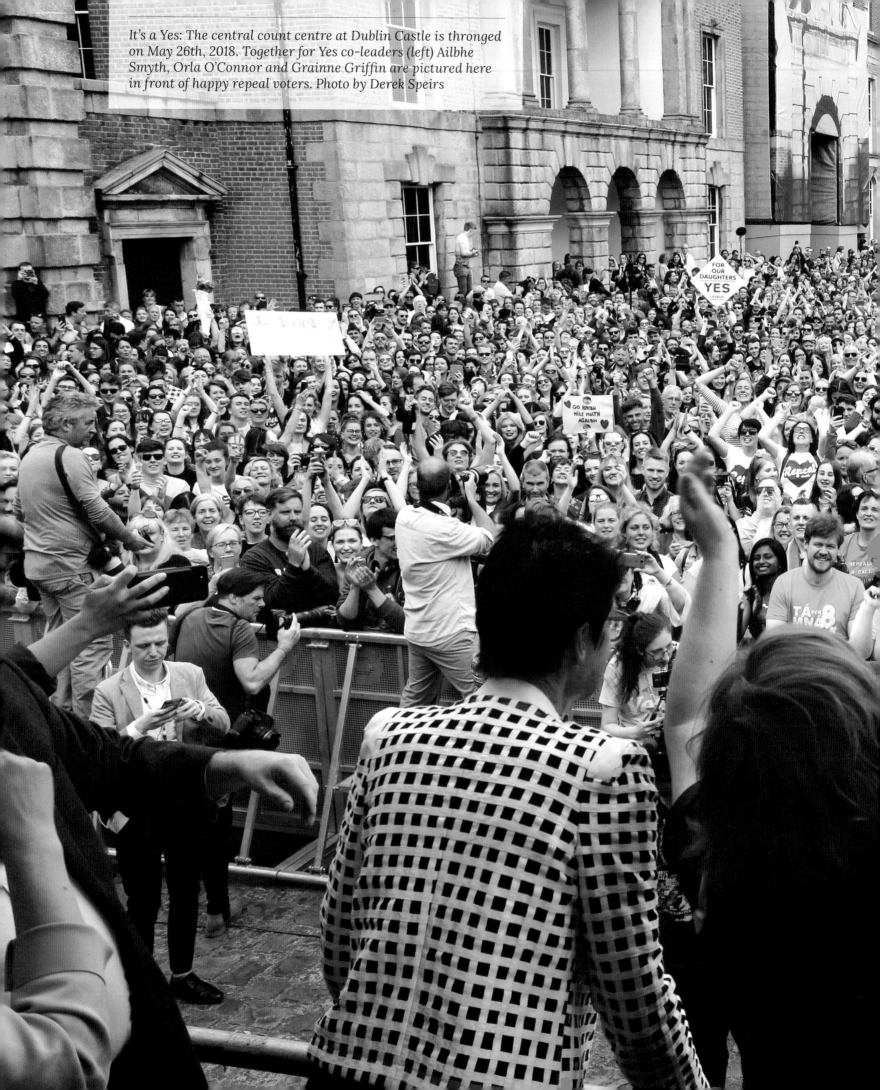

It's a Yes: The central count centre at Dublin Castle is thronged on May 26th, 2018. Together for Yes co-leaders (left) Ailbhe Smyth, Orla O'Connor and Grainne Griffin are pictured here in front of happy repeal voters. Photo by Derek Speirs

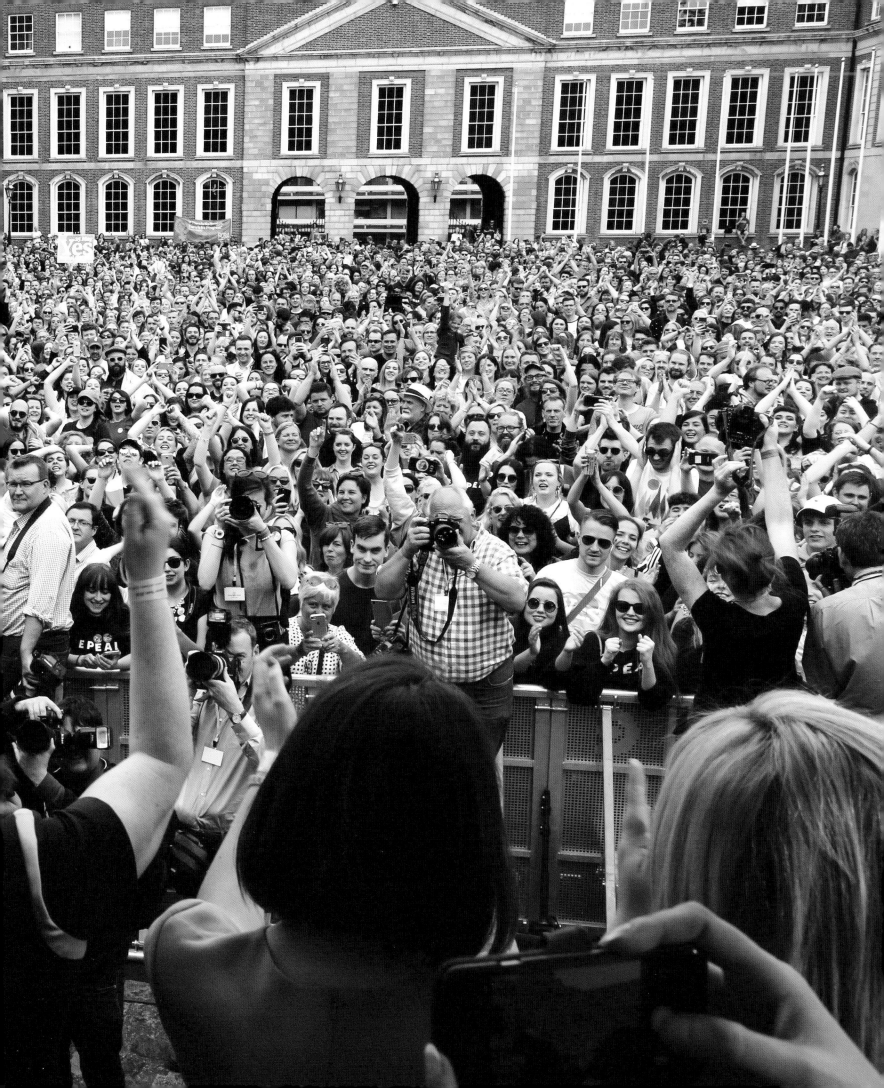

Right: Savouring a historic victory in Dublin Castle on May 26th, 2018. Photos by Derek Speirs.

Road to Repeal

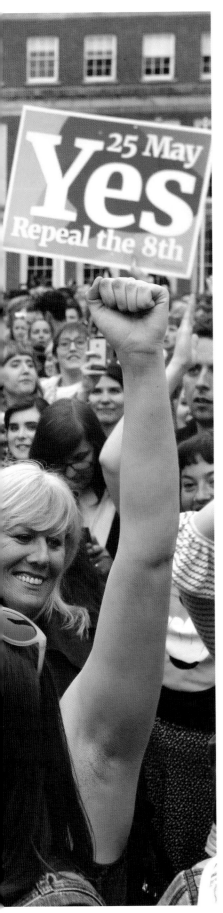

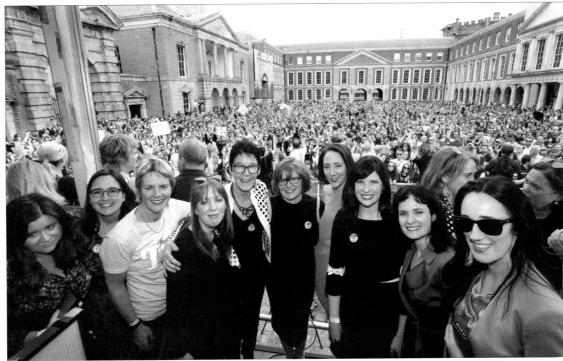

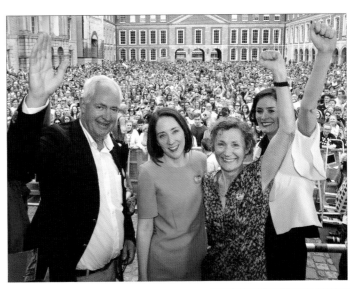

Top, from left: Together for Yes team at Dublin Castle Sarah Clarkin, Silke Paasche, Orla Howard, Sinead Kennedy, Ailbhe Smyth, Orla O'Connor, Grainne Griffin, Sarah Monaghan, Deirdre Duffy and Amy Rose Harte; Above, from left, Dr Peter Boylan, Grainne Griffin, Dr Veronica O'Keane and Kate O'Connell TD. Photos by Derek Speirs.

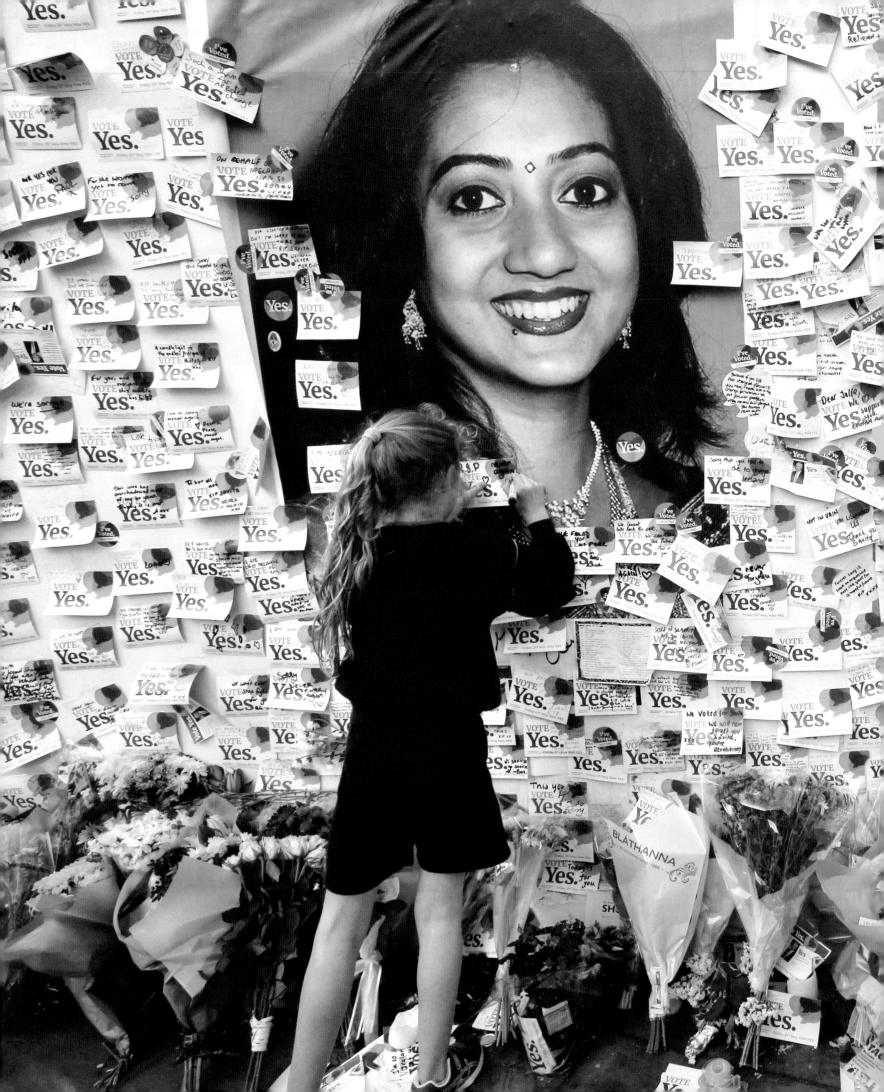

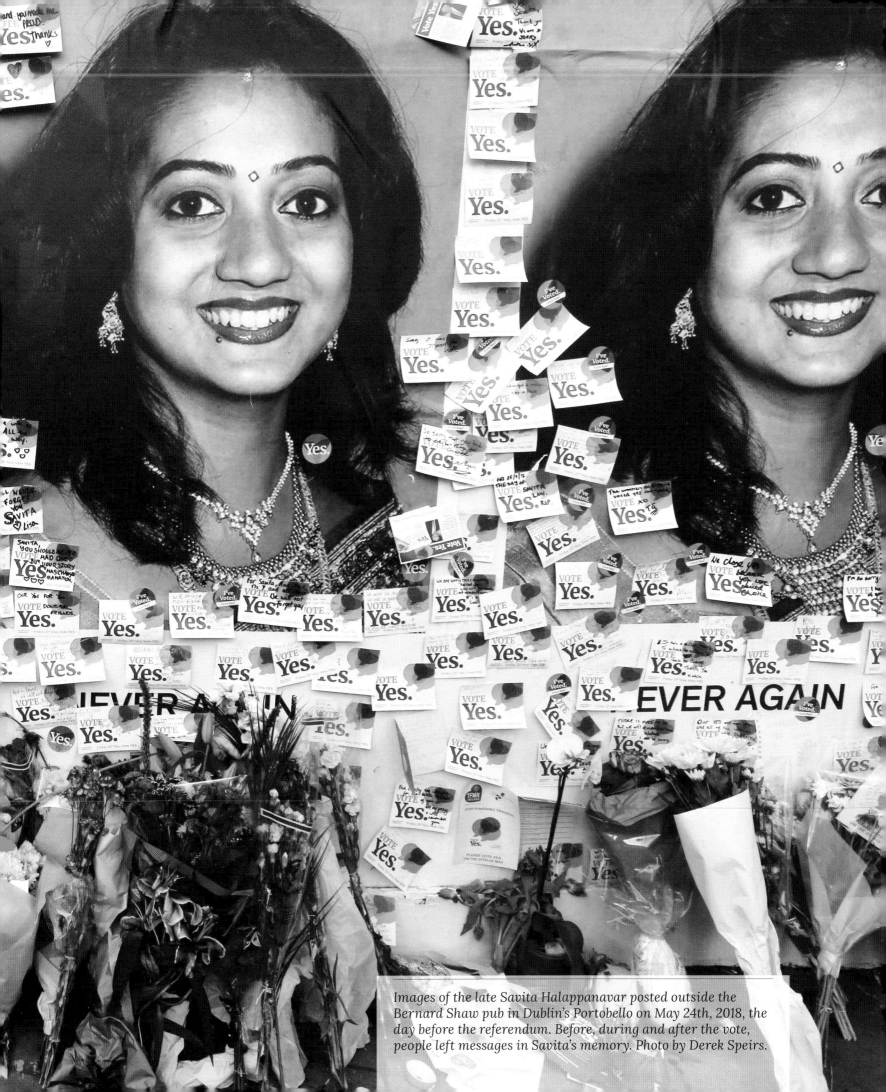

Images of the late Savita Halappanavar posted outside the Bernard Shaw pub in Dublin's Portobello on May 24th, 2018, the day before the referendum. Before, during and after the vote, people left messages in Savita's memory. Photo by Derek Speirs.

NATIONAL MATERNITY HOSPITAL AND ROME

Health Minister Simon Harris committed in 2018 to building a new National Maternity Hospital on the grounds of St Vincent's Hospital in Dublin. In 2019, landowners the Religious Sisters of Charity continued their wait for the Vatican to allow them lease their land to the State. Rome's conditional assent to the land transfer in 2020 only caused further unease. Some predicted canon law, under which the landowners operate, would extend to the National Maternity Hospital and limit reproductive healthcare – as continues to be the case with St Vincent's. The Campaign Against Church Ownership of Women's Healthcare has kept up the pressure on what it terms "a grossly inadequate arrangement". Author and campaigner Marie O'Connor said: "... to expect a hospital [on lands owned] by the nuns' company to provide a full range of healthcare, including contraception, sterilisation, abortion, IVF and so on is unrealistic." At time of writing the ownership issue is still unresolved and a matter of public controversy.

Below: Activist Sheila O'Byrne addresses the rally.

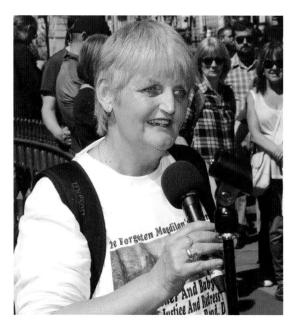

Photos by Derek Speirs.

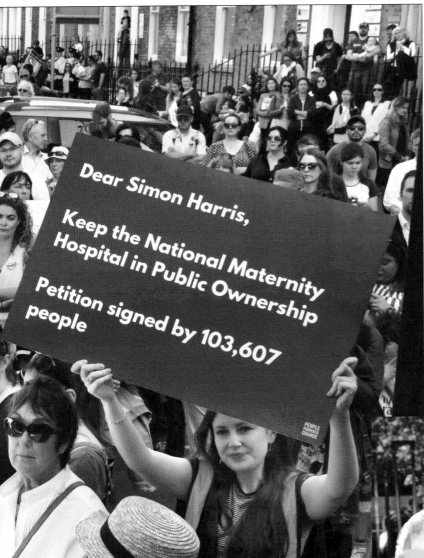

Left: At Merrion Square, Dublin, a protest organised by Uplift, The National Women's Council of Ireland, Parents for Choice in Pregnancy and Stillbirth and Justice for Magdalene Research among others presents a petition signed by over 100,000 people to Health Minister Simon Harris on May 7th, 2017. The demand was that the new National Maternity Hospital be publicly owned.

Dear Simon Harris,

Keep the National Maternity Hospital in Public Ownership

Petition signed by 103,607 people

Right: Helen Guinane, Parents for Choice, speaking at the event.

THE NORTH IS NEXT

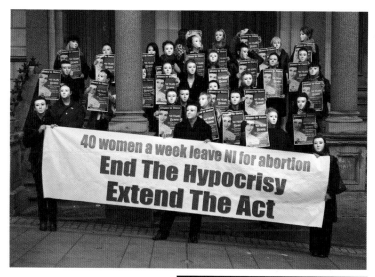

In 2013, a mother in Northern Ireland was prosecuted under the 1861 Offences Against the Person Act for obtaining abortion pills for her 15-year-old pregnant daughter. The 1967 Abortion Act in England and Wales was never extended to Northern Ireland. The woman had to wait six years to hear she had been acquitted of the charge when abortion was decriminalised in the state in 2019. That was when the Westminster Parliament in London voted overwhelmingly to liberalise Northern Ireland's abortion laws largely due to the activism of two Labour Party MPs. The devolved Parliament, Stormont, had collapsed.

In 2020 the British government published a legal framework for health trusts to deliver abortion services. Some but not all provided limited access to terminations on restricted grounds.

This resulted in 1,014 women and girls having to travel to England or Wales to obtain pregnancy terminations. Others had to travel within Northern Ireland to find a Health Trust which might provide them with services or travel south of the border.

Above: 40 Women protest on the steps of St Columb's Hall, Derry in 2008. Photo courtesy of George Row.

Right: 40 Years Behind Alliance for Choice poster, designed by Denise Meenan.

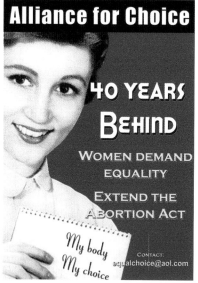

Alliance for Choice, emphasising abortion as a human rights issue, kept up the pressure internationally and in the courts. Urging caution, the Alliance said in 2021: "Statements of intent fall short given that despite the decriminalisation of abortion in NI in October 2019, followed by the NI Abortion Regulatory Framework in April 2020, the abortion services we need and require are nowhere near being realised. We need action and we need it now."

Northern Ireland Health Minister Robin Swann of the Ulster Unionist Party blocked advances to implement abortion services through health trusts. He was supported in this by the Democratic Unionist Party.

Substantial proportions of obstetricians and gynaecologists, both Catholic and Protestant, were reported to be available to engage with new services according to a University of Ulster study.

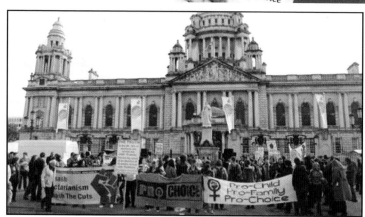

Above: Alliance for Choice marks International Day for Decriminalisation of Abortion 2012 outside Belfast City Hall. Photo courtesy of George Row.

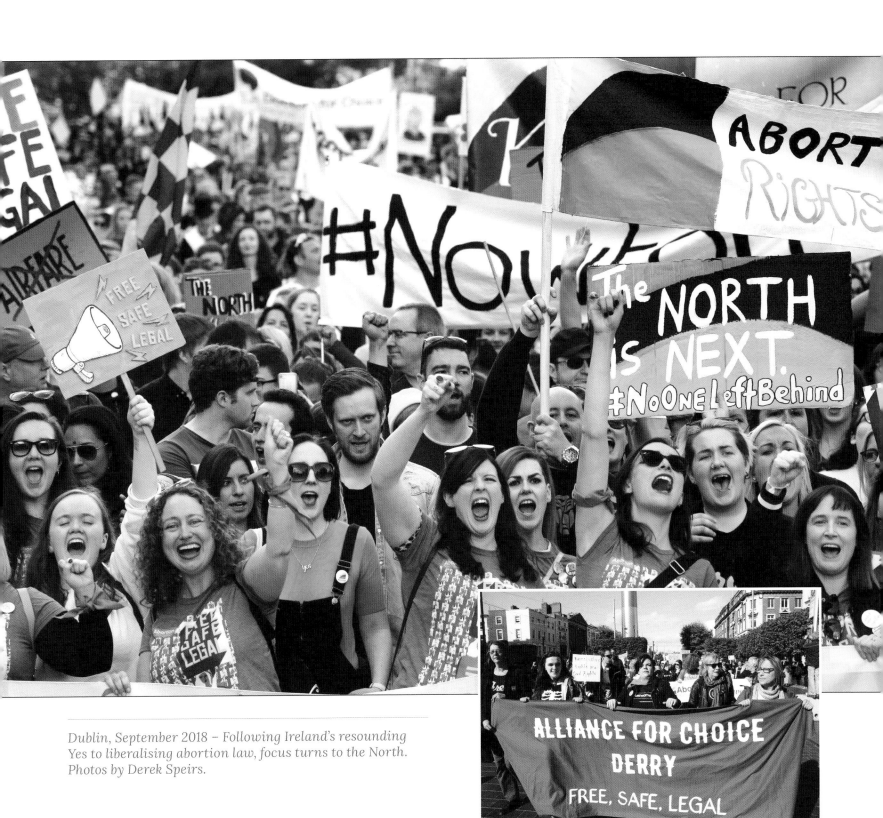

Dublin, September 2018 – Following Ireland's resounding Yes to liberalising abortion law, focus turns to the North. Photos by Derek Speirs.

CLOSING NOTE

Our present will become the past of other men and women. We depend on them to remember it with the complexity with which it was suffered. As others, once, depended on us.

– Eavan Boland (1944-2020) – poet, Irish Women's Liberationist, lifelong feminist

The Road to Repeal has shown the gradual emergence of a movement in Ireland for reproductive autonomy and the demand for respect for women's bodily integrity. Initially slow, the movement gathered momentum until women were confident enough to confront taboos and not merely ask but demand their right to control their bodies.

In 2019, 1,014 women from Northern Ireland and 375 from Ireland had a pregnancy terminated in Britain. Of those, 15 per cent were 40 years old or older; 74 per cent were more than 12 weeks' pregnant; 20 per cent were single with no partner; 81 sought terminations on grounds of congenital or chromosomal malformation or similar conditions in the foetus.

The Road to Repeal is not over, but as Sally Rooney acknowledges in The New Yorker in 2018: "When the referendum passed, I felt like the official institutions of the state were catching up to the country I had grown up in."

Abortion law in 2021 Ireland still contains unreasonable criminal sanctions for deviating from its complexity. The waiting time limits have no basis in medical evidence and many women and girls face travel restrictions. Some Catholic-run hospitals are permitted at this time to withhold medical services, including legal abortion. Some GPs are unwilling to supply the abortion pill. In Northern Ireland, the Alliance for Choice and its many component organisations, continue the struggle to implement the right to bodily self-determination.

At time of writing, a promised review of the Health (Regulation of Termination of Pregnancy) Act 2018 was still outstanding.

Battles globally around women's bodies have not gone away.

In Ireland, the shameful outcomes of old and newer attitudes to maternity co-exist: the Magdalene Laundries, Mother and Baby Homes, the "harrowing roll of maternal deaths" read into the Dáil record by Clare Daly TD in May 2019.

Controversy over the new National Maternity Hospital has hinged on uncertainty about canon law and state law and which would have ultimate authority over procedures performed there, including terminations. Since mid-2018, the Campaign Against Church Ownership of Women's Healthcare has forced this issue onto the agenda, showing, if it needed to be, that efforts to protect women's access to full medical care are grassroots driven.

The 3,000-page report of the State's Commission of Investigation into Mother and Baby Homes has faced legal challenges. While consultation was supposedly encouraged, women survivors have had to go to court to try to get inaccurate reporting of their witness statements removed or amended.

Ironically, these challenges came 70 years after the late Noël Browne's revolutionary Mother and Child scheme was dismantled by then Taoiseach Éamon de Valera and Archbishop John Charles McQuaid.

Bernadette McAliskey said in 2017 "we're still here … demanding something we demanded almost 50 years ago". Road to Repeal sets out in words and pictures five decades of campaigns, movements, and above all the individual sacrifices that finally brought choice – albeit limited – into Irish maternity services.

We are right to recall and celebrate May 25th, 2018, to acknowledge the debt owed to previous activists, and continue to do whatever is needed, wherever it is needed, to make the planet safer for women and girls everywhere.

Therese Caherty and Pauline Conroy
March 2022

Máirín Johnston, Nell McCafferty, Máirín de Burca, Marie McMahon and the late Mary Sheerin (1939-2021), veterans of the 1970s' Irish Women's Liberation movement, pictured at the Abbey Theatre, Dublin, on April 10th, 2017, for a musical account of their activism. The Train by Rough Magic Theatre Company was written by Bill Whelan and Arthur Riordan. Photo by Derek Speirs.

EDITORS

Derek Speirs has been described as "Ireland's most renowned photographer of social scenes and social issues" by Rev Peter McVerry. He has excelled in illustrating the invisible, the unwanted, the hard to find and the rebellious over five decades. He has been widely exhibited, most recently at the Galerie Dezernat5 as part of the Filmkunstfest in Schwerin in Germany. His photo publications, such as Pavee Pictures and 30 Years of Pavee Point, have been widely acclaimed. He cooperated with Gene Kerrigan in Goodbye to All That, a publication addressing Ireland and the career of politician Charles Haughey.

Pauline Conroy is a social scientist, policy analyst and author who has published extensively on reproductive rights since the 1980s. Her publications on gender themes, poverty issues and reproductive rights have been published in the UK, Italy, Denmark, Germany, Canada and the US. She has been an expert in social policy with the European Commission, the Council of Europe and the International Labour Organisation. Pauline was co-editor of Gender in Irish Society in 1987 with Galway University Press. In 2018 she authored A Bit Different – Disability in Ireland with Orpen Press.

Therese Caherty is a journalist, trade unionist and feminist writer who engaged in the major turning points in reproductive rights campaigns in recent years. She was assistant editor in women's publisher Attic Press. She has extensive experience in print journalism and is a former member of the Irish Executive and Equality Councils of the National Union of Journalists. She was NUJ rep for the Irish Congress of Trade Unions Women's Committee. She co-founded and chaired the Irish Women Workers Commemorative Committee, and the Trade Union Campaign to Repeal the 8th Amendment.